CATALONIA FROM ABOVE

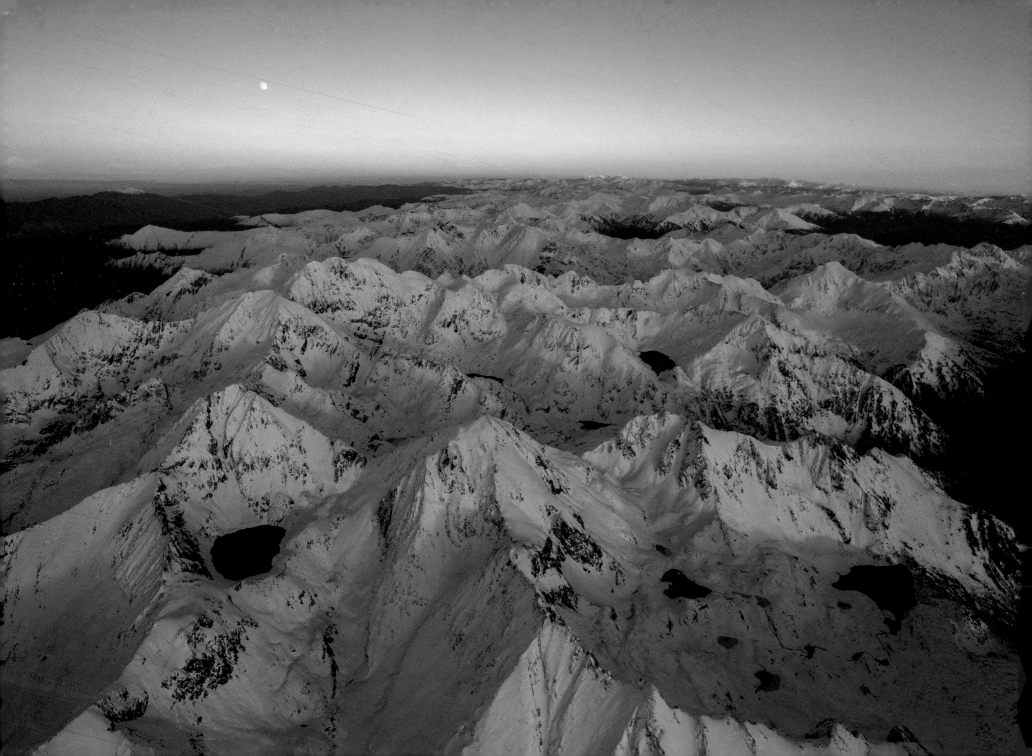

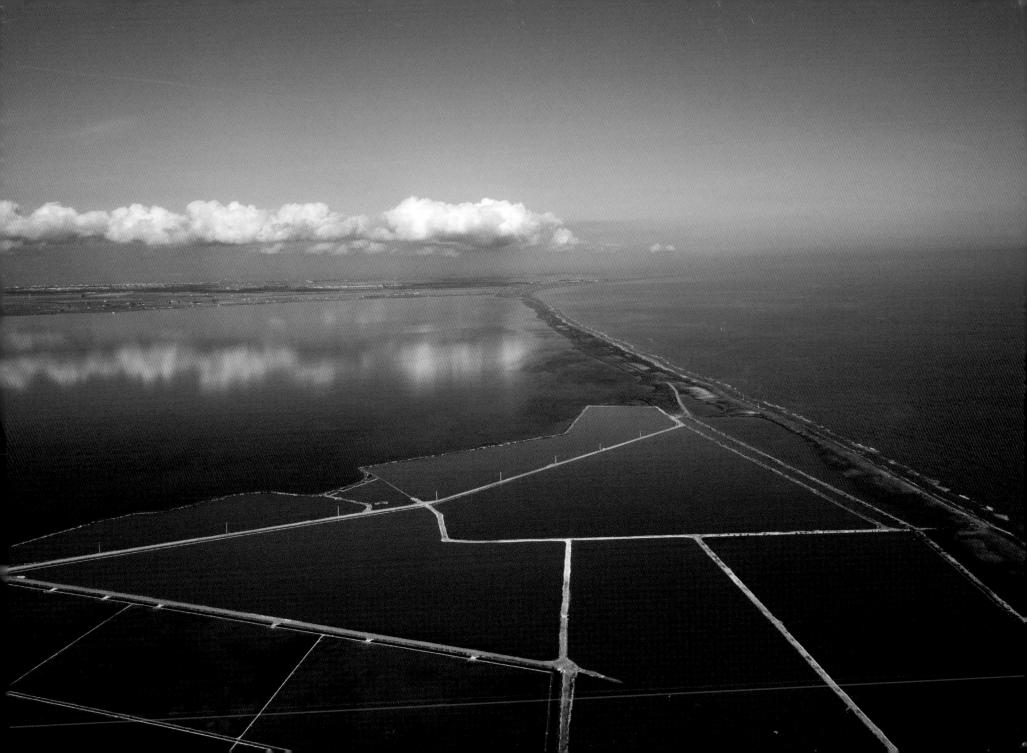

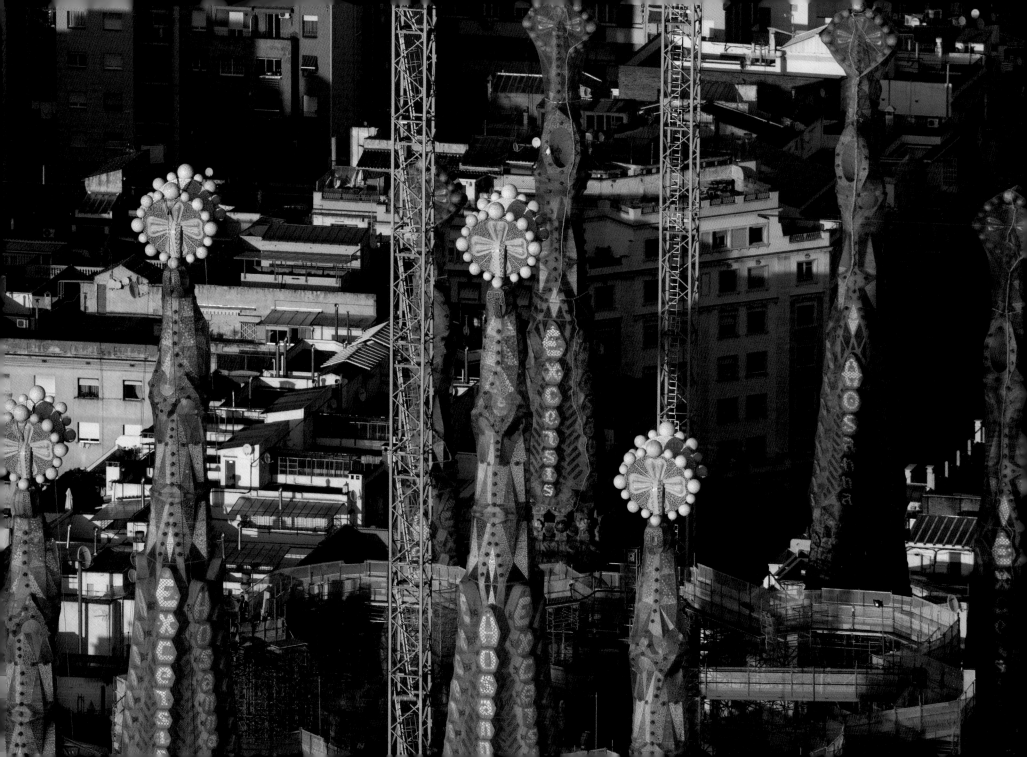

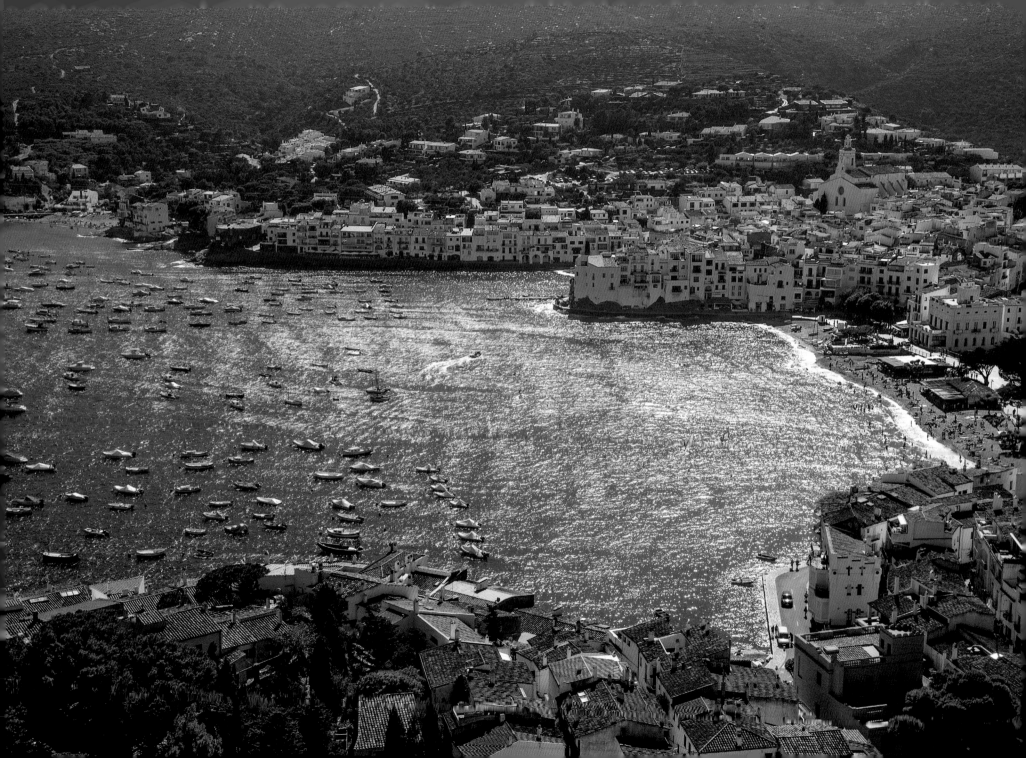

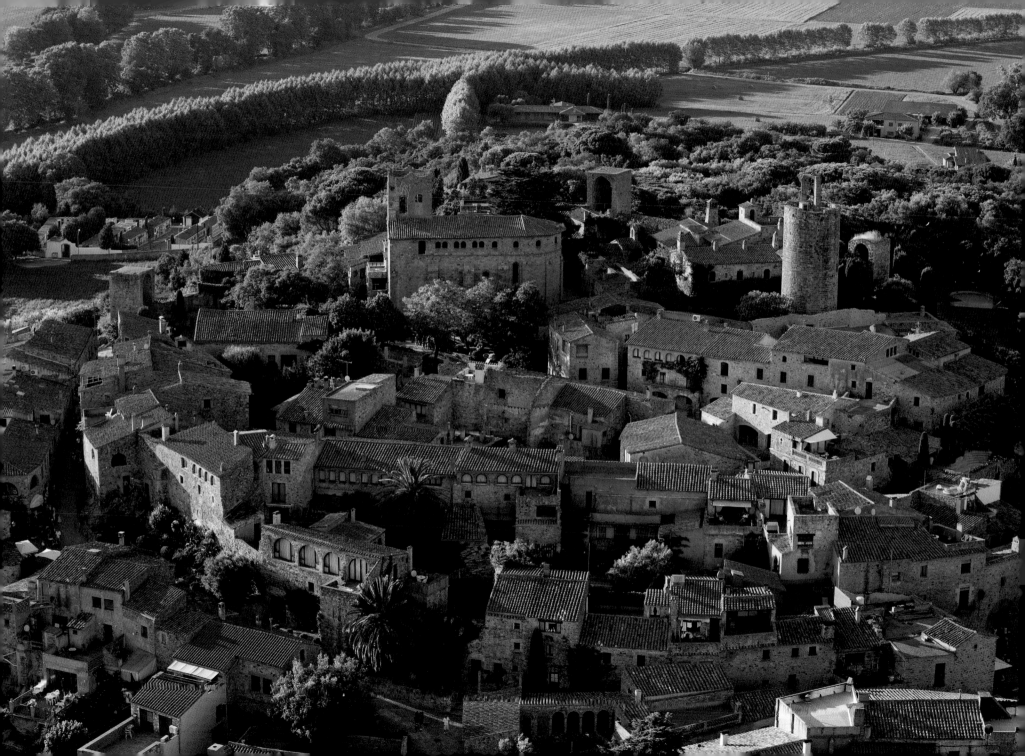

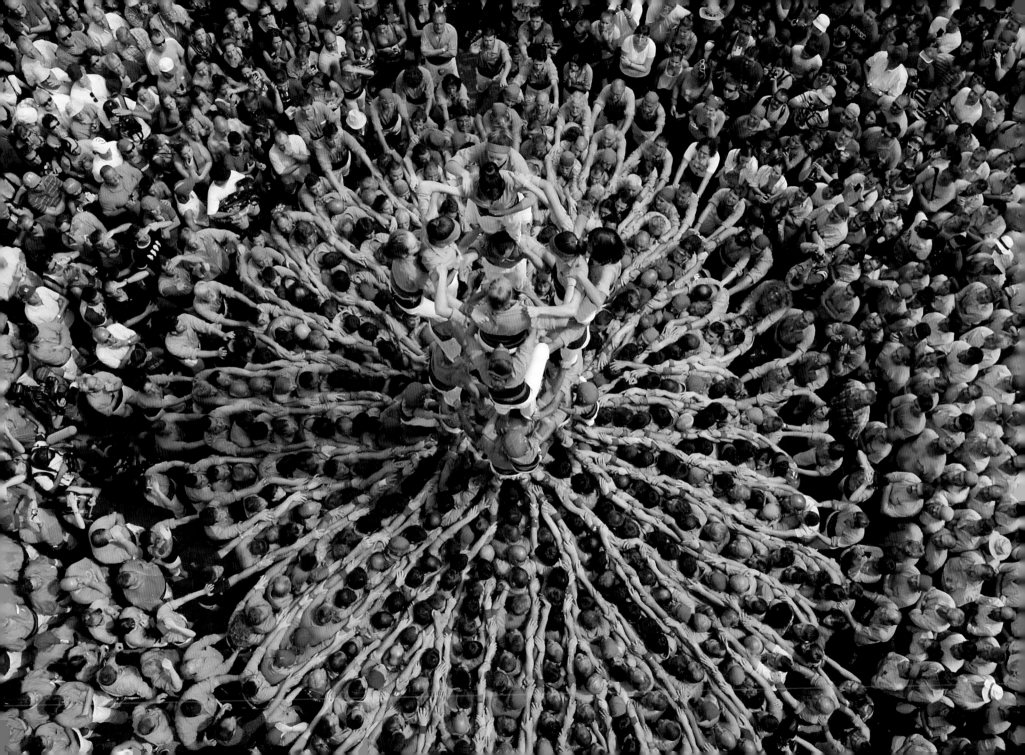

Generalitat de Catalunya
Government of Catalonia
Catalan Tourist Board

www.catalunya.com

CATALONIA FROM ABOVE

YANN ARTHUS-BERTRAND

Text by Ramon Folch

ABRAMS | NEW YORK

> 'Originality consists of returning to the origin'
> Antoni Gaudí

My love affair with Catalonia has never ceased to grow… although its origins were timid.

At first I was somewhat familiar only with Barcelona, the domain of *modernista* architecture which introduces nature into the city, on its façades, in its parks, in its avenues… With his grandiose Sagrada Família and Casa Milà, with the details of his architecture, Gaudí managed to magnify what part of my work has invariably expressed: love of nature.

But I was far from knowing what awaited me beyond the Catalan capital.

The world of Catalonia unfolded before my eyes in the entire diversity of its landscapes, straddling the sea and the mountains down to the Ebre basin. I delighted in these contrasts, in this cultural, architectural, religious and linguistic *'mille-feuille'* of the Iberian Peninsula.

And all this without overlooking the lifestyle of the Catalans, which alternates constantly between exuberance and seriousness; a free people who express their coherence in the form of those impressive human towers. Not to mention their dynamism and creativity, which have gone far beyond the excessively restrictive frontiers of this magnificent region…

I had known for some time that the influence of the Catalan soul formed part of my everyday life, from Perpignan station, haunted by Dalí, via Saint-Paul de Vence to Paris, without forgetting the 'superb' Montserrat Caballé, who managed to unite the classical world of Bellini with the pop music of Queen.

'Painting is studying the ripples caused by a pebble as it falls into the water, a bird in flight, the sun as it sets over the sea or behind the pines and bay trees of the mountain'. I have sought inspiration in this quote from Miró to guide me on my adventure.

In this book I present you with my Catalonia and propose a journey full of beauty, surprises and poetry far removed from the usual clichés. I sincerely hope it will arouse your curiosity and your desire to discover.

YANN ARTHUS-BERTRAND

There are as many landscapes as people who contemplate them. In the words of Albert Einstein, 'Facts are facts but perception is reality'. We observe the same facts, though each of us constructs in our own minds the reality we perceive. How many Catalonias are there? As many as there are gazes. The gazes of different people, the different viewpoints of the same people. This book garners the gaze of Yann Arthus-Bertrand as he observes the Catalan landscape from the air. Do not therefore seek the Catalonia you may already know. Look for the one he has seen.

Neither should you expect an exhaustive, Cartesian account, since this book shows fragments of an impressionist painting. Each photograph is a brush stroke. Later you will have the opportunity to put the pieces of the jigsaw puzzle together in your mind as you think over what you have seen. Then you will realise that this set of apparently unconnected images belongs to a precise, unrepeatable reredos, a reredos that would have been equally precise and unrepeatable, though radically different, had Yann Arthus-Bertrand directed his gaze towards another country.

This he has done on other occasions. Yann Arthus-Bertrand has contemplated the entire world, in fact. Now he has concentrated his gaze specifically on Catalonia at many different scales, ranging from broad landscapes to the small phenomenon of a human tower as it is raised by a group of castellers. And invariably from above; invariably from that disconcerting angle of vision provided by aerial views. Disconcerting because our eyes are accustomed to seeing things at ground level. This is why we humans appreciate views from high vantage points, because they allow us to see other things in the things we have already seen. Or to see something new that was otherwise hidden behind impenetrable obstacles. Hence the fact that Yann Arthus-Bertrand's photographs are so captivating. They constitute a different gaze directed from a different place by a different person who masters a different specific medium of expression. A singular gaze which I have been privileged enough to include in a territorial discourse and to endow with its corresponding account.

Catalonia is a small country, with a total surface area of just over 32,000 km^2. It is extremely varied, even so. The coastline, the Pyrenees and a set of plains lying unexpectedly amidst stretches of highly rugged terrain generate multiple forms and give rise to a wide variety of local climates. The result is a multicoloured mosaic. On the same day you may ski in the mountains, lie on the beach and head for the horizon on an interminable plain. It is also an ancient country, like the rest of Europe. At each step you will come across vestiges of Iberian, Roman, Moorish or Carolingian times; or examples of the genius of the Renaissance, of the Baroque, of Neoclassicism or of contemporary art. Monuments punctuate the landscape; Yann Arthus-Bertrand's aerial camera perceives and captures it. Varied photographs of a highly varied territory.

Now it is up to you to make the meta-reading. I suggest you attempt to perceive your own particular landscape through Yann Arthus-Bertrand's gaze. They will all be perceptions of the Catalan space, none will be exhaustive, and they may even inspire you to go and see things for yourself. In that case, you will be warmly welcome.

DR. RAMON FOLCH
SOCIOECOLOGIST

CATALONIA

PREVIOUS PAGES

Central Pyrenees; La Trinitat salt flats, Ebre Delta
(see p. 33); Sagrada Família (see p. 102); Sant Feliu
del Riu (see p. 108); Cadaqués (see p. 70); Trullo
Reservoir (see p. 192), Puls (see p. 59); Castellers
of Vilafranca (see pp. 118-119).

CONTENTS

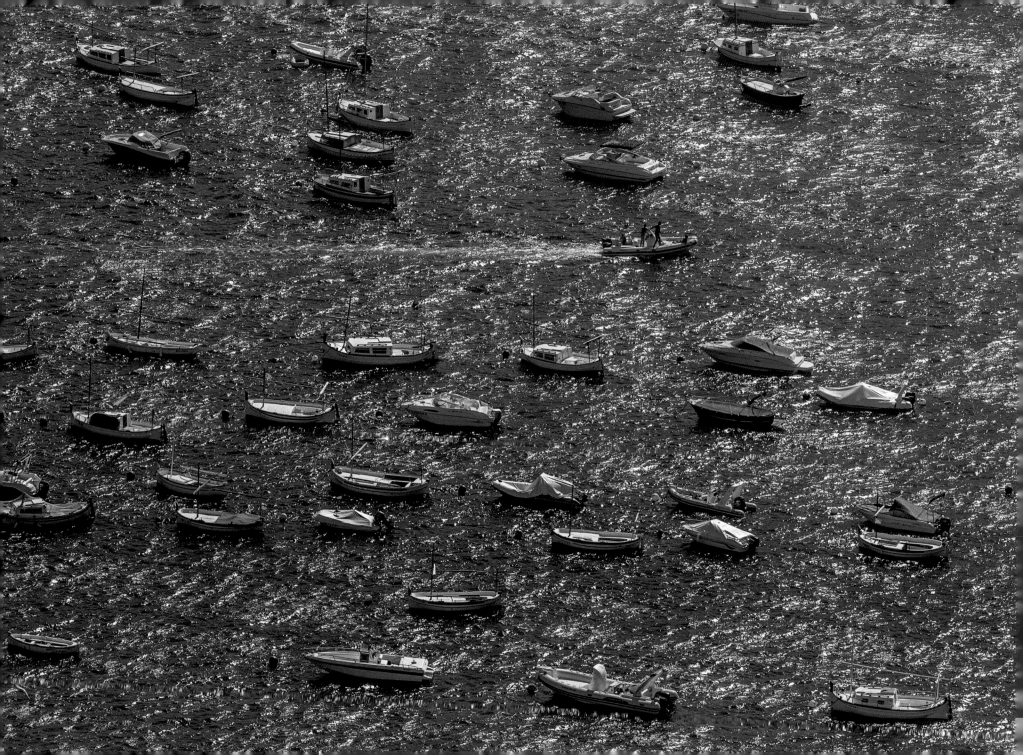

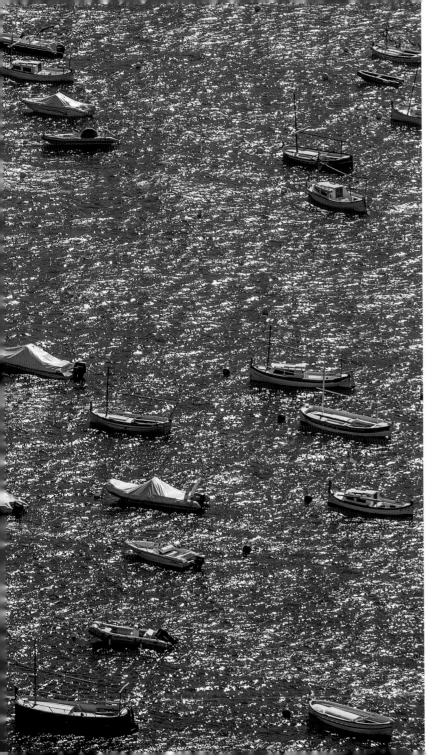

BESIDE
THE SEA

MARE NOSTRUM

The West was born in the Mediterranean. For the great cultures of Antiquity (the Fertile Crescent, Egypt) and for the Greeks and Romans, the 'sea' was the Mediterranean. Travellers -extremely few and far between at that time- spoke about remote oceans, but the tangible sea, the scenario for fishing and seaborne trade, was the Mediterranean. Western cultural points of reference, including the major religions, are Mediterranean in origin. Rome was the centre of this space and from its privileged location it created a great circum-Mediterranean empire. The Romans regarded themselves as scions of the Mediterranean and it was over the entire Mediterranean that they governed. Consequently, they felt justified in calling it the Mare Nostrum.

Today, the Mare Nostrum has many co-owners. And a host of tenants. Furthermore, as a sea it is showing signs of wear and tear. Even so, it continues to be a splendid sea for mankind; a blue, salty sea, yet poor at the same time. Blue, because it reflects the light of these latitudes; salty, because evaporation is highly intense, indeed, greater than the freshwater supply from rivers and direct rainfall (if it were not for the constant influx of water from the Atlantic through the Straits of Gibraltar, by now it would have become a dried-up

basin); and poor because the nutrients that fertilise the upper levels, where sunlight sets vital processes in motion, tend to settle on the seabed since there are practically no upward currents to carry them back to the surface.

A small portion of the Mediterranean corresponds to Catalonia, one of so many sub-seas of the Mare Nostrum such as the Aegean, the Ionian, the Tyrrhenian and the Adriatic. But there is also a Catalan or Balearic Sea, which though less salty and less blue than the Hellenic Mediterranean is nonetheless equally captivating. For centuries it opened up our horizons, allowing us to expand to the East and beyond. For centuries the Mediterranean has been our *'pont de la mar blava'* (bridge over the blue sea), to use what has become a popular literary expression. Catalonia, at the head of the Kingdom of Aragon, dominated the waters of the Mediterranean and set up consulates of the sea in almost one hundred Mediterranean ports.

The Balearic Sea, therefore, constitutes a natural extension of Catalan territory into which Catalonia becomes progressively, intimately dissolved. The Ebre Delta, in its ambiguous condition as a wetland, symbolises this situation. It is the perfect metaphor for a territory that begins in the mountains and becomes configured on the coast, beside the sea.

MOUTH OF THE EBRE | 40º 43' 57" N, 00º 52' 09 E

The Islet of Sant Antoni and the Buda and El Garxal lagoons on the final stretch of the River Ebre through its delta

The present-day mouth constitutes its third in recent decades.

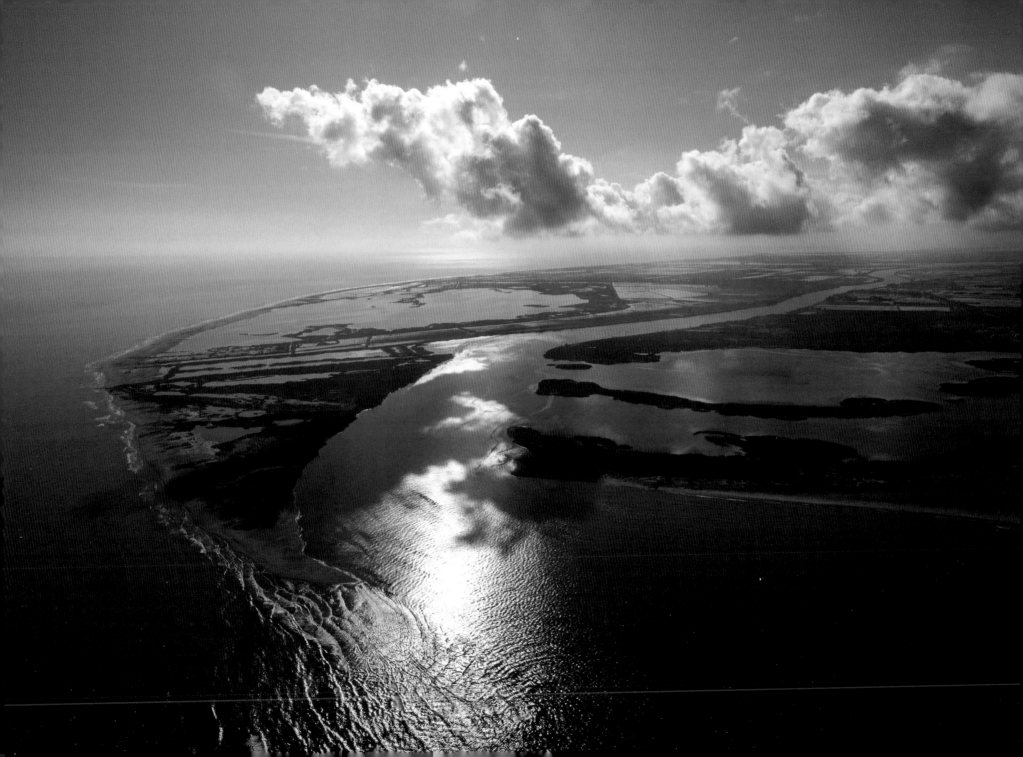

BEACHES, CAPES AND DELTAS

From the River Sènia in the south to Cape Falcó (Portbou) in the north, Catalonia has some 580 km of coastline. This is a considerable coastal strip for a country of only 32,000 km². That part of the coastline which is relatively regular and straight, that is, discounting the sinuosities, would measure scarcely 350 km. It is oriented predominantly from south-west to north-east, although the final stretch, between Cape Begur and Cape Falcó, veers mostly from south to north. Offshore islands are few, limited to a number of largely insignificant islets.

The geological nature of this coastal strip has given rise to a great variety of landscapes. Thus, the crystalline and metamorphic rocks (granite and slate) that predominate in the north have generated a craggy coastline, while the calcareous formations and modern sedimentary terrain have fostered the creation of more or less extensive beaches or else of relatively low-lying rocky coasts lacking in sand. The action of rivers has also had a part to play in modelling the littoral, either by carrying down silt which the marine currents then redistribute along the coastline, or depositing it at their mouths to form deltas.

On the Catalan coast there are three deltas in the strict sense of the term: the Tordera Delta, between Malgrat and Blanes, the smallest of the three; the Llobregat Delta, of considerable dimensions (some 95 km²), between Barcelona and the Garraf Massif; and the Ebre Delta, the largest and most spectacular of all (320 km²), at the southern end of the Catalan coast between L'Ampolla and Sant Carles de la Ràpita.

In short, we might say that the north coast, from Barcelona upwards (known as the 'costa de llevant') is predominantly rocky, with beaches interspersed with a considerable number of coves, while the south coast, from Barcelona downwards (the 'costa de ponent') is alternately low-lying or rocky, with longer beaches and only a few coves. The beaches of the granitic or slaty *costa de llevant* are of coarse sand (pulverised granite and small pebbles), while the *costa de ponent* is characterised either by limestone cliffs or fine calcareous sand beaches. We therefore have coastlines and beaches to suit all tastes and preferences.

ILLES MEDES | 42º 02' 50" N, 03º 13' 20" E
Less than one kilometre from the shore, opposite L'Estartit, lies the tiny Illes Medes archipelago, a set of calcareous islets with a lighthouse and a populous wildfowl colony.

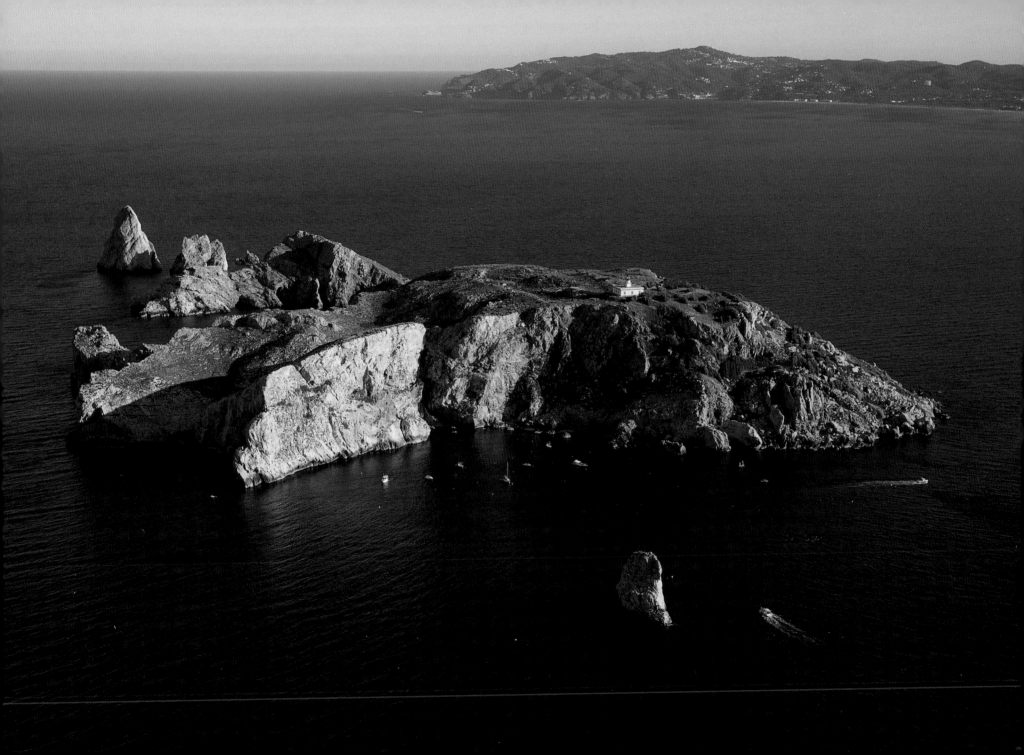

LIVING WITH THE WAVES

The human population has gradually become concentrated on the coast. Large inland cities are relatively few, while those a long distance away from the littoral belt are fewer still. Were it not for the weight of history, which tends to consolidate ancient land occupation strategies, large inland cities would be even rarer. However, it is not only the big metropolises that seek the coastline, small towns and villages also proliferate there. Indeed, the coasts of many countries have become almost a continuum of human settlements.

The Catalan coast is a case in point, needless to say, being a littoral belt where mankind has been present since remotest times. The Iberian peoples of two thousand years ago or more preferred to settle near the coast, though at a certain distance from the sea for reasons of both security and health (given the abundance of salt marshes that were veritable breeding grounds of malaria), while the Greeks began to establish trading colonies on the Catalan coast itself as from the VIth century BC. The Romans also founded coastal cities, Barcelona and Tarragona being the two most prominent examples.

Today, a total of seventy Catalan cities and towns share the coastline, while coastal urban nuclei surpass this figure, since the same municipality may comprise two or more such nuclei, more or less concentrated human settlements. Beside the sea or only a few hundred metres inland a total of around three and a half million people currently live, and in the summer, with the influx of visitors, the figure rises to four million or more. This means a density of almost five thousand per kilometre, that is, five people per metre on the coastline if they were all to gather there at the same time. More, in fact, because around 210 of the 820 km of coastline correspond to ports, wharves and breakwaters.

These statistical averages, however, are far removed from actual reality. Indeed, one third of the Catalan coast is the object of special protective measures and the population density never reaches the extremes indicated above, far from it. The littoral belt is strongly humanised, certainly, although it has managed to preserve its captivating beauty, often by virtue precisely of the picturesque nature of its inhabited nuclei.

PORTLLIGAT | 42º 17' 36" N, 03º 17' 09" E

Salvador Dalí's house, standing right beside the water in the small cove of Portlligat, one of the beautiful tiny fishermen's havens that pepper the craggy coastline of Cap de Creus.

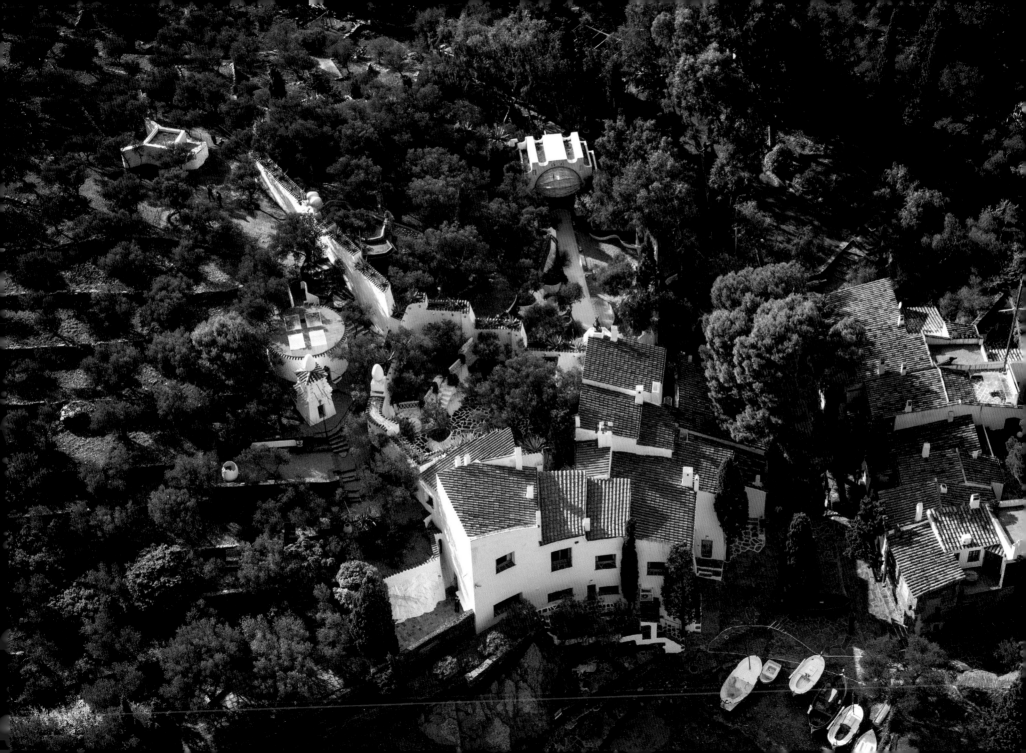

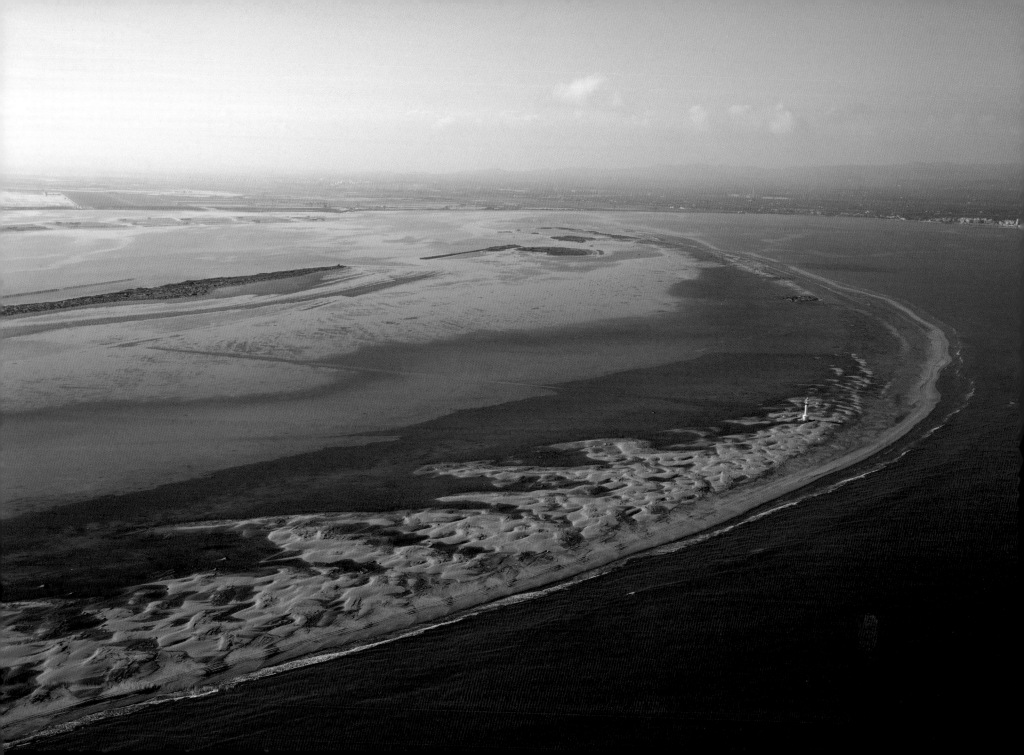

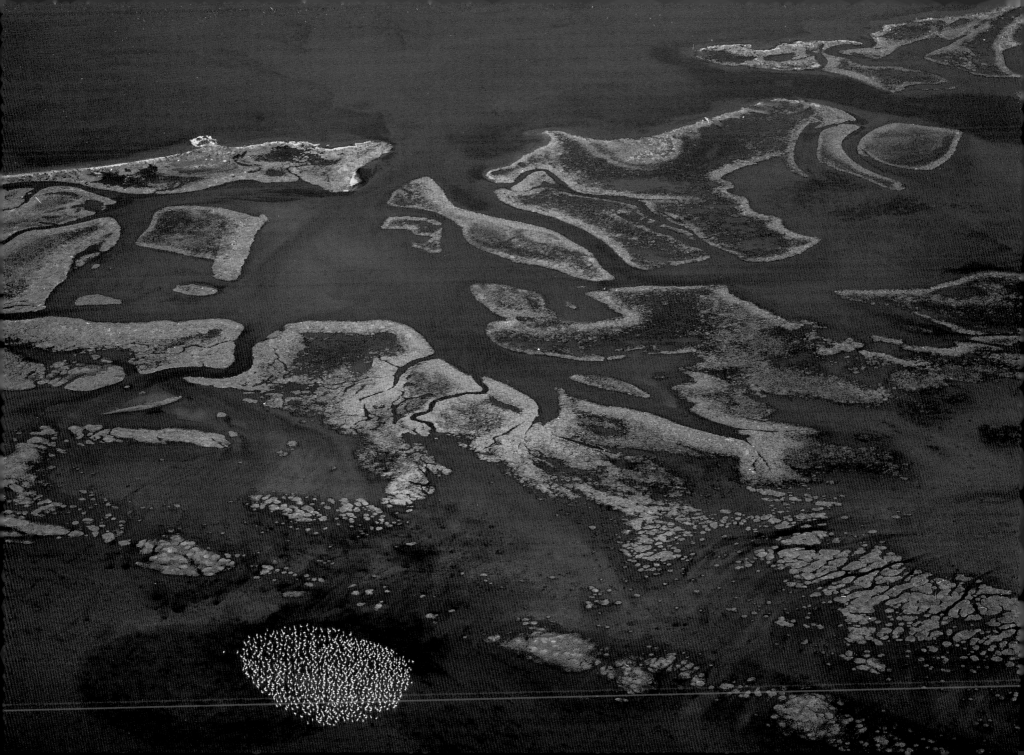

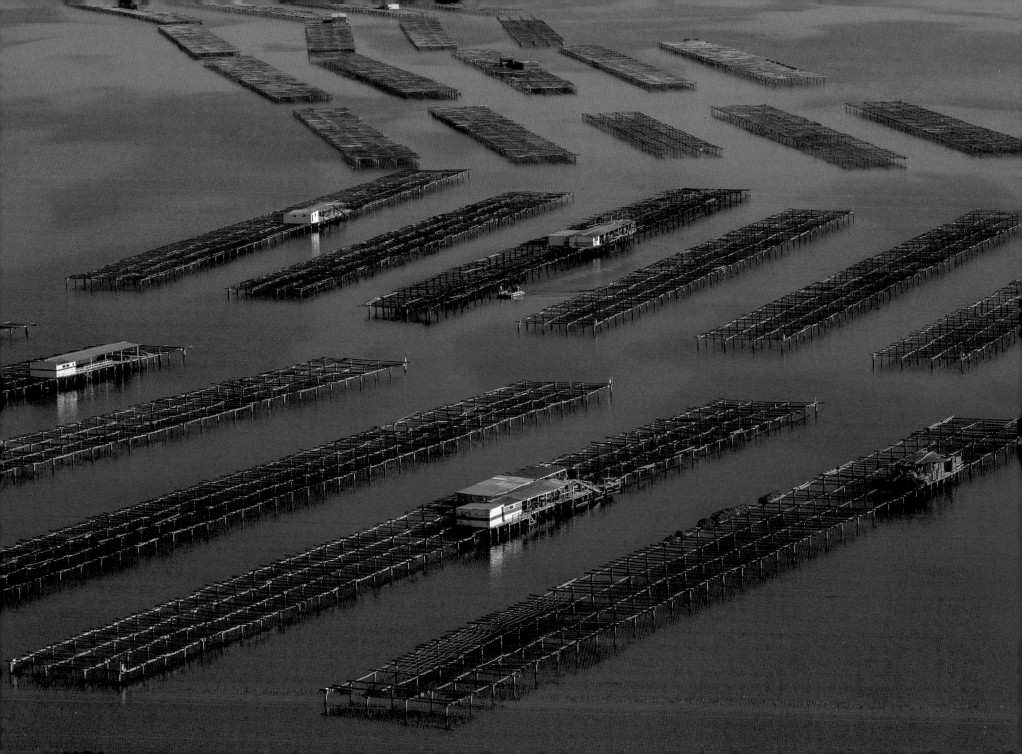

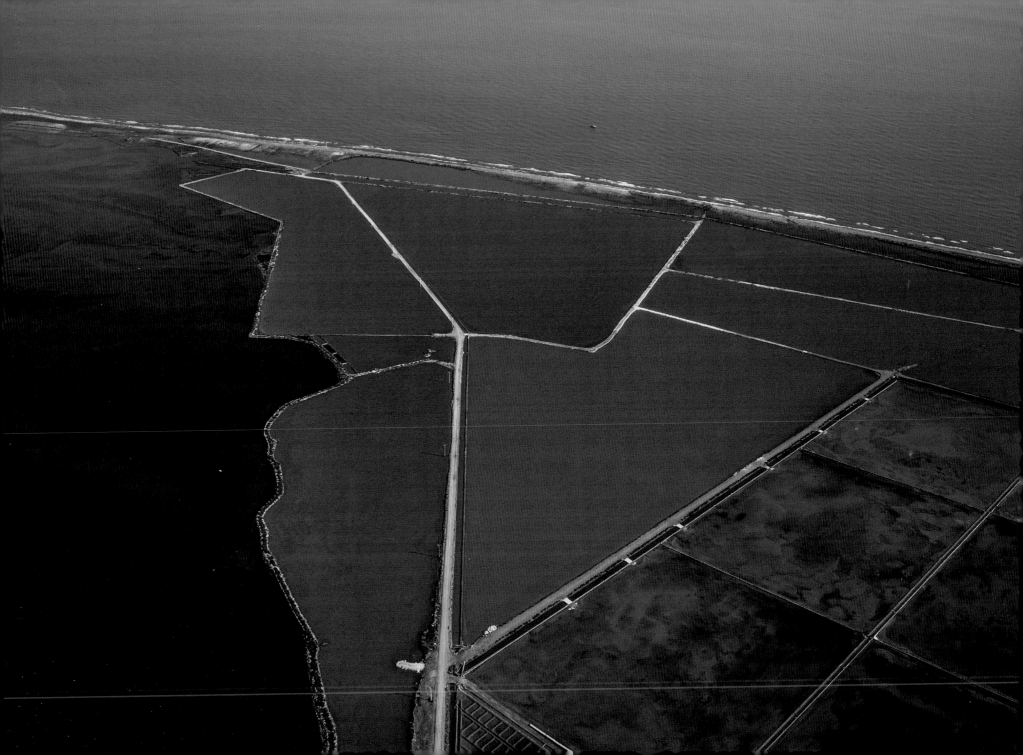

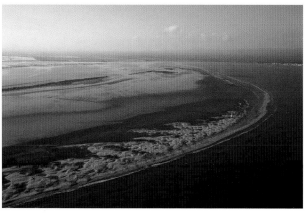

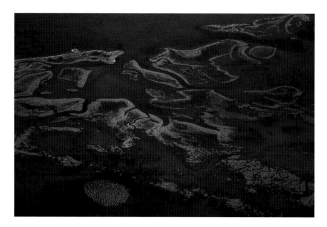

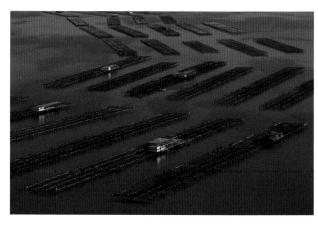

PUNTA DEL FANGAR, EBRE DELTA
40º 47' 10" N, 00º 45' 54" E

For centuries the River Ebre has been carrying down eroded matter from the land around its basin. As deforestation increased, the soil became more vulnerable and erosion stronger. The coarser materials are deposited quickly on the river bed while the finer particles remain suspended in the water and may reach the mouth. There the river loses all its impetus and even the finest matter becomes sedimented. This is how the delta was formed, stretching from inland towards the sea. Punta del Fangar is one of the advance points in the Ebre Delta, which is today receding, or almost, because upriver dams greatly reduce water flow and deprive it of sediments. The river deposited, and continues to deposit, sediment, which the marine currents open into a fan shape at Punta de Fangar, on the left bank, and at the almost symmetrical Punta de la Banya on the right bank (see the photograph on page 27).

PUNTA DE LA BANYA, EBRE DELTA
40º 34' 00" N, 00º 38' 00" E

The Ebre Delta is now a natural park, combining farmland with strictly protected areas. On Punta de la Banya there are extensive tracts carpeted with bacteria, formations only a few millimetres thick and very similar to what must have been the first forms of biological occupation of the Earth thousands of millions of years ago. They constitute the most ancient form of solar energy capture. The saltwater languishes among the bacterial carpets creating a kind of dream landscape, unparalleled practically anywhere on the planet, the scenario for unique species of fauna. Large flocks of flamingos (*Phoenicopterus ruber*) fly back and forth over it thou-sands of times (below in the photograph). These flamingos, delicate pink in colour, have returned to nest on the delta now that it is a protected area. Their synchronised movements, as they plough through the air or walk through the salt marsh, constitute a genuine spectacle. In 2013 the Terres de l'Ebre were declared a UNESCO biosphere reserve.

BAY OF EL FANGAR, EBRE DELTA
40º 46' 28" N, 00º 44' 09" E

The sheltered bay of El Fangar is a mirror-like expanse of calm, shallow waters, covering an area of some six-hundred hectares at depths ranging between one and three metres. Since the nineteen-eighties, aquafarming has become a widespread activity here. While fish-farming prevails elsewhere on the Ebre Delta, aquafarming in El Fangar focuses on raising molluscs, above all mussels (*Mytilus galloprovincialis*) and oysters (*Crassostrea gigas*). From a palaphytic structure made of criss-crossing beams, called a musclera, two or three-metre-long ropes hang down to which the baby mussels are fixed and allowed to grow. From the muscleres of El Fangar and Els Alfacs together, on the Ebre Delta an annual total of three million kilos of mussels and around 400,000 kilos of oysters are collected. These muscleres constitute an atypical landscape that did not exist several decades ago.

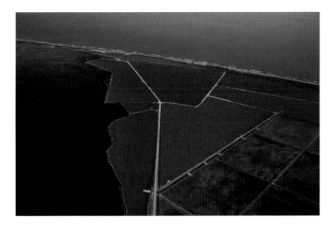

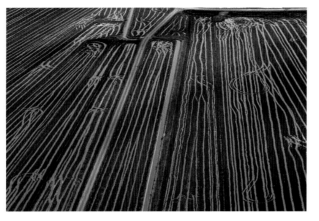

LA TRINITAT SALT FLATS, EBRE DELTA
40º 35' 08" N, 00º 41' 24" E

The sea is blue, salt is white; why, then, are some salt flats pink? Because of the proliferation of bacteria when the water is very salty and warm. And not any kind of bacteria but rather of several species on the genus *Halobacterium*. It is an ancient organism, very similar to the first living beings that appeared on the planet some thousands of millions of years ago, when extreme temperature and salinity conditions prevailed, comparable to those of today's salt flats, above all in the summer. This pink colour corresponds to a pigment on the membrane of *Halobacterium*, bacteriorodhopsin, which captures energy from sunlight. When the salinity level drops or the water cools, the bacteria disappear and the salt flat loses its pink tone. On those of La Trinitat, in the bay of Els Alfacs on the Ebre Delta, we may appreciate this phenomenon. The contrast between pink and blue is a very striking one.

RICE FIELDS ON THE EBRE DELTA
40º 44' 32" N, 00º 43' 29" E

Two centuries ago, the Ebre Delta was a vast inhospitable and insalubrious salt marsh infested with mosquitoes. Only the areas close to terra firma were timidly occupied by the occasional peasant farmer who, forced by necessity, was impelled to cultivate those ungenerous lands. Little by little, however, they managed to make headway. Near the banks, the impetus of the river water kept the soils suitable for agriculture, while the rest were salty soils impossible to cultivate. Until in the XIXth century groups of people from Valencia taught the locals how to cultivate rice. Thanks to the freshwater that flows through two lateral canals, one on either bank, and along the 400 kilometres of resultant irrigation channels, it became possible to flood the fields from April to September and temporarily eliminate the salt. This now constitutes an anthropic ecosystem that provides the habitat for a wide range of fauna species. Unfortunately, intensive use of agrochemicals has substantially impoverished it in recent years...

FIELDS ON THE TERRACES OF THE EBRE
40º 43' 44" N, 00º 34' 06" E

The two canals that invigorate agriculture on the Ebre Delta originate some 40 kilometres upriver, at the Xerta lock, a medieval work of hydraulic engineering that made it possible to divert part of the river water (it is a low-lying barrage that allows the water to flow over it). Until they reach the Delta, these two canals run parallel to the river, one on either bank, and for this reason they are called the right Ebre canal and the left Ebre canal. Along the way they irrigate the river terraces, which have become fertile fields with an abundance of water in the midst of the thirsty surrounding landscape. This vigorous agriculture overlapped by industrial elements generates a new kind of landscape that was unimaginable centuries ago.

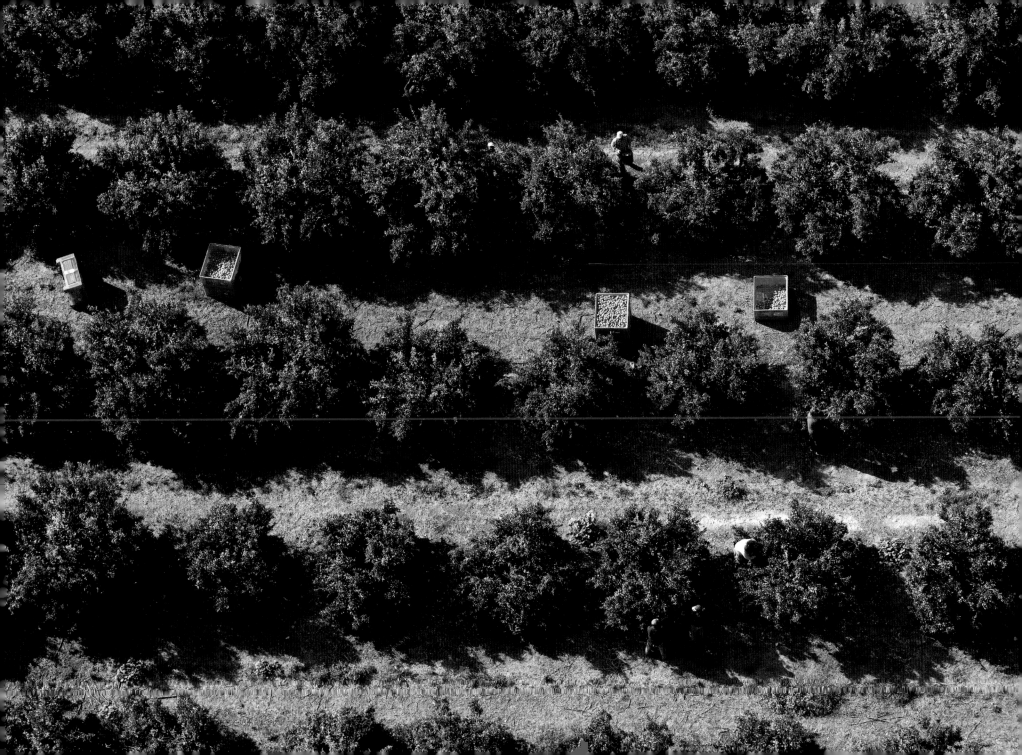

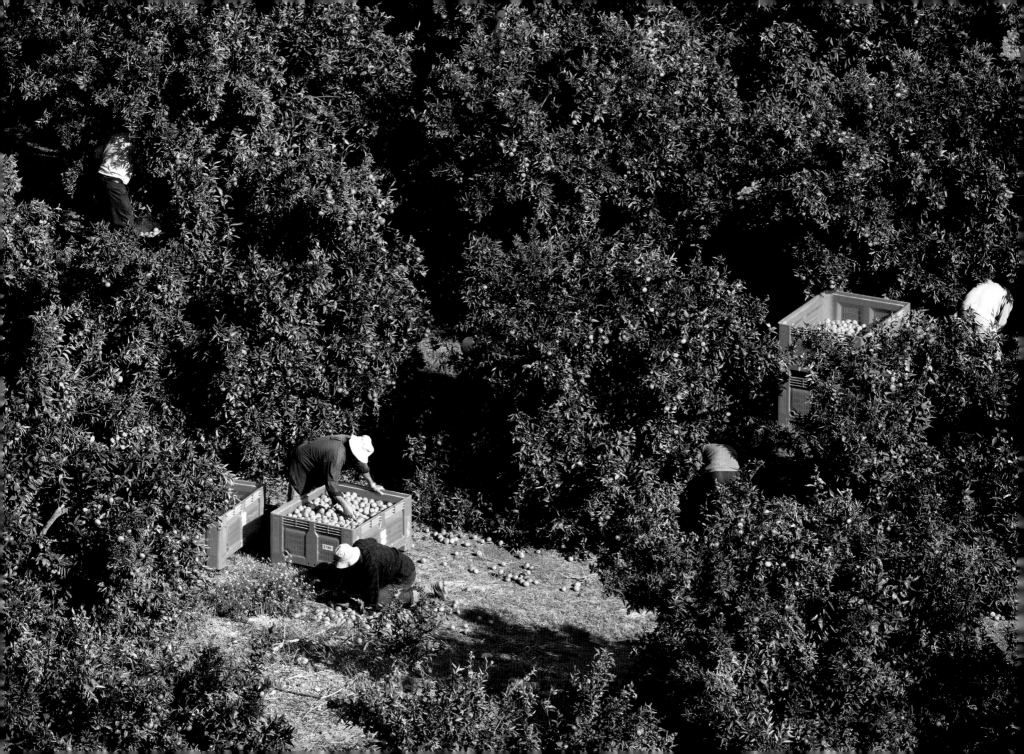

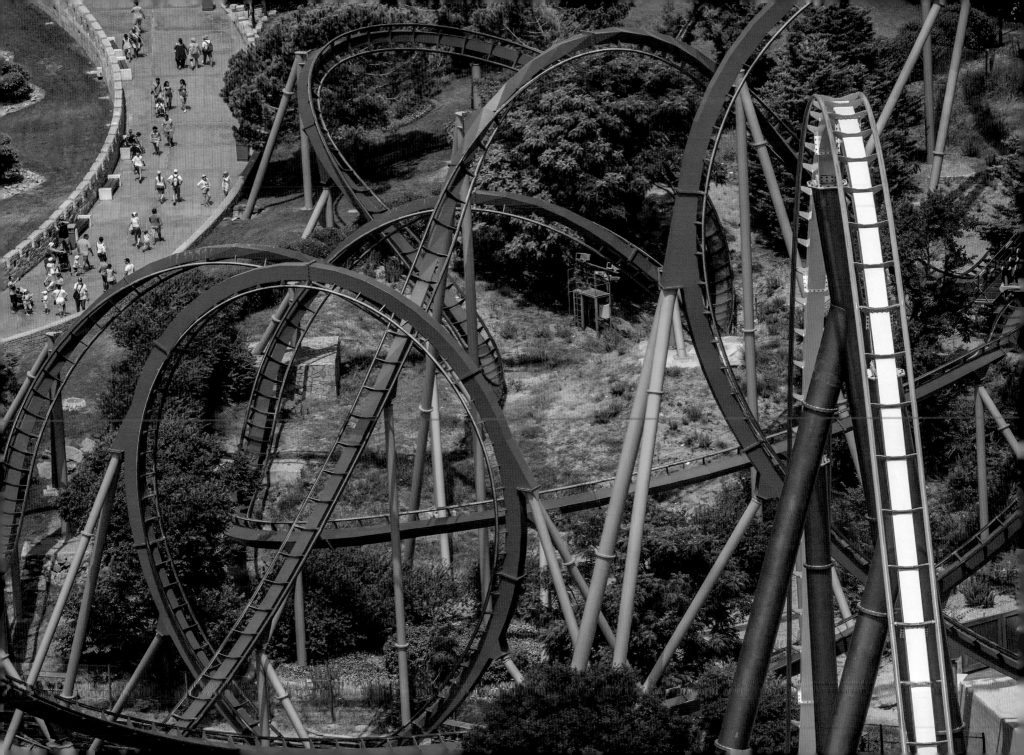

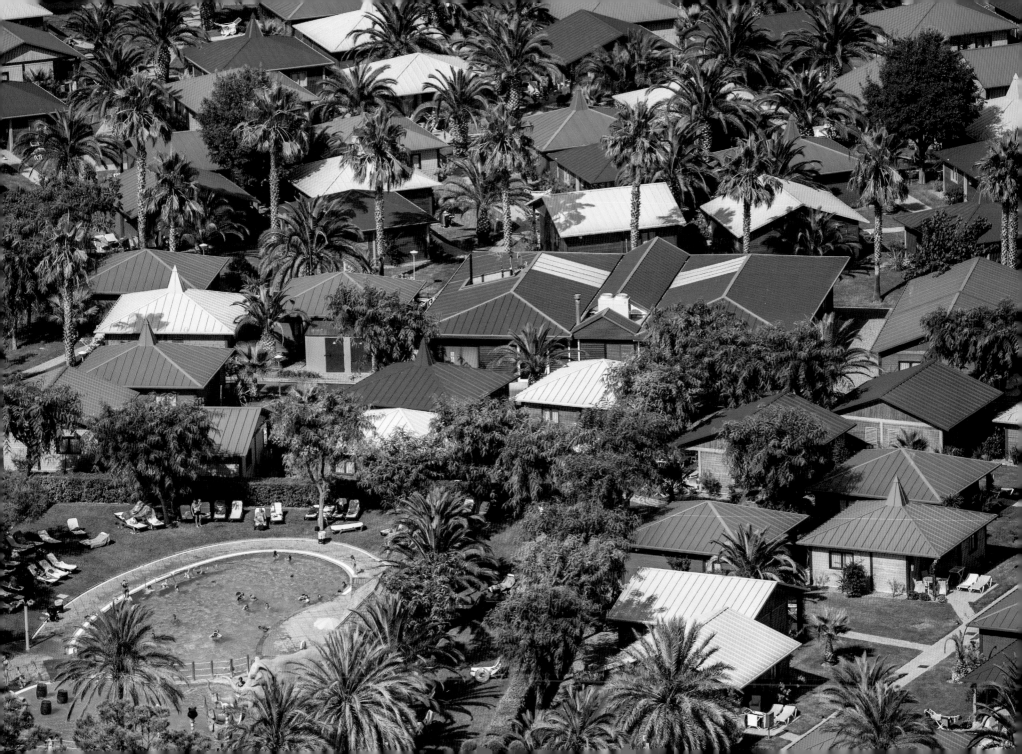

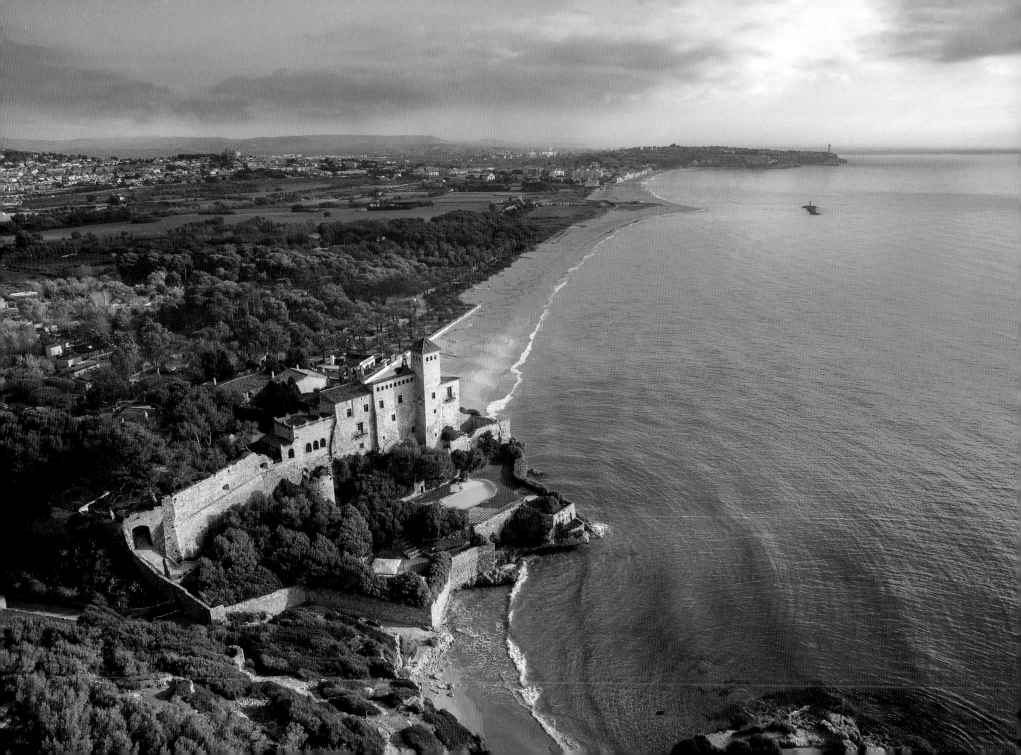

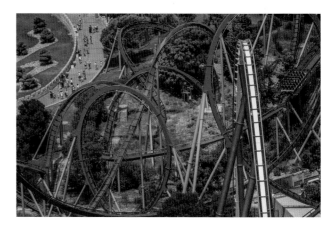

THE ORANGE HARVEST IN THE BAIX EBRE
40° 44' 25" N, 00° 33' 38" E

The perennial glossy green of orange-tree leaves contrasts vividly with the bright colour of the fruit when the time has come for the harvest which, incidentally, takes place in the depths of winter, a rare season for harvesting. Orange trees burst into bloom in the spring-the penetrating aroma of orange blossom is truly intoxicating at this time of year-, the fruit begins to ripen in the summer and the trees become laden with glowing spheres with the arrival of the winter cold. This explains Goethe's enthusiasm for the Mediterranean: trees covered with leaves and fruit in the season of Arctic snows... Today, however, we are less aware of this than before, because markets worldwide have oranges all year round, either kept in cold storage or imported from the opposite hemisphere, where the seasons are reversed.

ORANGE TREES IN THE BAIX EBRE
40° 44' 25" N, 00° 33' 38" E

Everyone associates orange trees either with the Mediterranean or with California, the North-American state with a Mediterranean climate. The fact, however, is that the orange tree (*Citrus sinensis*) is native to South and South-East Asia, although it has adapted very well to the southern Mediterranean, where it was introduced in the mid-fifteenth century. 'Do you know where the country of orange trees in flower lies?', asked Goethe, referring to the Mediterranean, in his *Ballad of Mignon* (*Wilhelm Meisters Lehrjahre*, 1796). Indeed, the orange is the tree that best symbolises Northerners' fascination with the luminous Mediterranean landscapes. The orange groves of the Catalan Baix Ebre mark the northern limit of this form of agriculture, since the tree cannot tolerate the winter frost that occurs above 41° N.

PORT AVENTURA
41° 05' 15" N, 01° 09' 25" E

1995 saw the opening, near Salou, of Catalonia's biggest funfair: Port Aventura. Over the years, this fair has gradually grown and undergone transformations to be converted into three different facilities: a theme park (Port Aventura Park), a water park (Costa Caribe Aquatic Park) and a golf course (Mediterranea Beach & Golf). The complex is Europe's sixth largest theme park with three and a half million visitors per year. The park's major attraction is the Dragon Khan, a gigantic roller-coaster 1,270 metres long, an itinerary that is completed in a thrilling two-minute ride. A total of eight complete roll-overs immerse users in an astonishing cascade of twists and turns. The colourful structure of the Dragon Khan, in bright blue and red, in combination with the white track of the Shambhala, another even more thrilling roller-coaster, dominates the Port Aventura skyline, constituting the park's most prominent identifying element.

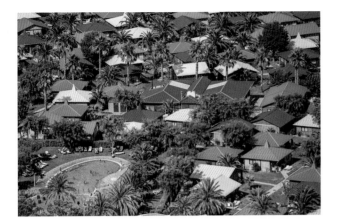

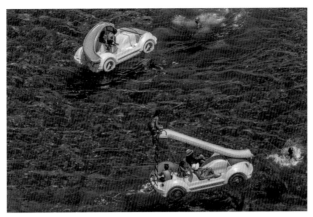

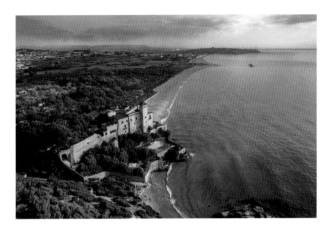

CAMPSITE IN CAMBRILS
41º 04' 42" N, 1º 06' 31" E

As in all popular tourist destinations, campsites are many on the Costa Daurada. Over the years, the offer has become diversified to the point where some sites have done away with tents and replaced them with bungalows. The long holiday season on this coast characterised by relatively mild winters has favoured this trend. The creativity of the owners of these facilities is expressed in a number of different ways. The cheerfully carefree nature of this kind of facility is often reflected in the use of bright colours, as on the roofs of these small apartments on a Cambrils campsite.

BATHERS ON THE COSTA DAURADA
BETWEEN 40º 31' 25" N, 00º 30' 50" E, I 41º 11' 20" N, 01º 36' 23" E

The Catalan south coast, between the towns of Alcanar and Cunit or Segur de Calafell, is known as the Costa Daurada (Golden Coast) and is more or less symmetrical with the Costa Brava in the north. Generally speaking it is a low-lying area, with few cliffs and dominated by long beaches. As from the beginning of the XXth century, the number of visitors to this coastal area has gradually increased to the point where today it is a mass tourist destination. Second-home estates have proliferated alongside the number of hotels. Thanks to the sandy bottoms and the shallow waters immediately offshore, this coast is highly suitable for families, who may enjoy its facilities practically throughout the year.

TAMARIT CASTLE
41º 07' 48" N, 01º 21' 39" E

In the mid-XIth century, Bernat Senifred de Gurb built a small castle beside the sea on one of the few rocky promontories on the Catalan south coast, near the city of Tarragona. The site soon became a fortified town with a harbour that gradually acquired importance during the Middle Ages: for example, part of the fleet of Jaume I, who in 1229 conquered the island of Mallorca, sailed from Tamarit, as the town was called. This small fortified nucleus was abandoned late in the XIXth century and, at the beginning of the following one, was purchased by the American industrialist and philanthropist Charles Deering. Responsibility for refurbishing what remained of the former fortified town, namely the walls, the church and the lord of the castle's palace, was entrusted to the painter Ramon Casas. It is now private property, the main dependencies of which are given over to the hotel industry.

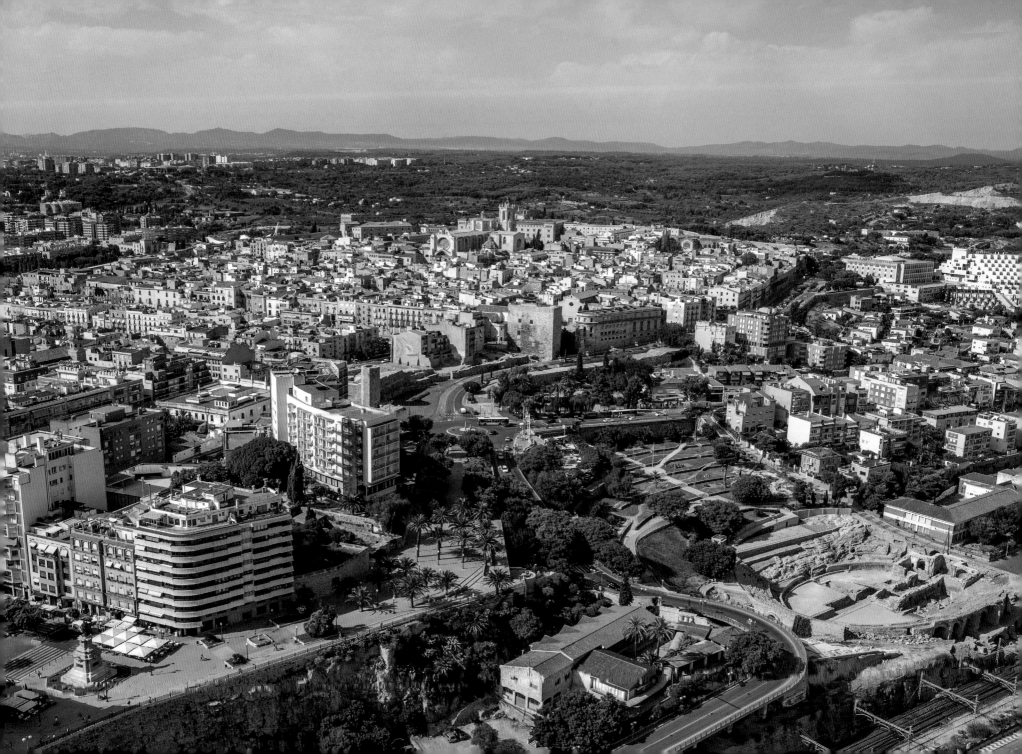

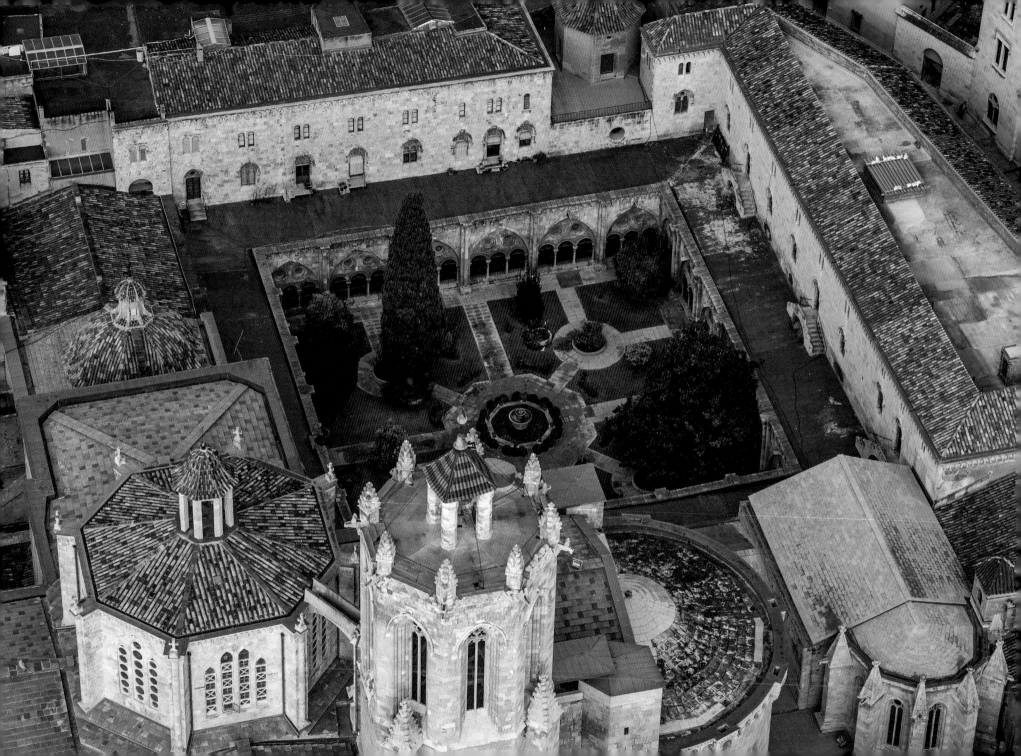

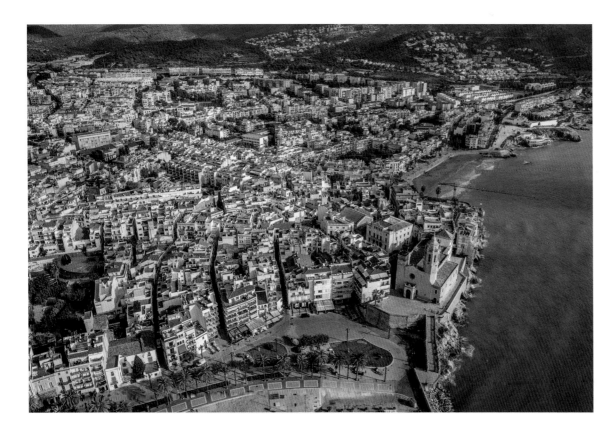

SITGES
41º 14' 04" N, 01º 48' 41" E

According to the Roman chronicles, Subur was an Iberian settlement of Cossetans or Ilergets located between Tarragona and the Llobregat. Some Romantic historians identified the settlement with Sitges, which since then has become known as Blanca Subur (White Subur). Sitges may not be Subur, but it certainly is white. At the end of the XIXth century, Santiago Rusiñol converted a former fisherman's cottage into his own private studio, Cau Ferrat. Following in his footsteps, the philanthropist Charles Deering, who had refurbished Tamarit Castle, commissioned Miquel Utrillo to transform the town's former hospital into a private residence, the present-day Palau Maricel. Thanks to the cultural life generated around these two buildings, Sitges became a town much esteemed by artists and writers. Today it is a first-class tourist centre with Cau Ferrat and the Palau de Maricel converted into museums. The unmistakable outline of the parish church of Sant Bartomeu and Santa Tecla stands out against the backdrop of the sea.

CANET DE MAR
41º 35' 20" N, 02º 35' 00" E

The parish church of Sant Pere constitutes the nucleus of the entire urban network of Canet de Mar, a dense fabric as befitting Mediterranean coastal towns, concerned more with shelter than with spacious areas of greenery. Indeed, due to the excessive sunlight Mediterranean towns have invariably tended to close in on themselves and to seek open spaces, when needed, beyond the urban boundaries. Beside the sea, this inward-looking trend is further accentuated. Particularly charming aspects of these Maresme towns are the *badius*, small inner patios or gardens normally located at the rear of houses, a kind of Mediterranean back yard (see the photograph on page 47). All in all, Canet de Mar is a vibrant town with an excellent beach and a substantial modernista architectural heritage, which combine to give rise to an attractive tourist destination.

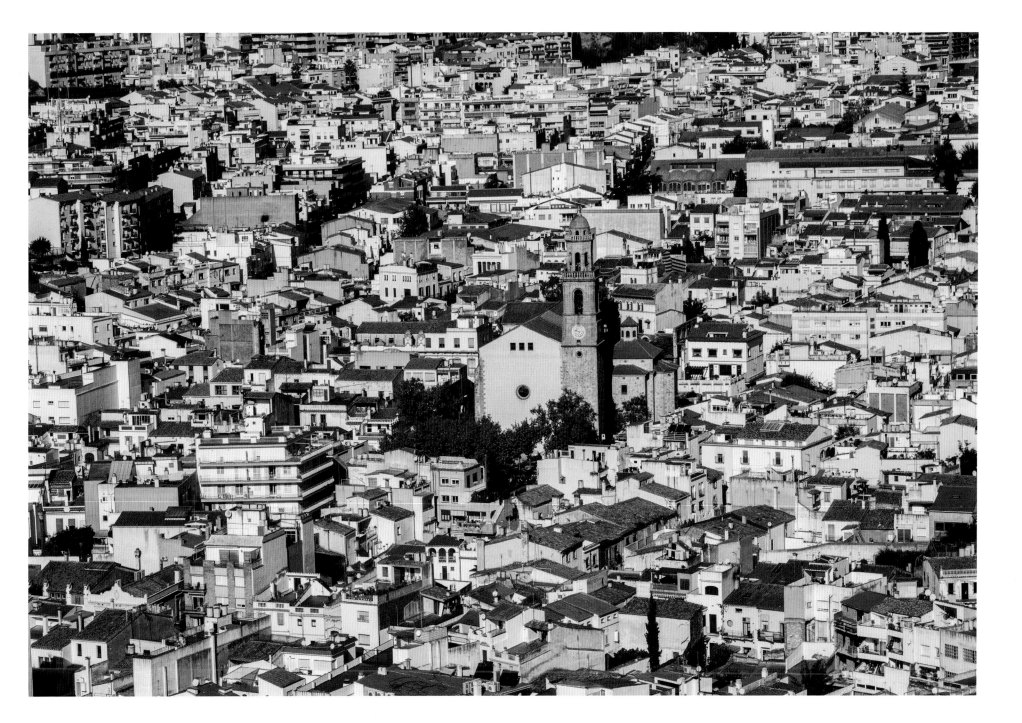

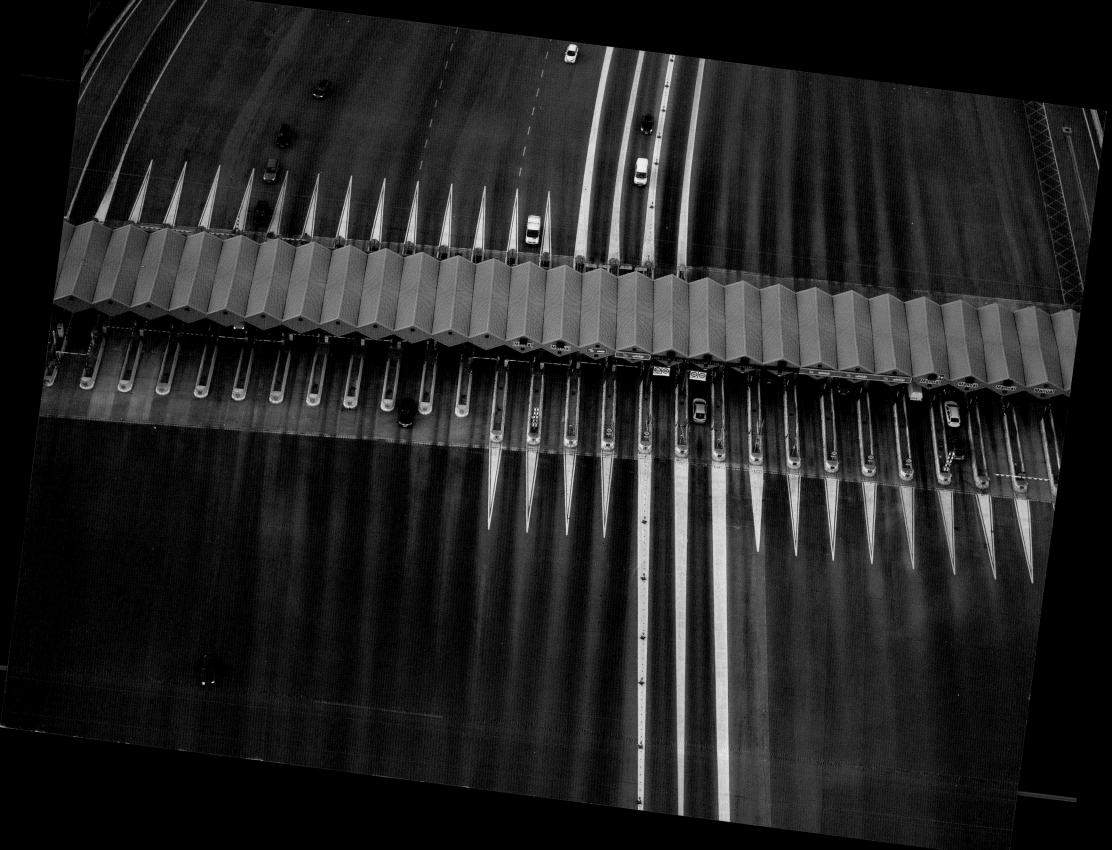

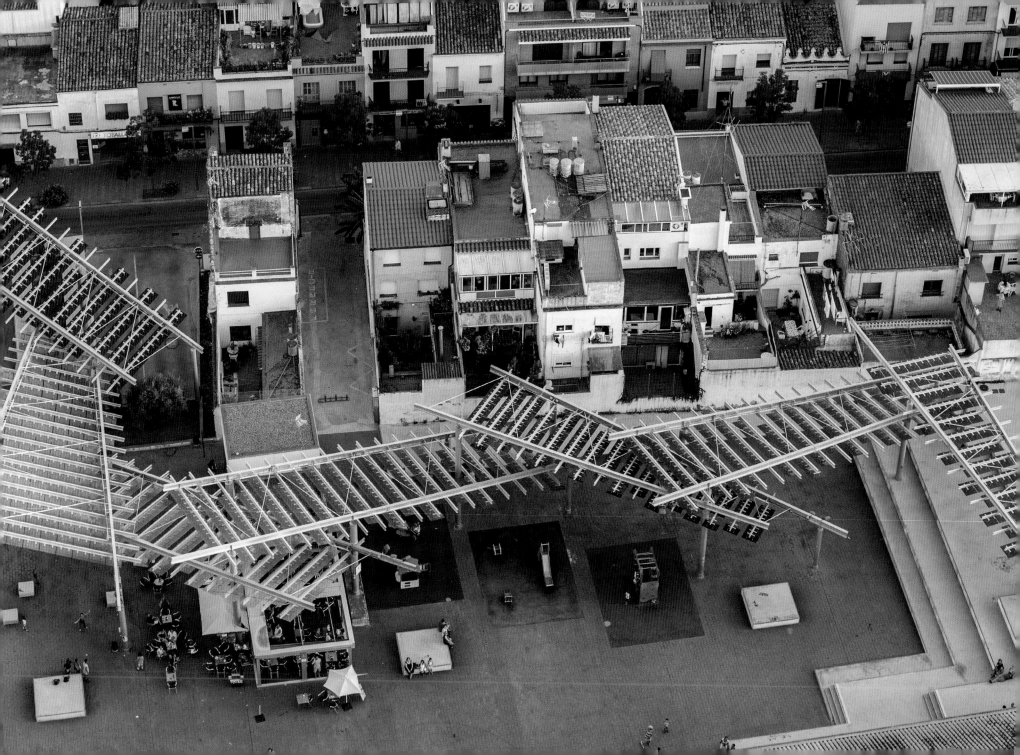

TARRAGONA
41º 07' 08" N, 01º 15' 30" E

Civitas ubi vern aeternam est: the city of eternal spring. This is how the Roman Emperor Hadrian described Tarragona. The city was founded by the brothers Gnaeus and Publius Cornelius Scipio as a military encampment in 218 BC, during the Second Punic War. They chose a strategically favourable vantage point on the coast, probably exploiting the remains of a former settlement of local Iberians (Cossetans) who would have built the original massive dry-stone block walls that the Romans subsequently developed. It soon became a big city, called Tàrraco, the capital of Hispania Citerior. The remains of that Roman city are widely visible still today, such as the amphitheatre, originally outside the walls (at the bottom of the photograph), the forum, the circus and, needless to say, the famous walls. The city's uptown area, where the forum and the great temple stood, became medieval Tarragona presided over by the cathedral, which was built on the ruins of the temple. Tarragona is today a modern city, proud of its illustrious past and recently declared a UNESCO World Heritage Site.

THE TARRAGONA CATHEDRAL CLOISTER
41º 07' 09" N, 01º 15' 29" E

Late in the XIIth century, construction began in Tarragona of a Romanesque cathedral on the remains of a former Roman temple. As in the case of so many other churches of the period, however, its design soon adopted the Gothic principles that came to prevail at the time. The work was considered complete at the end of the XIVth century and has come to be regarded as one of the finest Gothic cathedrals in Catalonia. Adjoining the church, an exquisite cloister (practically a perfect square since it measures 46 x 47 metres) combines the cathedral's two architectural styles: the semicircular Romanesque arches are embraced in groups of three by larger blind ogee arches. The central landscaped patio is encompassed by four six-section galleries beneath cross vaults comparable to those of Poblet Abbey (see the photographs on pages 162-163). The capitals on which the cloister arches rest are particularly outstanding. The entire Tarragona cathedral complex was recently restored.

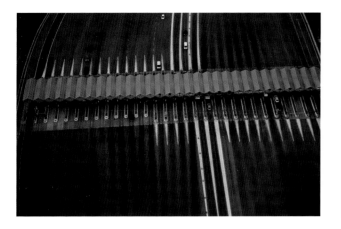

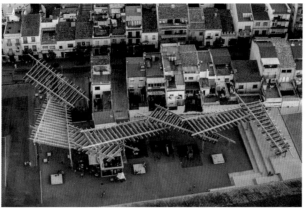

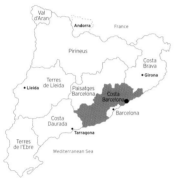

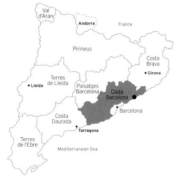

TOLLGATE ON THE C-32, ARENYS DE MAR
41º 35' 15" N, 02º 32' 19" E

The first steam train on the entire Iberian Peninsula went into service between Barcelona and Mataró in 1848. This itinerary was destined to become a historical one on two occasions, for in 1970 it was served by the first Iberian motorway. This was also the highway on which the first signs appeared limiting top speed to 100 km/h (a speed regarded as exceptional at the time) as well as the first toll gate. Payment at the gates was made either conventionally or else by throwing coins into a small collector until the sum of 25 pesetas was reached. It was an innovative system, which was soon replaced by the credit card and later by electronic control (Teletac). In either case, due to the great number of users (around one hundred thousand vehicles per day) the number of payment booths had to be increased. The Arenys de Mar tollgate, the earliest of all, is now a huge comb through which a vast number of vehicles is filtered every day

PERGOLAS IN CANET DE MAR
41º 35' 23" N, 02º 34' 49" E

The pergola was invented by the Romans; indeed, the term comes from the Latin *pergula*, which means an open shaded walkway. Vernacular Mediterranean architecture has featured the pergola since time immemorial. At first it was a light structure supporting a vine or similar climbing plant that would eventually constitute a kind of roof permeable to the breeze and to rain. During the Renaissance, far more sophisticated pergolas began to appear, whose structure was by now a substantial architectural element. And now there are entirely inorganic pergolas that provide shade as from the very outset. These are widely used in public spaces that require immediate shade combined with low maintenance costs. They have become widespread in Mediterranean tourist areas as examples of their creators' imagination and creativity.

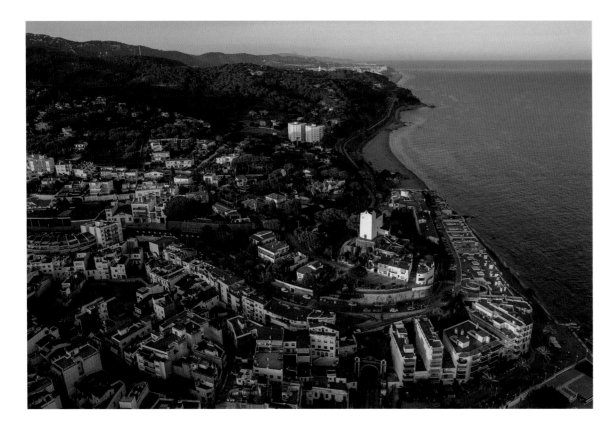

SANT POL DE MAR
41º 36' 06" N, 02º 37' 34" E

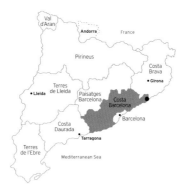

Sant Pol de Mar is fruit of a territorial logic different from those of Canet or Calella. Its streets follow contour lines because the town's original nucleus, around the Monastery of Sant Pol, stood on top of a rocky outcrop that jutted out into the sea. All that now remains of the monastery is the church, known as the hermitage of Sant Pau, a solid whitewashed building that prevails over the landscape. From the time of the foundation of the monastery, in the Xth century, to the coming of the railway at the end of the XIXth century, Sant Pol was a modest fishing village. Thanks to the train, however, the Barcelona bourgeoisie fell in love with Sant Pol and converted it into a fashionable summer resort for the upper classes. A great number of second homes and *modernista* villas were built, some of which are still standing. And despite the mass tourism phenomenon that prevails along the entire Catalan coast, Sant Pol still preserves the charm of its recent select past

CALELLA DE LA COSTA
41º 36' 49" N, 02º 39' 32" E

Although the town's true name is Calella de la Costa, it came to be known by many as Calella dels Alemanys (Calella of the Germans), due to the great influx of Central European tourists, mostly Germans, as from the 1960s. Now, in the XXIth century, tourism has become diversified in terms of provenance, though the number of visitors has not diminished. Indeed, Calella welcomes around 250,000 tourists each year, which is a lot for a town with a permanent population of only 18,000. Its main attraction is the beach, needless to say: eighteen hectares of clean golden sand that stretch along three kilometres, blessed by a mild climate with summers that begin early and endure into October. This is characteristic of the entire Maresme coast, in fact. Calella, however, is not a resort generated exclusively by tourism, since it has existed since the XIIth century and in the XIXth became a major industrial and commercial town that exported its products to Latin America. Times change; and so do towns.

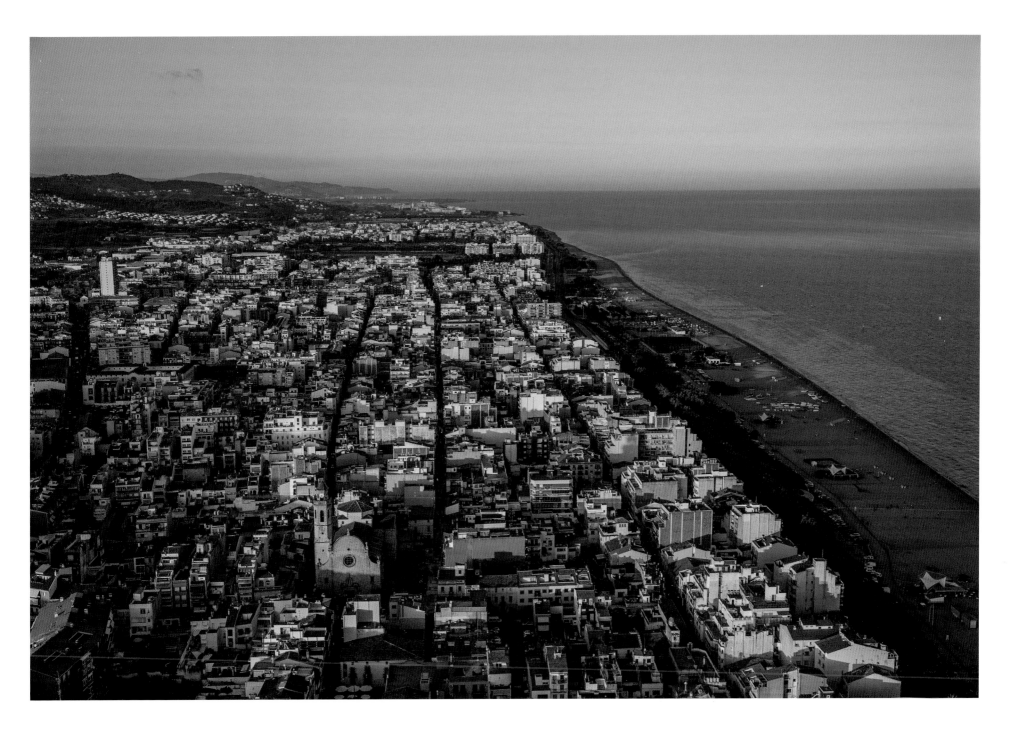

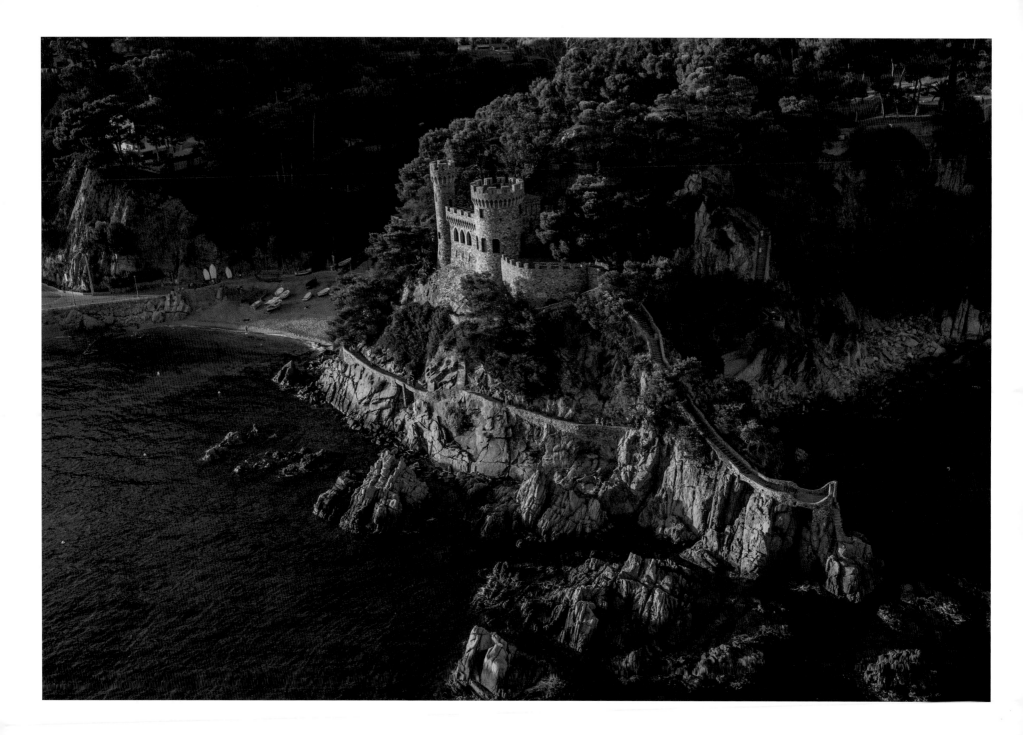

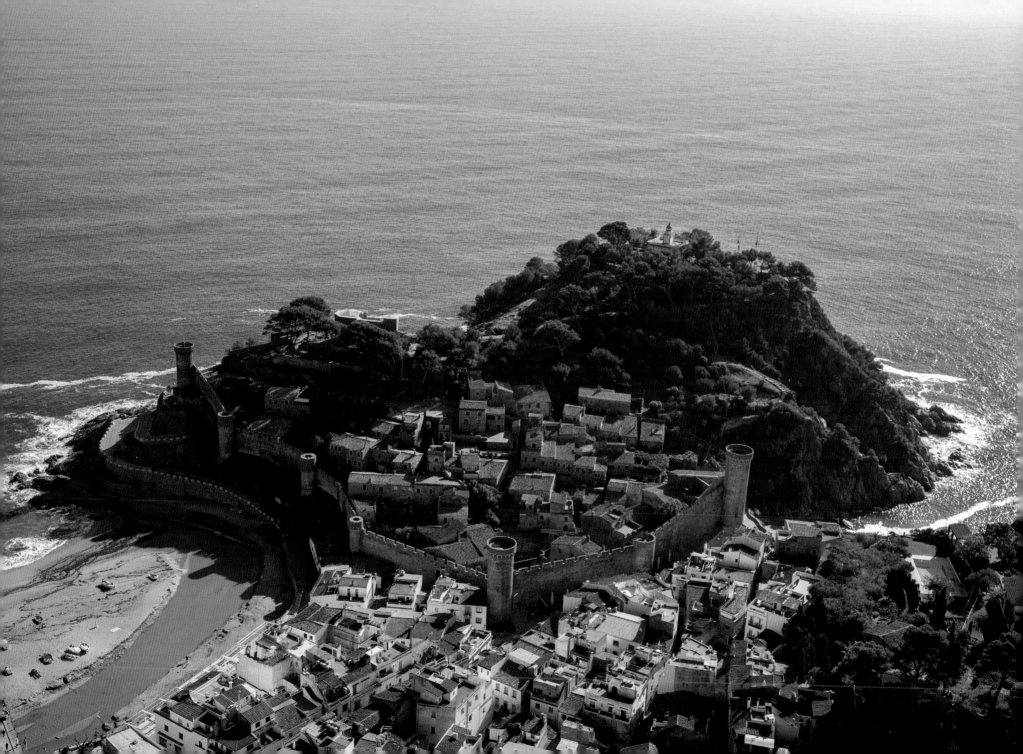

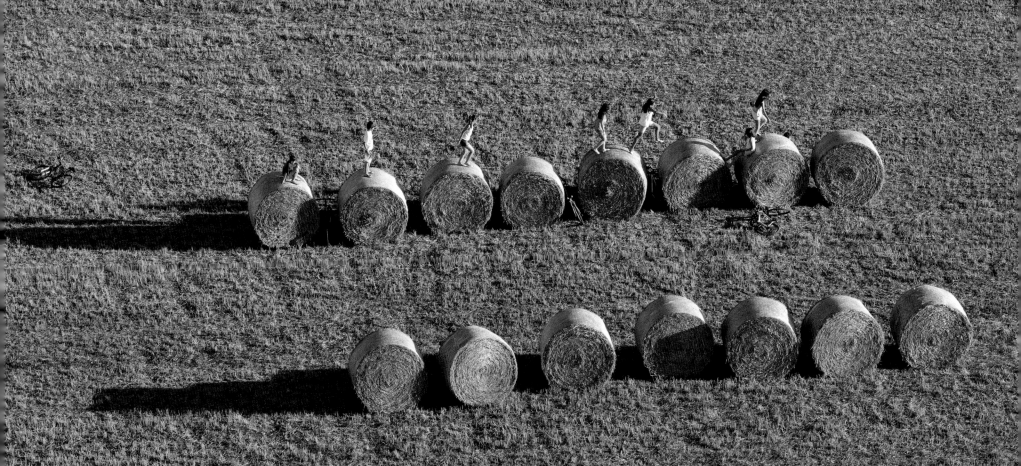

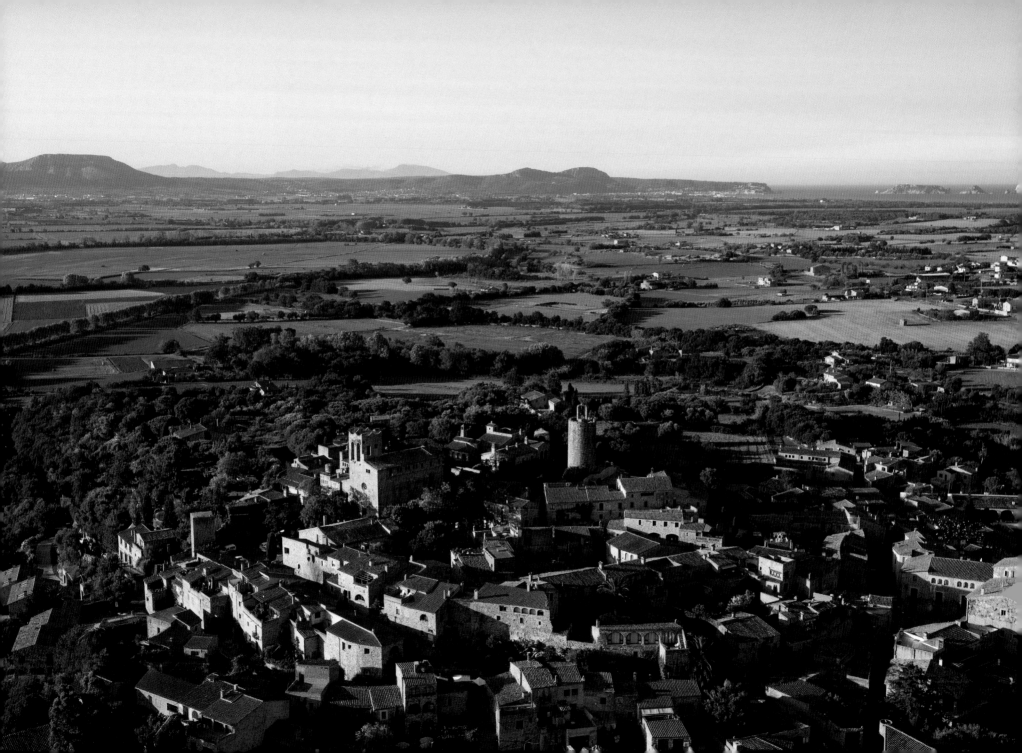

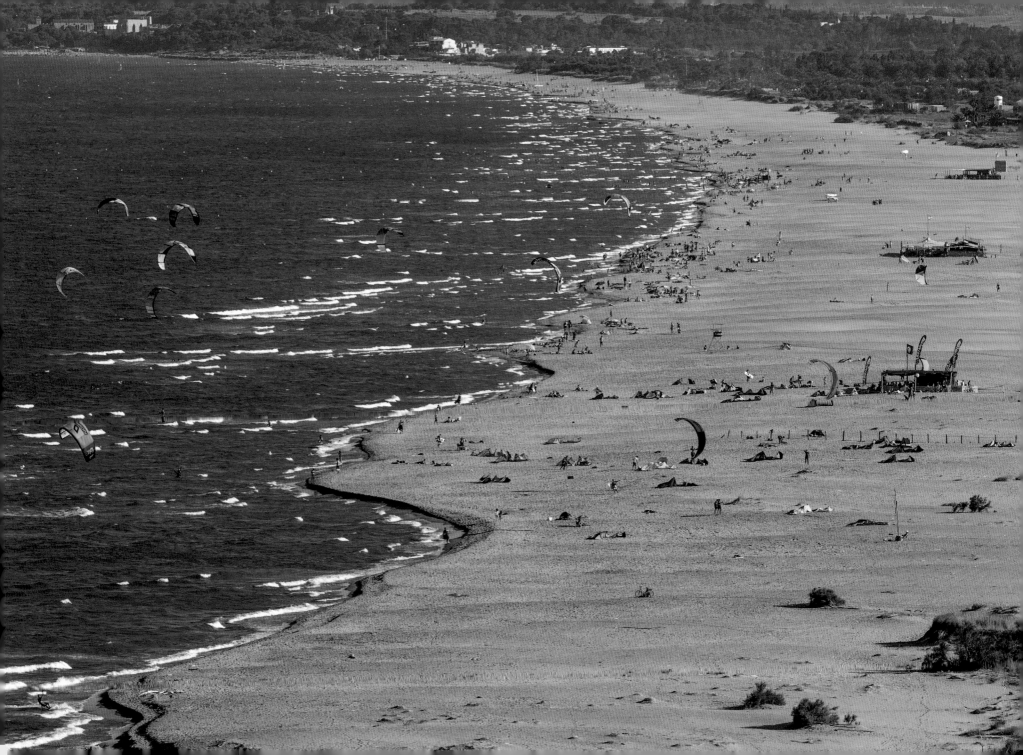

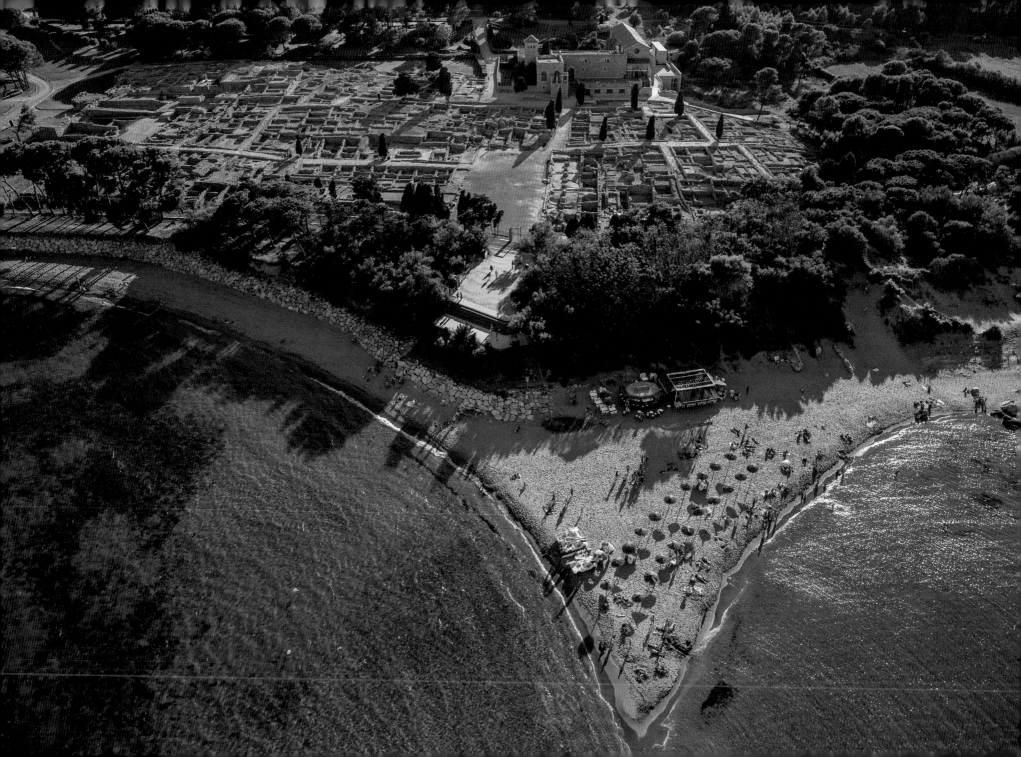

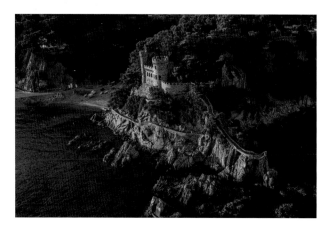

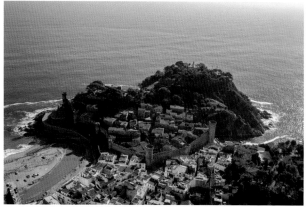

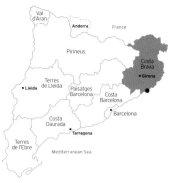

CASTELL D'EN PLAJA, LLORET DE MAR
41º 41' 57" N, 02º 51' 34" E

Narcís Plaja i Martí was a biscuit manufacturer, and Galetes Plaja became a very popular brand name in the Girona region during the first third of last century. Having amassed a considerable fortune, the factory owner decided to have a house built beside the sea. And not just an ordinary house, but a castle. Or, to be more precise, a house that resembled a castle. Construction work began in 1935 on the exceptional site of a rocky promontory that stands at one end of Sa Caleta beach in Lloret de Mar. Its construction was interrupted during the Civil War and then resumed in 1940, when it was at last completed. Among the inhabitants of Lloret this fake castle was the object of considerable controversy; even so, it became one of the town's icons, above all when tourist development on the Costa Brava converted Lloret de Mar into one of the main destinations. Today, the Castell d'en Plaja features in the photo albums of thousands of people from all over the world.

TOSSA DE MAR
41º 43' 01" N, 02º 55' 56" E

Tossa de Mar, on the other hand, has genuine —and very sizeable— medieval fortifications. It is known that the area was settled by the Romans and, even earlier, by the Iberians, over three thousand years ago, although today's Tossa dates back to the IXth, as we learn from a diploma issued by Charlemagne. In 1186, Ramon de Berga, Abbot of Ripoll, who had jurisdiction over the place, ordered the town to be fortified and a castle to be built. The complex was built between the XIIth and XIVth centuries, encompassing what is referred to as the Vila Vella (Old Town), while the Vila Nova (New Town) spread out beyond the walls, where it still stands. The castle, on the Cap de Tossa, was demolished early in the XIXth century and replaced by a lighthouse, but the three-hundred metres of walls, with their seven circular towers, were preserved. They now constitute the most important medieval construction on the entire Catalan coast and the most esteemed emblem of Tossa, one of the most popular resorts on the Costa Brava.

WHEATFIELD IN PALAU-SATOR
41º 59' 19" N, 03º 06' 40" E

How did the people of the Costa Brava make a living before tourism? It makes sense to ask this question. One century ago nobody could have imagined that the local economy would become based on the hotel and associated businesses geared towards the needs of visitors. The coastal inhabitants were devoted to fishing, which was essentially a subsistence activity, although most of them also had a small kitchen garden, while a number of peasant farmers cultivated the extensive fields inland. Even today, large stretches of tilled land still exist only a short distance away from the coastline itself. On the plains of the Empordà, for example, one need travel only a few kilometres inland to come across fruit-tree orchards or wheatfields, such as this one in Palau-sator, another exquisite village of medieval origin. But do not bother to look for the sheaves that the reapers of yesteryear used to pile up in the field as the harvest progressed, because now the work is done by machines. Times change.

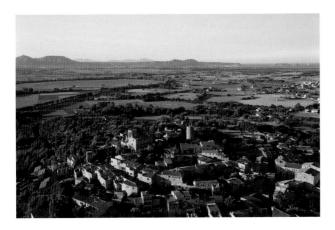

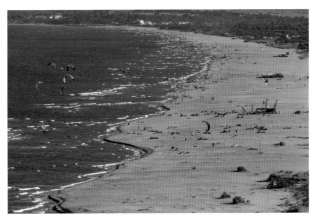

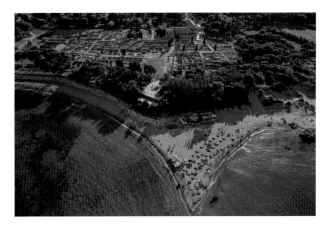

PALS
41º 58' 11", N 03º 08' 52" E

Pals is a veritable success story, since it was one of the first towns on the Costa Brava to have its splendid medieval architecture thoroughly refurbished and restored. Its name comes from the Latin palus, meaning 'marsh' (from which 'palustre' –pertaining or related to marshes– and 'paludism' –malarial disease– derive). Due to the salt marshes of Pals, fed by the River Ter, the town was an unhealthy place to live for centuries, but it was also the first Catalan town where, as from the XIVᵗʰ century, rice was cultivated on an intensive basis. Thanks to rice and fishing, Pals prospered and became endowed with a mighty castle, of which only the so-called Torre de les Hores (Tower of Hours) remains, an imposing cylindrical structure built in the XIIᵗʰ century and crowned by a small XVᵗʰ century belfry-cum-clock tower, hence its name. There are no walls, although the streets follow the circular layout characteristic of many fortified medieval towns. Naked stone continues to be the hallmark of Pals's exquisite architecture.

KITEBOARDERS IN THE GULF OF ROSES
42º 11' 01" N, 03º 06' 38" E

Between the Montgrí massif and Cap de Creus lies the wide bay of Roses, a small, gently arching gulf some twenty kilometres long. The bay of Roses, together with adjacent Pals beach, constitutes an exception to what is otherwise the craggy relief of the Costa Brava. Between the two, on either side of El Montgrí, L'Escala and L'Estartit open onto the two stretches of sand. The Alt Empordà is a windswept region and the bay of Roses its maritime gateway. Hence the fact that these beaches have invariably been a favourite spot for surfers and, more recently, for kite-boarders, rather than for conventional swimmers. Indeed, this is one of the virtues of diversity: everyone can find something to suit their tastes, however different they may be. The Costa Brava therefore expresses itself differently depending on where you are; always wildly, though.

EMPÚRIES
42º 08' 05" N, 03º 07' 14" E

In ancient Greek ἐμπόριον (emporion) meant 'trade'. In Latin, the corresponding term was emporium. The word has lived on in modern Romance languages, so that 'emporium' (empori in Catalan) denotes a place of great wealth and abundance. It is therefore by no means hard to imagine why in 580 BC the Phocaean Greeks from Massalia (Marseille) founded a settlement on the hillock called Sant Martí, hard by L'Escala. It was a trading centre with the local indigenous population called Ἐμπόριον (Emporion). For us, of course, it is Empúries. Extensive vestiges remain, partially Greek, partially Roman, of what the town was between the VIᵗʰ century BC and the IIIʳᵈ century AD. The original settlement or Palaeopolis (Old Town) is now beneath the modern town of Sant Martí d'Empúries. Later, to the south, they built the Neopolis (New Town, whose ruins appear in the photograph) while to the east, even later, the Romans founded their Empuriae. A magnificent complex of great archaeological value.

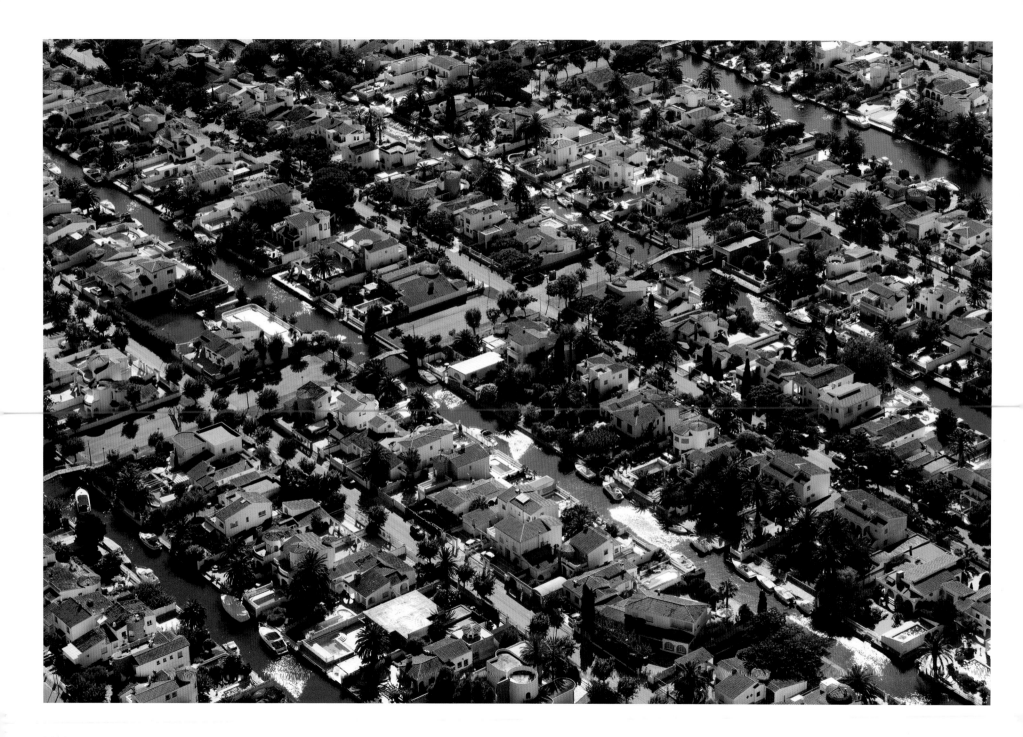

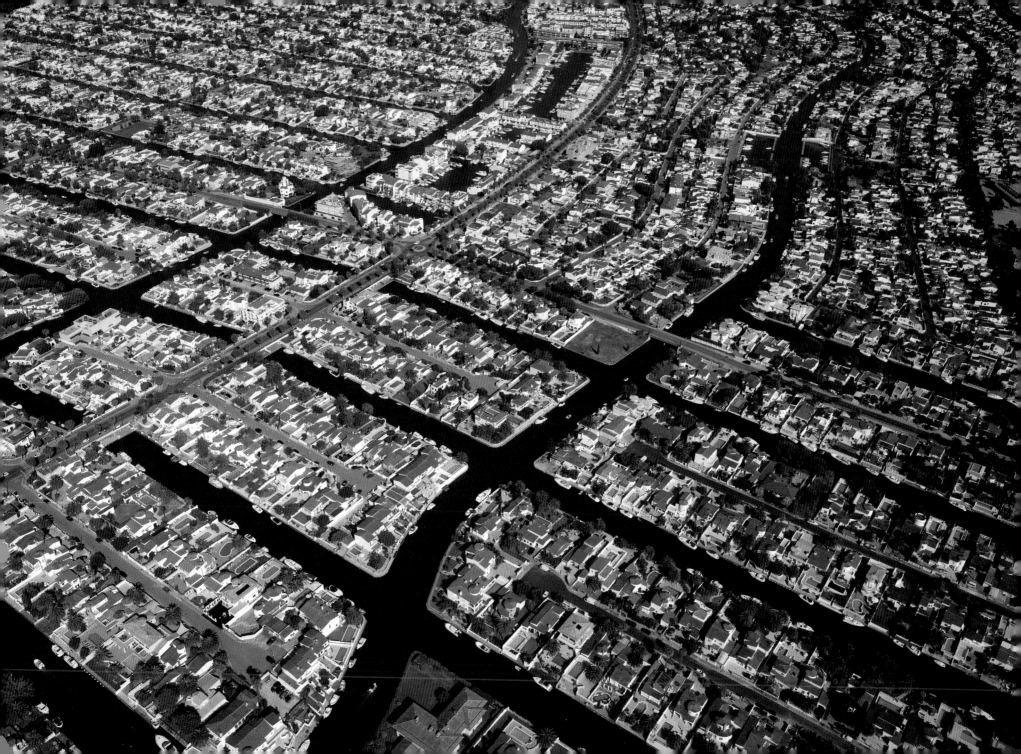

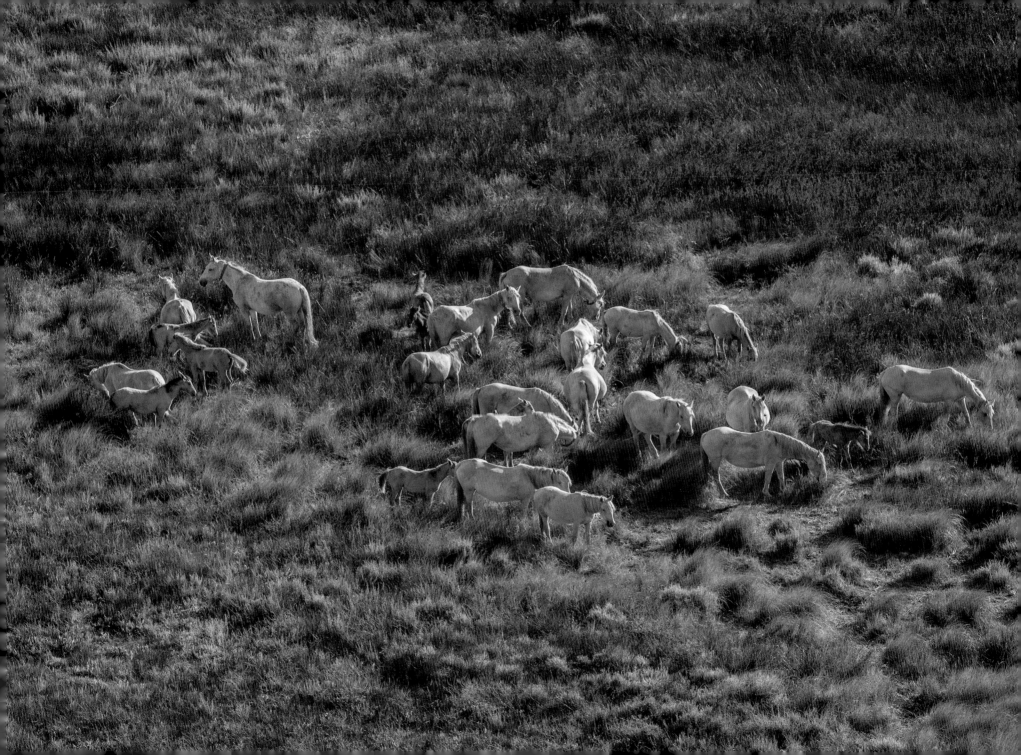

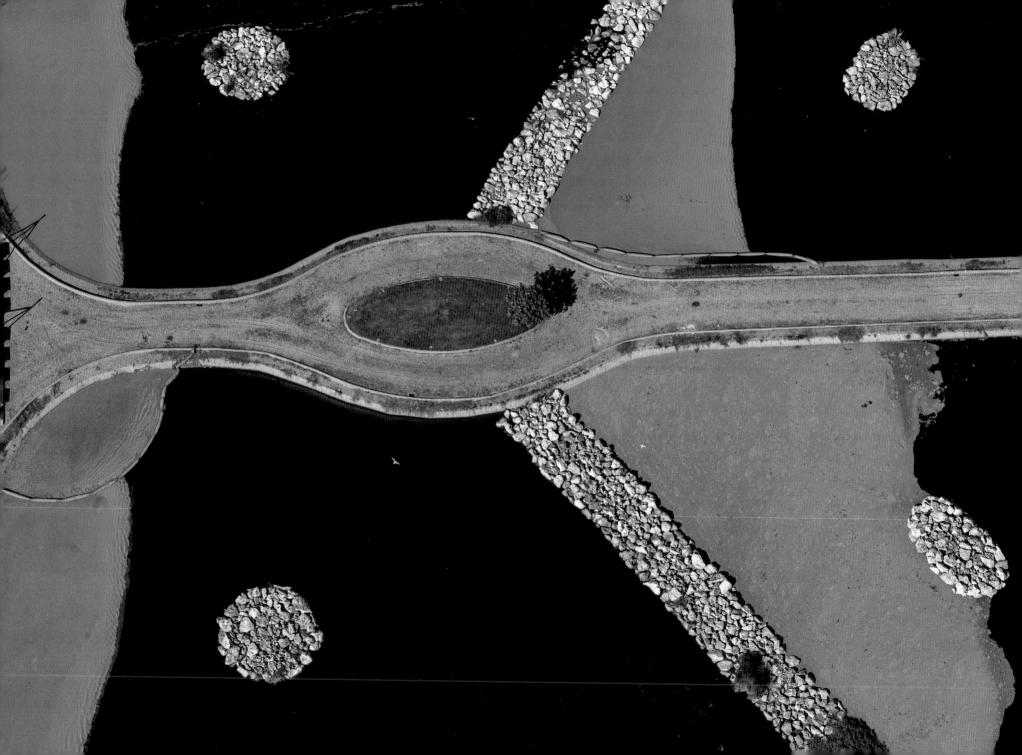

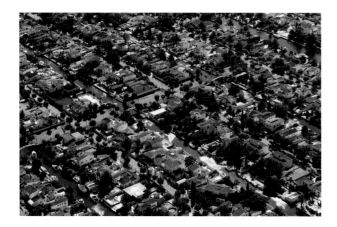

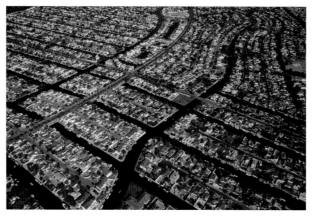

EMPURIABRAVA
42º 15' 01" N, 03º 07' 09" E

In the 1960s a number of developers coined the term *Empuriabrava*, a hybrid between Empúries and Costa Brava, as the name with which to christen an artificial town in the municipality of Castelló d'Empúries. Built in emulation of the residential marinas that had sprung up at that time in Florida and on the coast of Provence, its concept was that of a coastal housing estate with navigable canals that led to one's doorstep, a concept that had already been tried out on a much smaller scale in nearby Santa Margarida (in the municipality of Roses). The idea was that each house would be accessible by land and by sea and equipped with its own swimming pool, and that potential buyers would belong to the middle-income bracket. This meant that the plots, the houses and the swimming pools were all small in dimension and practically identical to each other. The estate attracted a host of purchasers from the rest of Europe, to the point where it became the largest marina of its kind in the world.

THE EMPURIABRAVA CANALS
42º 15' 01" N, 03º 07' 09" E

In Empuriabrava there are fourteen thousand dwellings, divided between houses and apartments. In order to provide each one with direct access to the sea, over twenty-four kilometres of inland canals and up to five thousand mooring jetties were built. From the air, this network of regularly arranged navigable waterways is a truly impressive sight. Unlike in Venice, however, these fourteen thousand dwellings are also directly accessible from the land, so that occupiers may park their cars outside the front door and their boats at the one at the back. This has been achieved thanks to a system of canals laid out in a fish-bone pattern and linked in such a way that bridges are hardly needed, an ingenious solution which has contributed to the success of the marina.

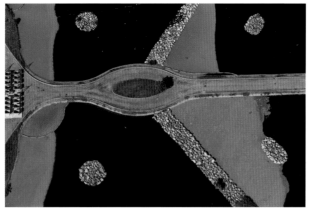

HORSES ON THE AIGUAMOLLS OF THE EMPORDÀ
42º 13' 17" N, 03º 06' 17" E

The rivers Muga and Fluvià reach at sea at the bay of Roses. Their former beds, now dry, and a number of associated pools constituted an extensive area of salt marshes (*aiguamolls*), comparable to those of Pals, though much bigger. It was an insalubrious area, though a very rich one for fishing and shooting marsh wildfowl (ducks, coots and so on). Over the years, the salt marshes gradually disappeared, initially as the outcome of draining undertaken for agricultural purposes and later due to the construction of marinas or conventional housing estates. By the 1970s all that remained were the Llaunes de la Muga and the former bed of the Fluvià, called the Riu Vell. Thanks to pressure on the part of ecologists, however, these remnants were saved and today they are grouped together as the highly popular protected area of the Parc Natural dels Aiguamolls de l'Empordà. The water birds have come back to nest en masse while the dried-up areas serve as pasture land for wild horses.

THE EMPURIABRAVA WATER PROCESSING PLANT
42º 14' 36" N, 03º 06' 17" E

The 75,000 summer inhabitants of Empuriabrava send their waste water to the municipal processing plant, which is far from a conventional facility of its kind. To the usual primary and secondary treatment systems this plant adds a tertiary sedimentation and lagooning process which is completed in the artificial Estany Europa wetlands. The waters conventionally treated at the plant are still rich in phosphorous and nitrogen, that is, in polluting elements if they are allowed to flow into rivers or in nutrients if they are used to fertilise plants. The latter is a task carried out by the artificial marshes. Reedbeds complete the purifying process while providing a habitat for wildfowl; indeed Estany Europa is one of Catalonia's last havens for the exquisite purple swamp hen (*Porphyrio porphyrio*). The waters thus regenerated serve to irrigate the Castelló-Empuriabrava pitch & putt course.

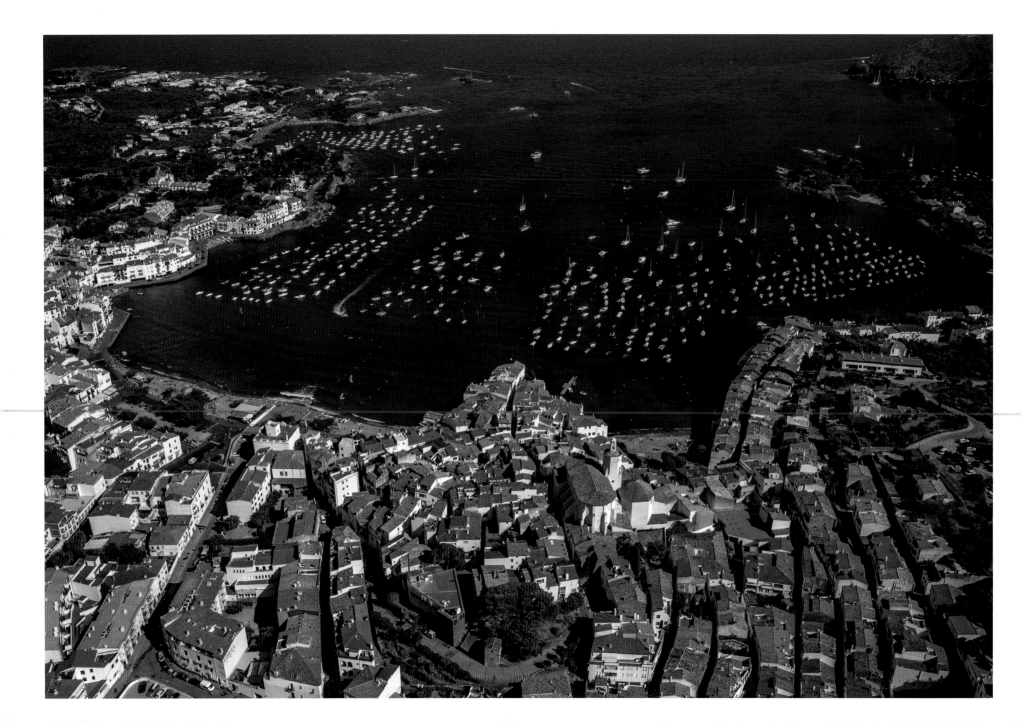

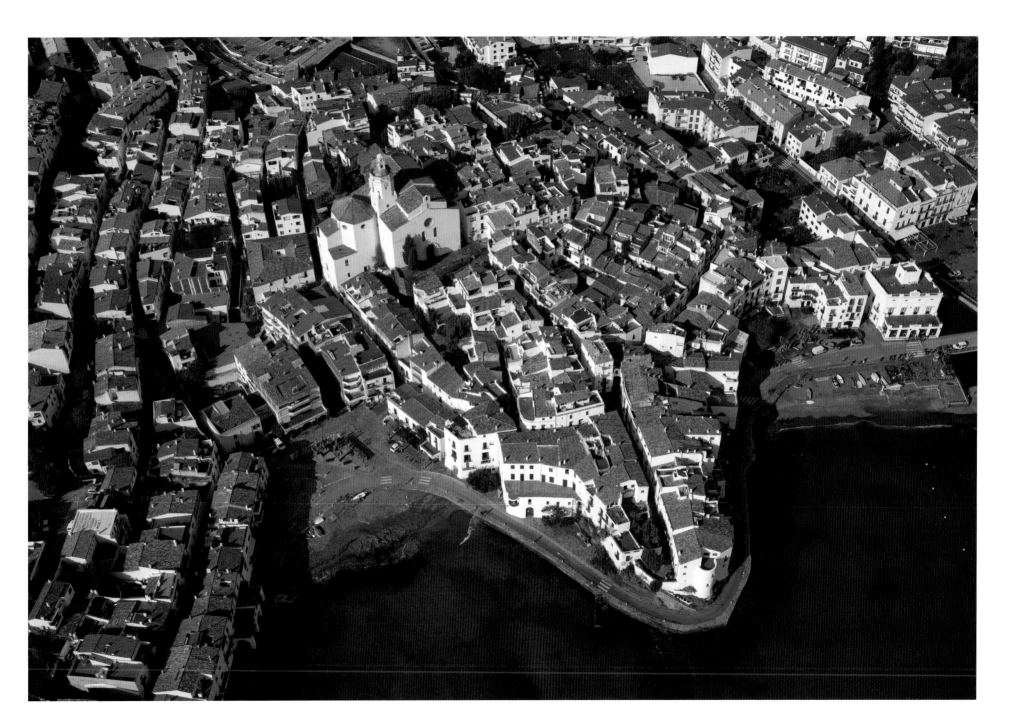

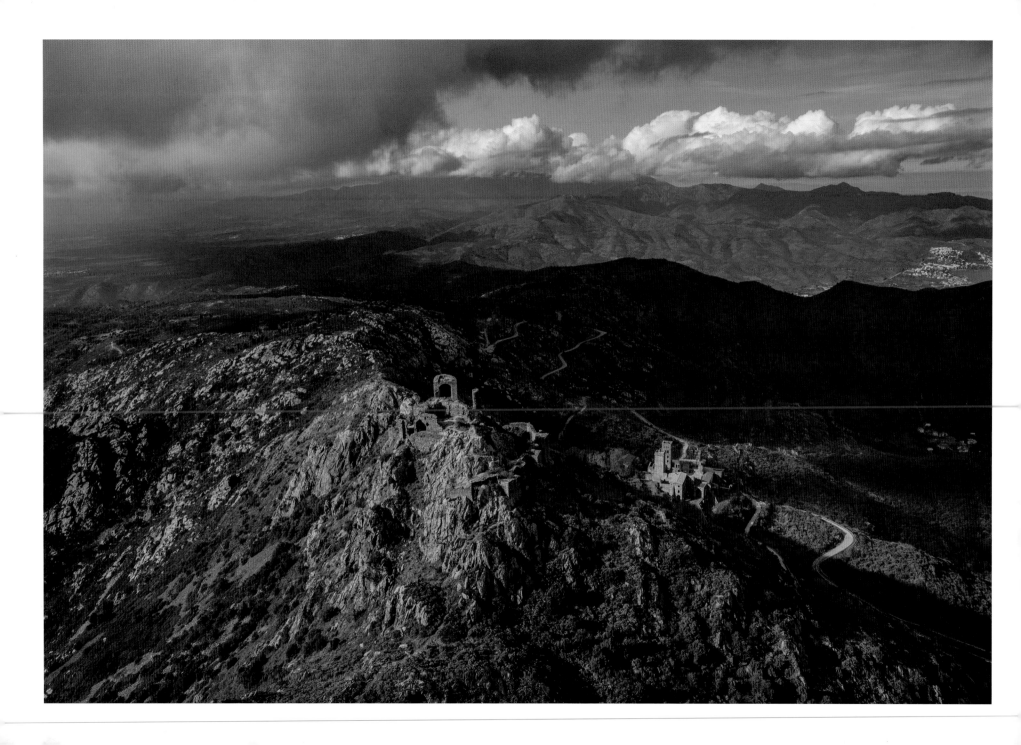

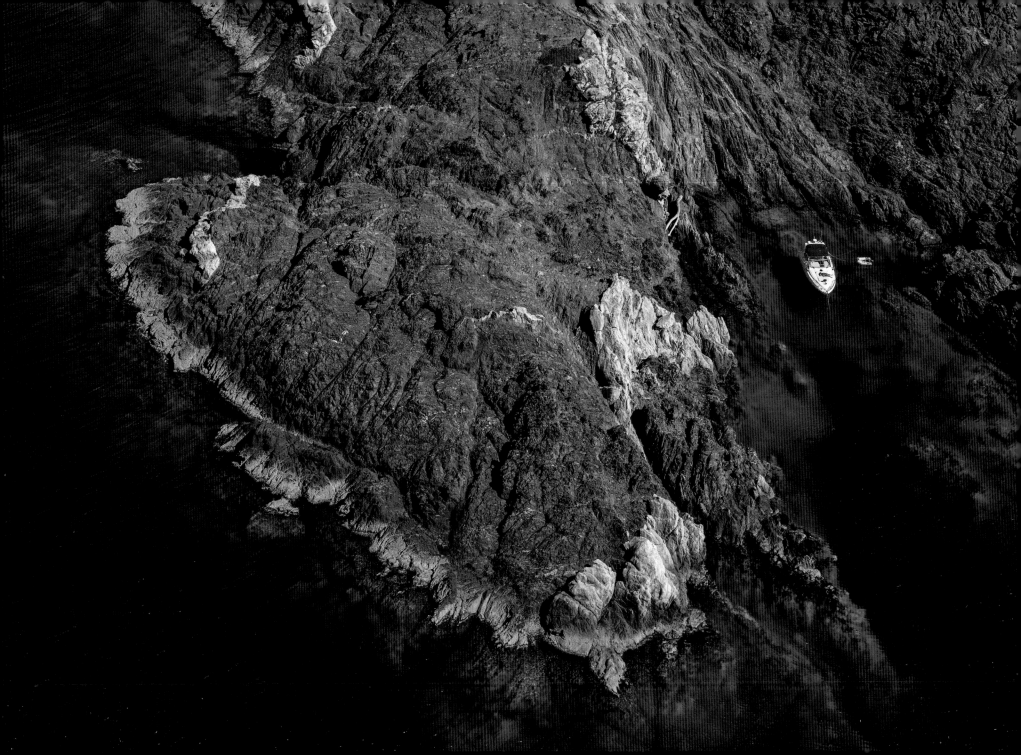

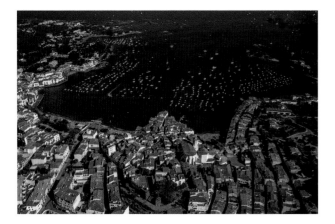

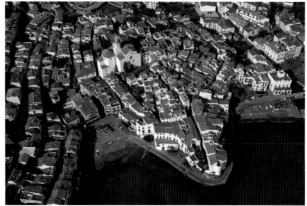

CADAQUÉS BAY
42º 17' 16" N, 03º 16' 37" E

The Costa Brava often folds back on itself. When this occurs, each section of the coast becomes a long line of interminable intussusceptions and twists and turns that together generate a kind of fractal structure of incalculable extension. Sheer cliffs, small coves, scatterings of islands and the occasional deeper, more extensive bay succeed each other. This is the case of the bay that lies between the islet of S'Arenella and the coves of S'Oliguera, to the east, features a relatively large beach and becomes closed off, to the west, by the Sa Planassa promontory. Bays such as this one were once the setting for fishing activities, navigation and piracy. Gradually, over time, people began to settle there. People who built small fishing villages. This is the origin of the town of Cadaqués, which stands beside the calm waters of its corresponding bay.

CADAQUÉS
42º 17' 16" N, 03º 16' 37" E

Cadaqués is an island on terra firma. Separated from the rest of the Alt Empordà by the El Pení massif, it once lived secluded in its narrow coastal valley, open only to the sea. Very open, indeed, because it is from the sea that the locals obtained fish and across the sea that they reached any port, even those of the Americas. There were even cadaquesencs who had been to Cuba but had never been to Figueres... All this changed last century, however. Salvador Dalí discovered Cadaqués and settled there in 1930, specifically in the cove at Portlligat. His presence attracted numerous intellectuals and artists, ranging from Federico García Lorca and Pablo Picasso to Walt Disney, Marcel Duchamp and Antoni Pitxot. In no time at all Cadaqués made the transfer from isolation to cosmopolitanism. Today it is a world-famous town with its own prestigious chamber-music orchestra and structured around the delightful original nucleus, a set of steeply-sloping narrow streets and whitewashed houses presided over by the Church of Santa Maria.

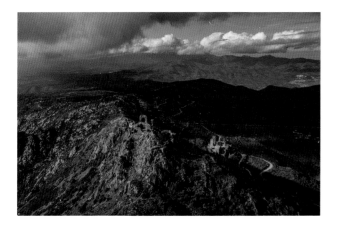

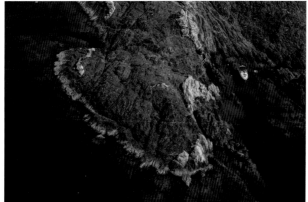

SANT PERE DE RODES
42º 19' 11" N, 03º 10' 04" E

CAP DE CREUS
42º 19' 09" N, 03º 19' 18" E

The Serra de Verdera mountain range is a ramification of the Albera massif, hard by Cap de Creus. It rises 670 m above sea level right below, so that from its highest point, crowned by the ruins of the Castle of Sant Salvador de Verdera, visitors may enjoy magnificent views. However, the genuine treasure of these mountains is the Benedictine Monastery of Sant Pere de Rodes, halfway up the slope and directly overlooking the sea. Records exist from 878 of a monastic community in the area, but it was not until 945 that the Benedictine establishment was founded. The monastery prospered until 1793, when due to wars and banditry it was abandoned by the community. The ruins are preserved of the monastery and of the magnificent Romanesque church, one of the most important in Catalonia. Declared a National Historical-Artistic Monument in 1930, the monastery has been a Cultural Asset of National Interest since 1993.

In Catalonia the day begins at Cap de Creus. This is the easternmost point on the Iberian Peninsula, which means that the sun rises here before anywhere else. It illuminates a truly dramatic landscape, a huge rocky promontory, practically bare of vegetation and constantly lashed by the wind. This area of grandiose beauty was declared a natural park in 1998. The total surface area of the park encompasses almost fourteen thousand hectares, over three thousand of which are beneath the sea; the point of Cap de Creus, which is the cape per se, covers one hundred or so hectares. Despite its scarcity, the vegetation is of great interest. The rock formations that emerge everywhere and have been whimsically remodelled by aeolic and marine erosion are among Catalonia's oldest. Palaeozoic metamorphic rocks (some five-hundred million years old) predominate, particularly black schists and whitish phyllites.

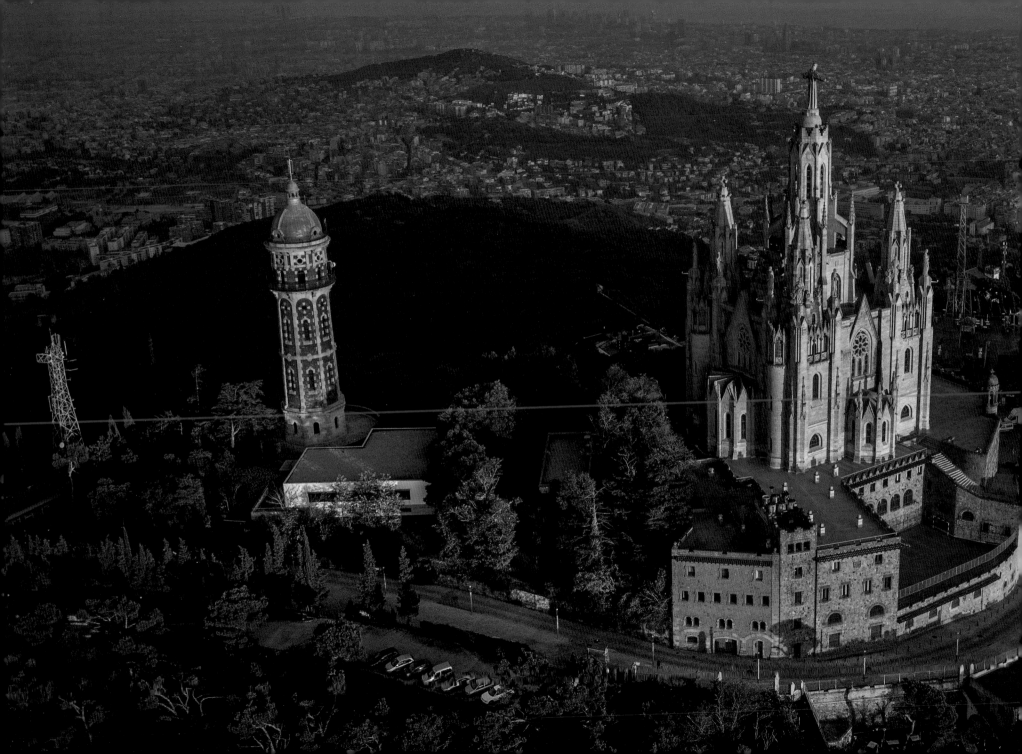

BARCELONA

GOTHIC
AND MODERNISTA

The splendour of cities lives on in the magnificence of their buildings. Both urban architecture and urban layouts constitute an open history book, and Barcelona is no exception to this rule, quite the contrary. The city has twenty centuries of history behind it, from all of which it preserves valuable elements. However, two forms of artistic expression stand out from all the rest, corresponding to two particularly brilliant periods: Gothic Barcelona and *modernista* Barcelona.

Barcelona was the capital of a medieval power: the Kingdom of Aragon. The Cathedral, Santa Maria del Mar, the Palau Reial Major, the Palau de la Generalitat, the Corn Exchange, the old Santa Creu Hospital, the Shipyards... are all religious or public buildings that reflect the splendour of that Barcelona which had so much specific weight in the Mediterranean. As one might expect, they are all concentrated in old Barcelona, to the point where, both abusively and significantly, the district became known as the Barri Gòtic. The Barri Gòtic contains the Roman, Romanesque and the renaissance city, and even neoclassical Barcelona, although the magnificent Gothic monuments constitute its distinctive traits.

The Industrial Revolution marked a further period of splendour for the city, not in political but rather in mercantile and economic terms. The bourgeoisie made a fortune, and its prosperity adopted visual form at the turn of the XIXth and XXth centuries, just when Europe as a whole saw the emergence of Art Nouveau in France, Jugendstil in Germany, Sezessionstil in Austria, Stile Liberty in Italy and Modern Style in the United Kingdom. In Catalonia, the new movement was termed *Modernisme*, to the point where perhaps it hoards the greatest number of *modernista* buildings in Europe, the work of a host of great architects such as Gaudí, Domènech i Montaner and Puig i Cadafalch.

Perhaps soon we may be able to speak of a third outstanding architectural trend, linked to the great drive of contemporary Barcelona and the city's penchant for avant-garde architecture. As in previous periods, the city lacks the objective conditions to favour extremely large-scale architectural works, preferring as it does to coherently amass remarkable buildings of smaller dimensions. It is certainly in such discreet excellence that the city's charm lies.

PARK GÜELL | 41º 24' 49" N, 02º 09' 10" E
Access stairway and first balustrades in the raised plaza at the Park Güell, with its characteristic ceramic-fragment cladding or trencadís, the work of Antoni Gaudí.

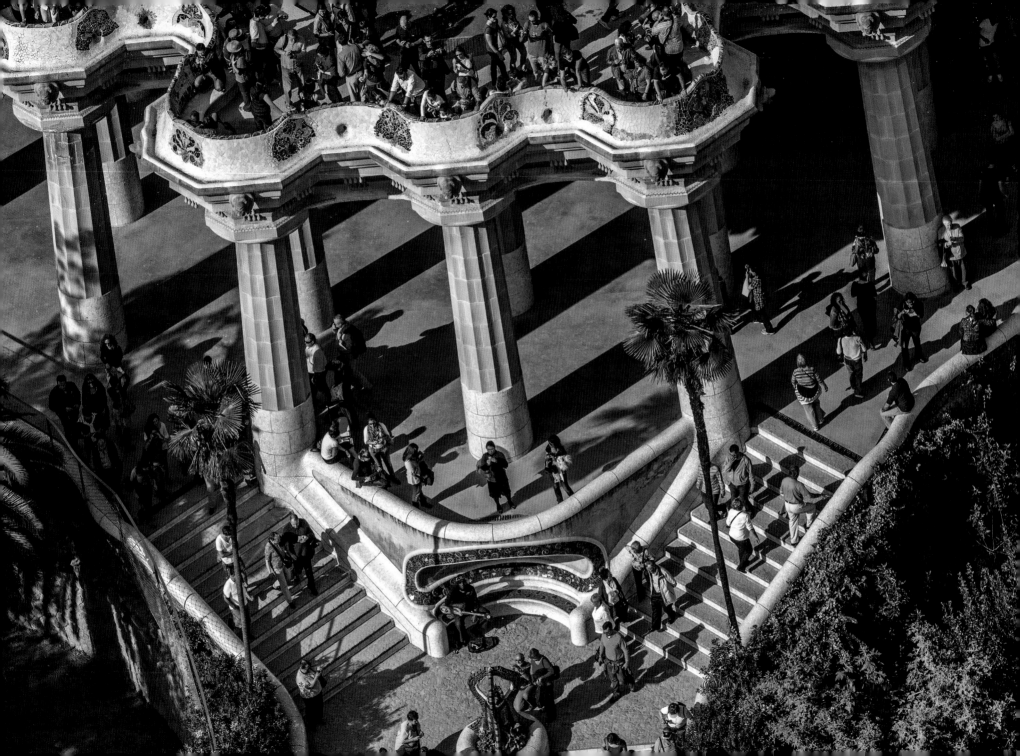

'DOWN
WITH THE WALLS!'

In the mid-XIVth century, Barcelona was endowed with its third system of walls. The functional Roman town already had one, the medieval town another and the small renaissance city still another. This third set of walls, successively modified and reinforced, lasted until the XIXth century. However in the XVth, XVIth and even the XVIIth centuries the population of Barcelona did not exceed 50,000, while by the mid-XIXth century the figure had risen to over 180,000. The city became straitjacketed by its own walls, and the people were crowded together in a tiny area.

'Down with the walls! was the rallying cry that spread like wildfire in 1841. Despite resistance on the part of the military authorities—Barcelona was a stronghold—, thanks to pressure from the people demolition work began in 1854. All of a sudden, the city was able to spread out freely over the plain, and this required a project that would guide that long yearned-for process. This project was provided by Ildefons Cerdà, one of the fathers of European city planning. His *Pla de Reforma i Eixample* (1859) endowed the city with a revolutionary urbanistic strategy in both formal and conceptual terms.

Barcelona's *Eixample* is still modern today, over one century and a half since its conception. It is based on a regular orthogonal gridiron layout consisting of octagonal units which generate equally octagonal spacious street junctions, known as *xamfrans* or chamfers. The streets in the Pla Cerdà were unusually wide for the time, consequently they have managed easily to absorb the extraordinary increase in traffic (one must bear in mind that they were conceived fifty years before the automobile was invented). The streets for carriages and pedestrians in Cerdà's design anticipated the circulation on the surface of urban trains when no city in the world as yet had a metropolitan railway (the London Underground, the earliest of all, was opened in 1863).

Cerdà's *Eixample* denotes a socially advanced concept with a mixture of uses and social classes. It is an equitable urban structure that allows for harmonious relations between people and avoids the emergence of fringe districts. Everything is centre; nothing is periphery. And thanks to its high-quality architecture, the *Eixample* is one of Europe's most interesting urban spaces. It need not surprise us, therefore, that millions of tourists visit it each year...

THE EIXAMPLE | 41º 23' 53" N. 02º 09' 59" E

The unmistakable gridiron of octagonal blocks in Cerdà's Barcelona Eixample, with the deliberate transgression of La Diagonal and the equally unmistakable presence of the Sagrada Família in the centre.

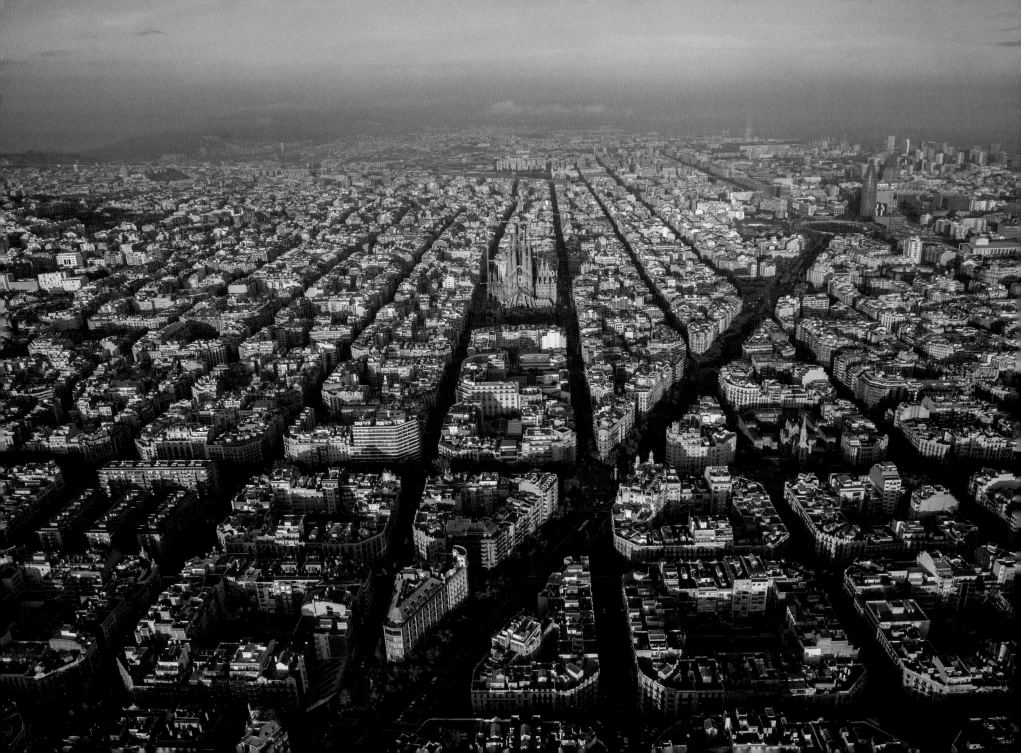

OH, BARCELONA!

Barcelona is one of the world's five most photographed cities, as we learn from the host of snapshots by tourists that circulate through the Internet. But before the 1992 Olympics, which were held in Barcelona, the city was practically unknown. It has therefore made a spectacular rise to fame in the space of a mere two decades. How come?

The city has undergone a considerable transformation process. For example, it now has over four kilometres of excellent urban beaches. Few cities in the world enjoy this privilege. The beaches were already there before 1992, of course, but they were inaccessible due to an insuperable barrier of old factories, dislocated warehouses and railway lines. XXIst-century Barcelona is fully open to the sea and its beaches are now accessible on foot, by car or by public transport. And its port has grown enormously to become Europe's number-one cruise harbour and the fourth largest in the world.

The transformations have gone far beyond the beaches and the port, however, since they have affected the entire city (1,500,000 inhabitants) and its much more extensive metropolitan hinterland (4,500,000 inhabitants). They are not only physical transformations in the form of plazas, streets and buildings but also, and to a similar or greater extent, functional transformations in terms of services and lifestyles. For example, public transport and pedestrian traffic along gratifying shop-lined streets with a wealth of cultural and recreational establishments account for 67% of Barcelona's urban mobility, a very high percentage. On the other hand, Barcelona hosts the World Mobile Congress and the World Mobile Centre, in other words, the city is the world mobile phone capital. Barcelona's architecture and urbanism are highly valued the entire world over. Thanks to this set of circumstances, Barcelona is one of the world's number-one tourist destinations and one of the most attractive cities in which to live and/or do business.

And all this without overlooking its two thousand years of history. On the contrary, cherishing its history and caring for its architectural and cultural treasures of the past constitute two of the main assets of this more than modern city. Romanisation, the Middle Ages, the Renaissance and industrial culture are all very visible on its streets. Barcelona is a different city, comparable only to itself.

LES CORTS AND THE CAMP NOU | 41º 22' 46" N, 029 07' 20" E
Harmonious encounter between the regular gridiron of the Eixample and the irregular street layout of the former town of Les Corts, the site of the Barcelona F.C. stadium, the city's permanent ambassador worldwide.

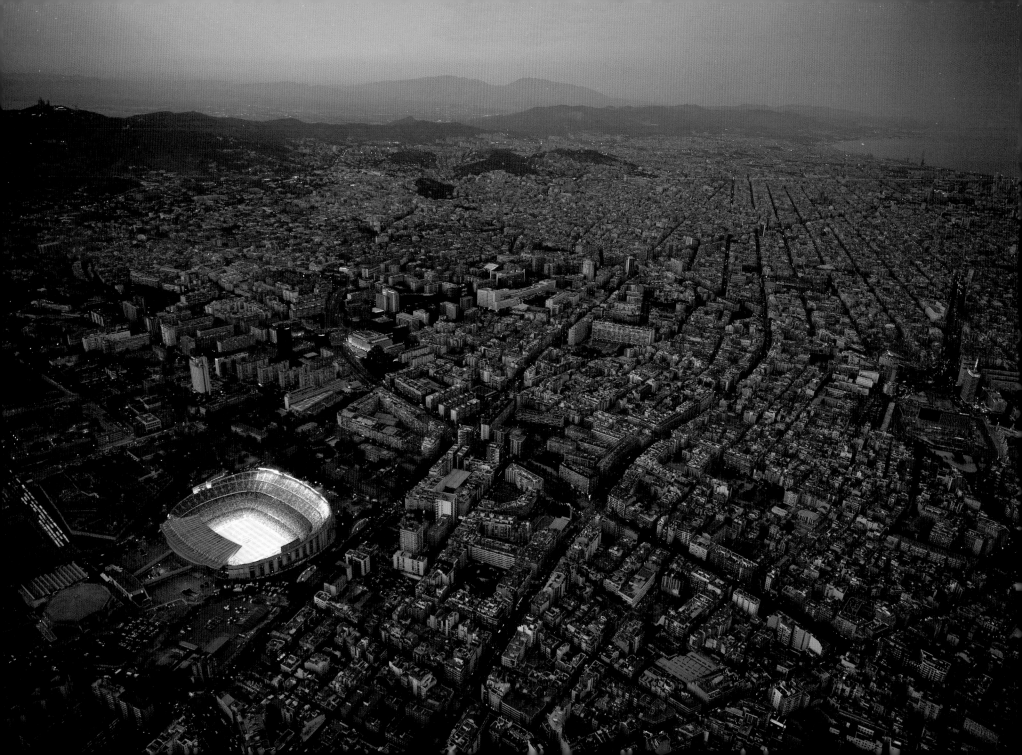

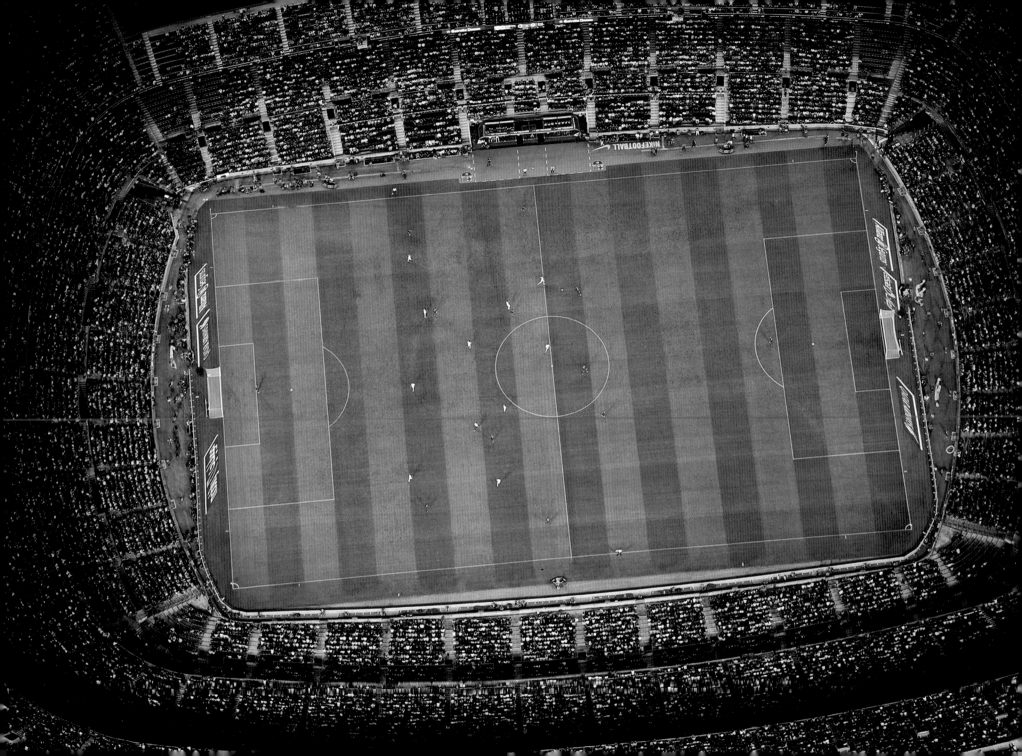

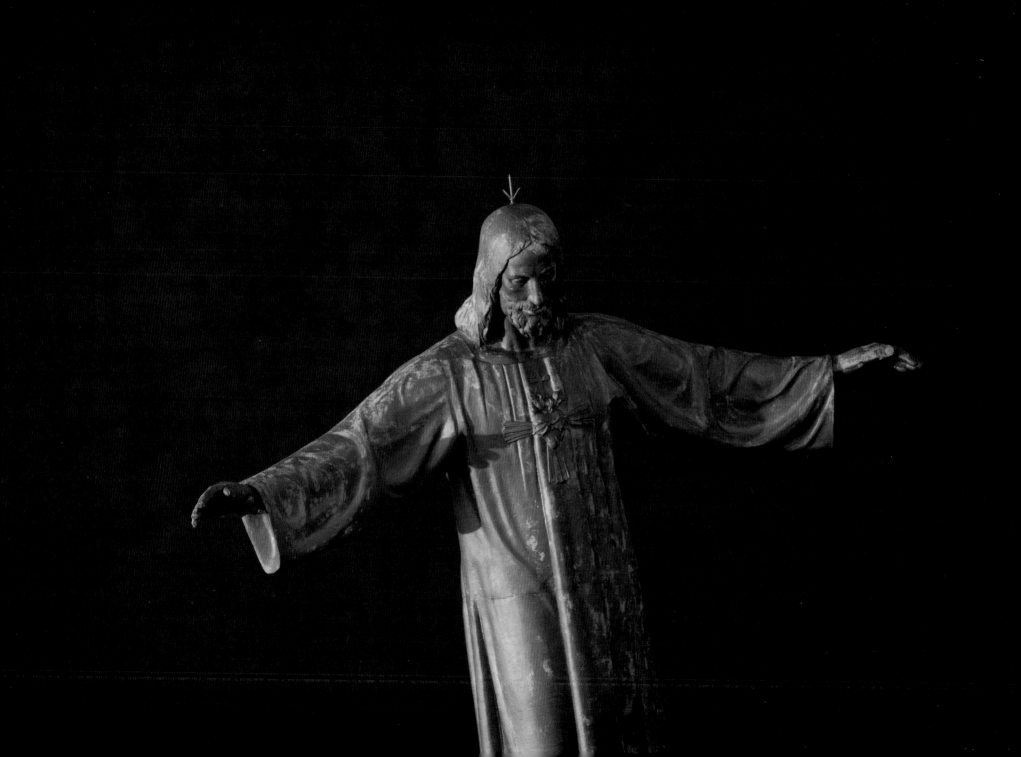

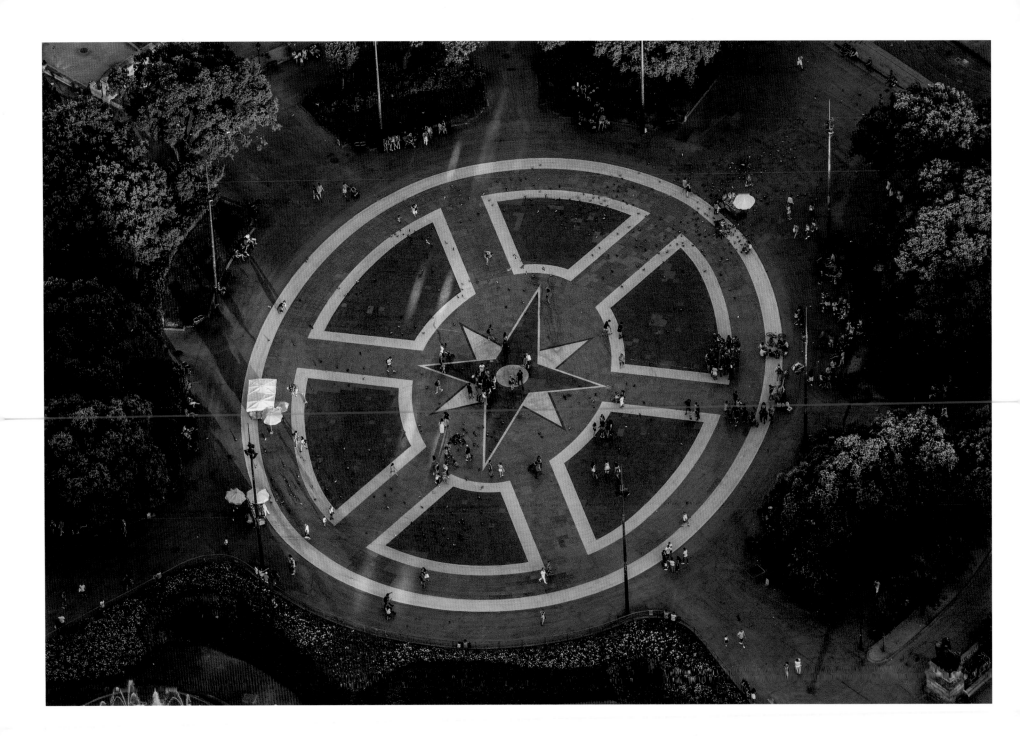

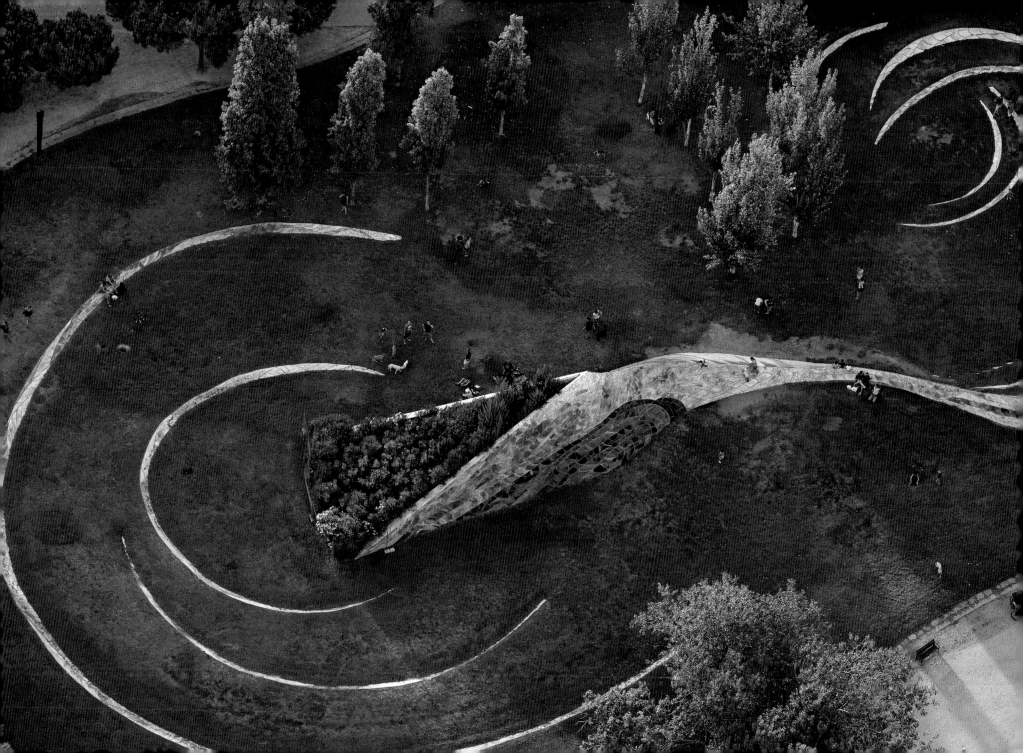

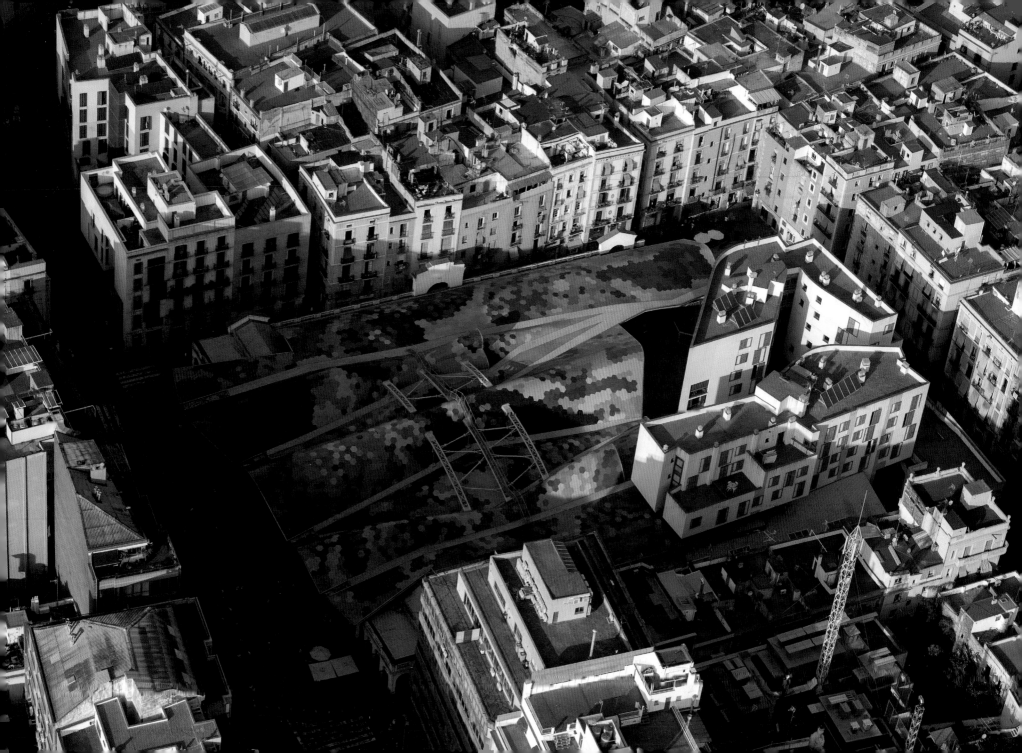

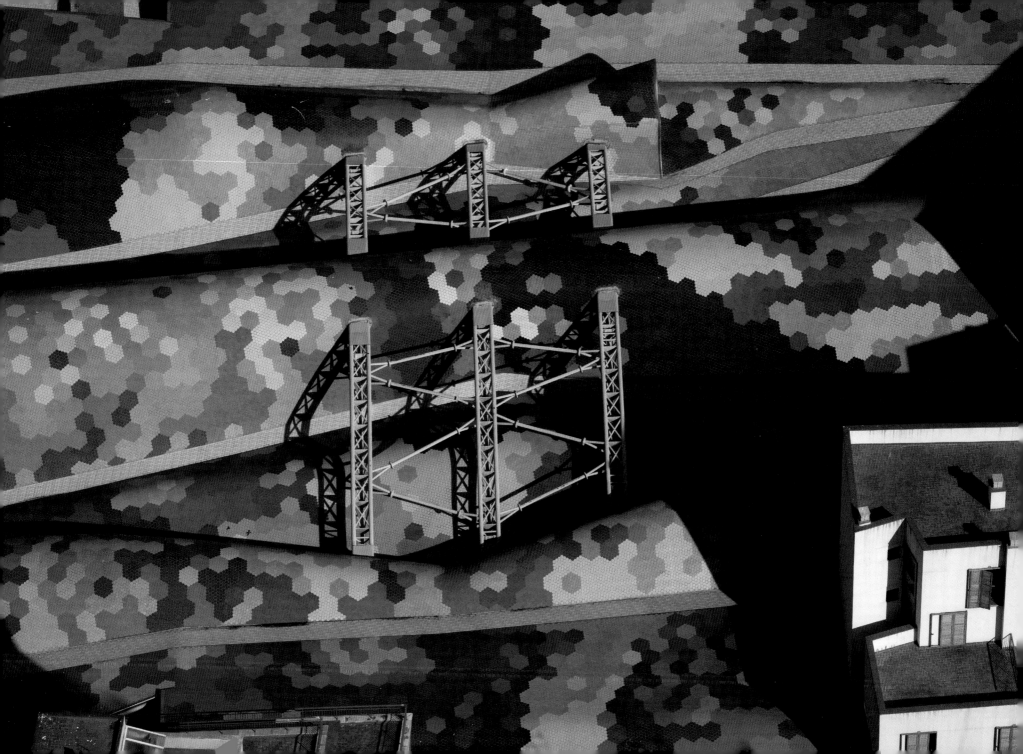

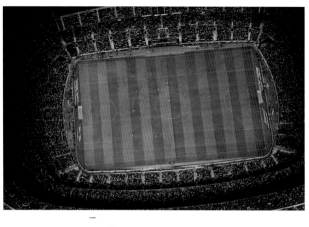

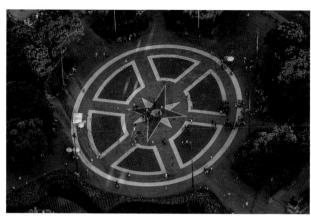

THE FUTBOL CLUB BARCELONA STADIUM
41º 22' 51" N, 02º 07' 22" E

Nobody ever calls it the Futbol Club Barcelona. Everyone calls it El Barça or El Barcelona. Most citizens of Barcelona regard it as a symbol of the city; therefore, it is usually said that *el Barça és més que un club* (El Barça is more than a club). Many people around the world first heard of Barcelona thanks to El Barça. The entity was founded in 1899 exclusively as a soccer club, although it soon came to include other sports: basketball, handball, roller hockey and, more recently, five-a-side football... Of all European clubs it is the one that has won most titles and during the 2008-2009 season it was the first football club in history to win all six cups at stake. Its current stadium, opened in 1957 with a seating capacity for 99,354, is an icon of world football. Curiously enough, it has no name: since its opening day it has been called Camp Nou (New Pitch) and nothing else. It is not so new, therefore, because it is already over one half century old...

SAGRAT COR DEL TIBIDABO
41º 25' 19" N, 02º 07' 07" E

In 1886, the Salesian Society had a small chapel built on the summit of Puig de l'Àliga, on the occasion of the visit to Barcelona of their founder (later canonised as St John Bosco). The chapel soon became transformed into a grandiose Neo-Gothic church, the work of architects Enric and Josep M. Sagnier, construction of which began in 1902 though it was not completed until 1961. To crown the church it was decided to place a great bronze statue of the Sacred Heart of Jesus. The first sculpture (1935), by Frederic Marès, was destroyed during the Civil War (1936) before it could be placed. The second, commissioned from sculptor Josep Miret, was cast in Olot, at the Foneria Barberí foundry, during the nineteen-fifties and placed at the foot of the church in anticipation of its completion. Finally, in 1961, it was raised to its present location. The gilt statue stands 7.4 metres high and weighs 4,800 kg.

PLAÇA DE CATALUNYA
41º 23' 13" N, 02º 10' 12" E

Times Square, Place de la Concorde, Trafalgar Square, Puerta del Sol... Every city has its own nerve centre. The core of Barcelona is Plaça de Catalunya, a relatively recent core and, incidentally, the fruit of chance occurrence. Until 1854, Barcelona was an entirely walled city. Outside the walls, opposite Portal de l'Àngel, there was an expanse of wasteland which was one of the first spaces to be incorporated into the new *Eixample* that Ildefons Cerdà had designed. However, nobody had anticipated building a plaza on the site, only the terminus for the Barcelona-Sarrià railway, opened in 1863. The area was a residual space for a number of years, until it eventually began to resemble a square. This point of suture between old Barcelona and the new *Eixample*, between the traditional Rambla and the new Passeig de Gràcia, became a decisive hinge. The colourful paving in the centre of the square, in the form of a wind rose, was laid in the nineteen sixties.

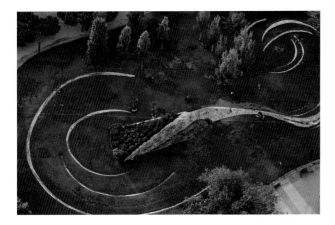

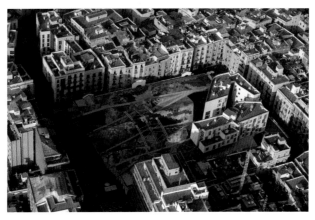

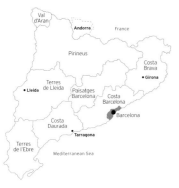

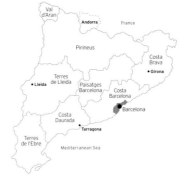

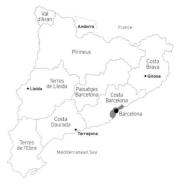

PARC DE L'ESTACIÓ DEL NORD
41º 23' 35" N, 02º 11' 00" E

Land art is a movement that began in the United States in the sixties. Instead of placing artworks in the landscape, the movement aspires to making landscapes which are works of art. It thereby establishes an indissoluble combination between nature and artistic artefacts. The Parc de l'Estació del Nord is a case in point, created in 1987 in what had become a disused railway terminus, built in 1861. This park is the work of the American sculptor Beverly Pepper. In homage to Antoni Gaudí and his *trencadís* (cladding made from irregular ceramic fragments which he applied to most of his buildings), she created the sculpture *Cel Caigut* (Fallen Sky), a wavy blue ceramic object that meanders over the lawn, on which people may walk or rest. In the same park Pepper also placed *Espiral Arbrada* (Branched Spiral), a sculpture made from a copse of lindens in the form of a spiral.

MERCAT DE SANTA CATERINA
41º 23' 10" N, 02º 10' 42" E

In 1223, shortly after it was founded in Toulouse (1215), the Order of Preachers, that is, the Dominicans, built a monastery in Barcelona dedicated to St Catherine. As time went by it became one of the city's major monasteries, with its own big Gothic church and its two-storey cloister. But having fallen into decline due to the vicissitudes of history, it was demolished in 1837. Its former site was occupied by Plaça de Santa Caterina, where a market was held. The Santa Caterina Market became one of the most important in the city and was eventually housed in an ad hoc building opened in 1847. This neoclassical building underwent a thorough refurbishment operation and was reopened in 2005. The surrounding area was also refurbished, though invariably respecting the original urban layout.

THE MERCAT DE SANTA CATERINA ROOF
41º 23' 10" N, 02º 10' 42" E

The new Mercat de Santa Caterina was endowed with an entirely brand-new and ground-breaking roof designed by architect Enric Miralles, a wavy structure clad with brightly coloured ceramic tiles. This roof invests the market with a feature both attractive and unmistakable; indeed, it has become one of the icons of XXIst-century Barcelona. And with good reason, for if there is one thing that characterises this city it is its ability to combine tradition with the avant-garde. Certainly, the façades of the XVIIth-century and XVIIIth-century buildings that encompass the square have no difficulty when it comes to engaging in dialogue with the spectacular colours and organic forms of the new market roof. Barcelona is precisely that.

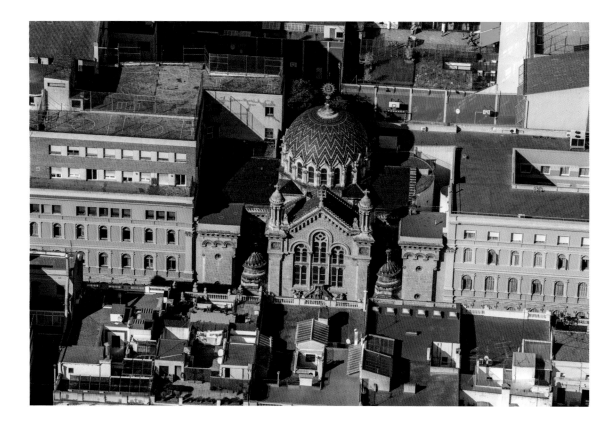

COL·LEGI DEL SAGRAT COR
41º 23' 24" N, 02º 10' 17" E

Barcelona is a dense city that constantly reformulates itself. Palaces transformed into museums, train stations into parks, old churches into markets: anything and everything may be expected. For example, a church encased between party walls and sports facilities on a flat roof... In 1881 the Jesuits opened a school, the Col·legi del Sagrat Cor, on Carrer de Casp, in an *Eixample* then at the height of its expansion. The new school resulted from the fusion of two earlier Jesuit colleges located in the old city, specifically on Rambla dels Estudis: the Col·legi de Betlem, founded in 1546 and the Col·legi de Cordelles, run by the Jesuits as from 1659. From the hundred or so pupils attending the school when it first opened, the number has now risen to 1,700. This would explain why storeys have been added, adjacent buildings occupied and the original church embedded into the complex, all of which is typically *barceloní*. The church, incidentally, is a notable example of pre-*modernista* architecture, the work of Joan Martorell,

THE FORMER SALESIAN CONVENT
41º 23' 54" N, 02º 10' 17" E

Joan Martorell designed and constructed many buildings in the XIXth-century *Eixample*. In 1877, on Passeig de Sant Joan he built a convent for the nuns of the Order of the Visitation, otherwise known as the Salesian Sisters (the founder of the Order was Francis de Sales, who was later canonised). Construction of the convent church was completed in 1885. It is an outstanding architectural complex, built from stone and naked brick, the convent revealing a clear Mudéjar influence while the church is Neo-Gothic in style, so beloved by the advocates of architectural historicism in XIXth Barcelona. Martorell was assisted by one of his pupils, who was most probably responsible for the coffered ceiling in the church. The name of this diligent, hard-working young man was Antoni Gaudí. Both the church and the convent were severely damaged by fire during the 1936-1939 Civil War. In 1942 the complex was acquired by the Marist Brothers, who converted it into a school. The church became the Parish Church of Sant Francesc de Sales.

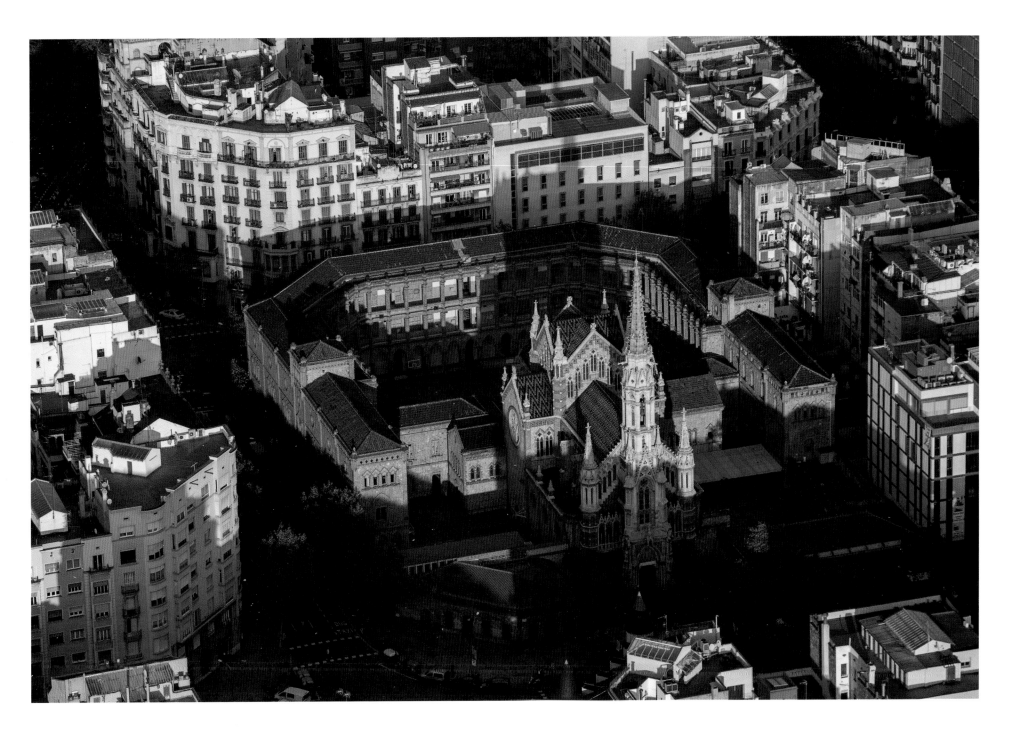

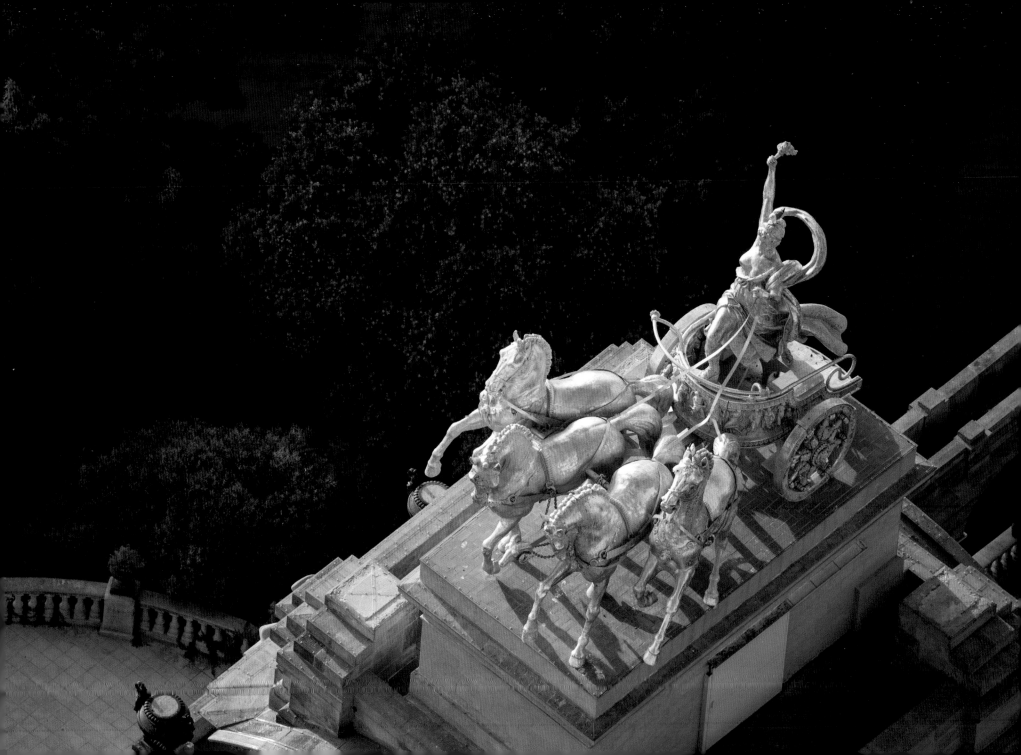

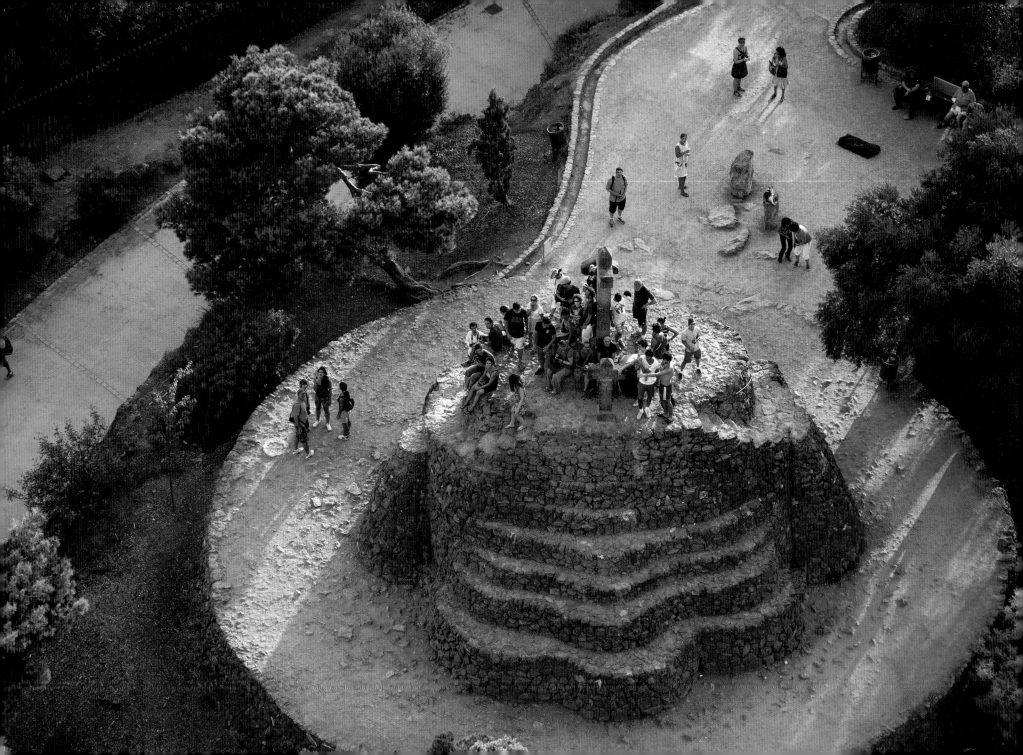

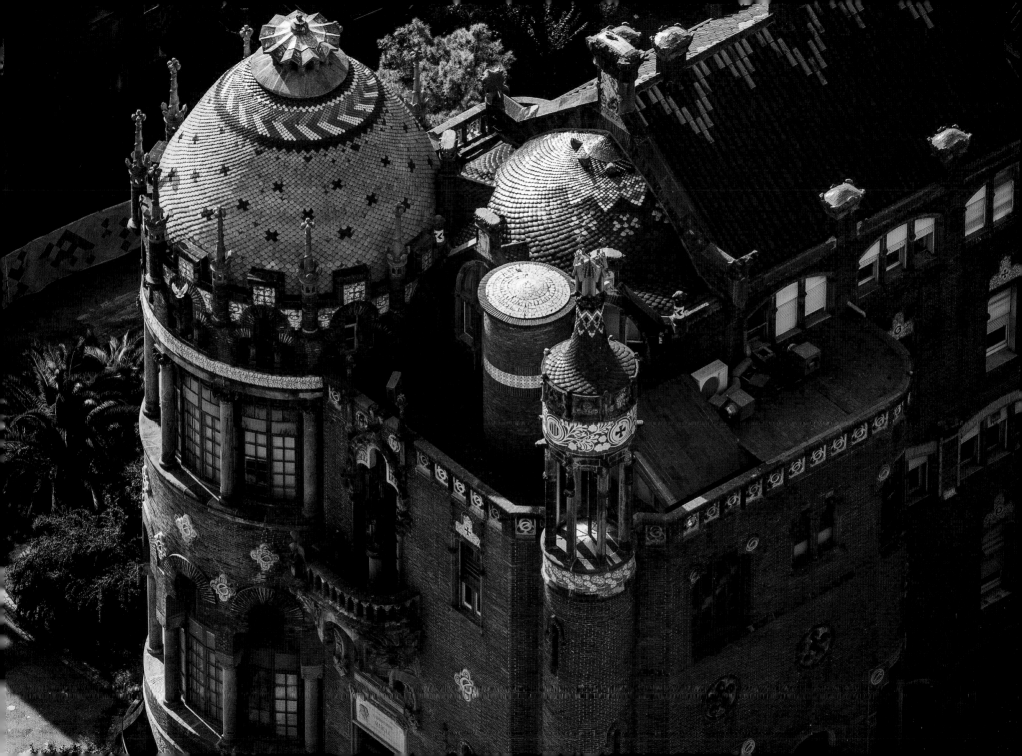

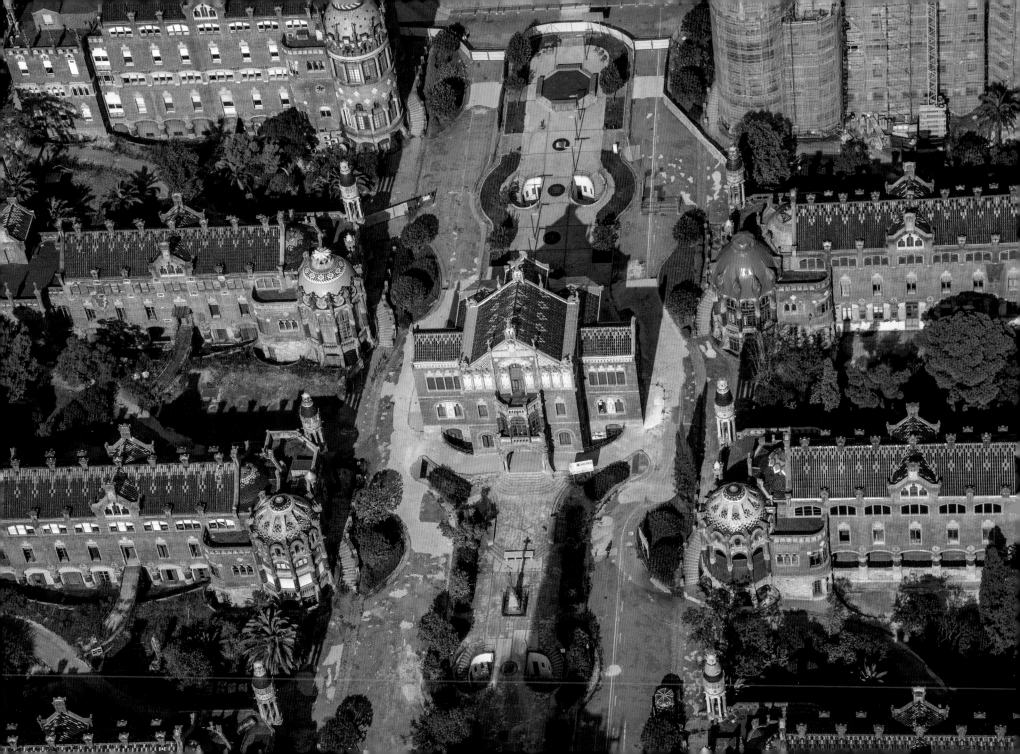

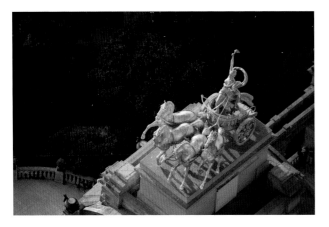

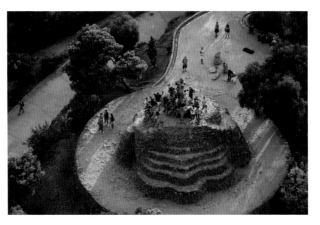

PARC DE LA CIUTADELLA
41º 23' 24" N, 02º 11' 11" E

Josep Fontserè Mestre was a Barcelona architect noted for his progressive social principles. In 1870 he entered the competition convened to transform the former citadel of Barcelona (built by Philip V as a means to repress the inhabitants after he had subdued the city in 1714) into an urban park. The aphorism that inspired his enthusiastic project was 'gardens are to cities what lungs are to the human body'. He won the competition and executed his project in time for the 1888 World Exhibition, which took place in the park. One of its outstanding elements is the great cascade profusely adorned with sculptural groups. At the top end stands the allegorical sculpture entitled *Aurora*, a thirty-ton bronze piece by Rossend Nobas. It seems clear that Fontserè had a part to play in choosing the theme: the torch of dawn dispelling the darkness of the hated citadel, which had recently been demolished, and flooding the new park for the people with light.

CALVARY IN PARK GÜELL
41º 24' 44" N, 02º 09' 04" E

Today the park is a must for thousands of tourists who visit Barcelona and who, besides contemplating all its works of architecture, invariably have their photos taken next to the small Calvary, as tradition dictates. The site was conceived originally as a private park, the garden for the house that industrialist, politician and patron of the arts Eusebi Güell Bacigalupi commissioned from Antoni Gaudí in 1900. In fact, the house and garden were to have been the initial elements in a luxury housing estate (hence the whimsical name Park Güell, with a 'k'), although the initiative was a failure and no further houses were built. Güell was Gaudí's genuine benefactor and commissioned several works from him (the Palau Güell, in the heart of the old city; the Colònia Güell in Santa Coloma de Cervelló and the Celler Güell in the Garraf region). After Güell's death in 1918, the park was purchased by the Barcelona City Hall in 1926. In 1984, it was declared a UNESCO World Heritage Site.

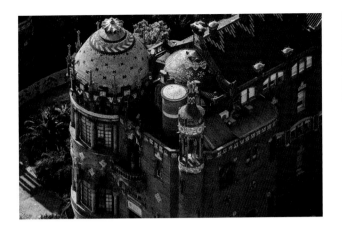

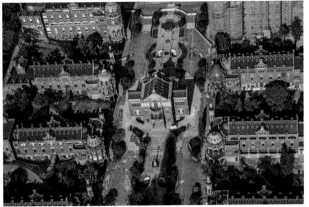

THE MARE DE DÉU DE MONTSERRAT PAVILION, HOSPITAL DE SANT PAU
41º 24' 44" N, 02º 10' 28" E

The Hospital de Sant Pau was highly modern for the time when it was planned (1905). Its different dependencies were separate pavilions surrounded by gardens and linked together by underground galleries. One of the last to be built was the Pavelló de la Mare de Déu de Montserrat (1911). Like all its counterparts, it conforms to the precepts of *Modernisme*, so much in vogue at the time: naked brick, glazed ceramics and stone mosaics or sculptures. The hospital project was drawn up by Lluís Domènech i Montaner, who was responsible for other exceptional Barcelona buildings such as the Palau de la Música Catalana and Casa Lleó-Morera. His son, Pere Domènech i Roura, continued with the project during the twenties. A new Hospital de Sant Pau went into service in 2009, while the huge complex of historical buildings, which covers an area of over nine hectares, was given over to institutional services, as in the case of the previous medieval buildings. In 1997 the complex was declared a UNESCO World Heritage Site.

HOSPITAL DE SANT PAU
41º 24' 44" N, 02º 10' 28" E

At the beginning of the XVᵗʰ century there were six hospitals in Barcelona, all of which were small. The authorities therefore decided to merge them into one and house the new institution in a spacious brand new building. This is how the Hospital de la Santa Creu came into being in 1401. Over the centuries, it was gradually endowed with a set of additional buildings, which it occupied until 1911 and which now accommodate cultural institutions (the eternal recycling so characteristic of Barcelona!). By the end of the XIXᵗʰ century the hospital facilities had become inadequate. Fortunately, this coincided with the decision on the part of banker Pau Gil, who died in Paris in 1896, to donate half his fortune to the construction of a hospital in Barcelona dedicated to St Paul (Sant Pau). After an agreement had been reached between Pau Gil's executors and the governors of the Hospital de la Santa Creu, the new Hospital de la Santa Creu i Sant Pau, commonly known as the Hospital de Sant Pau, was built. Work on the main nucleus was completed between 1905 and 1911.

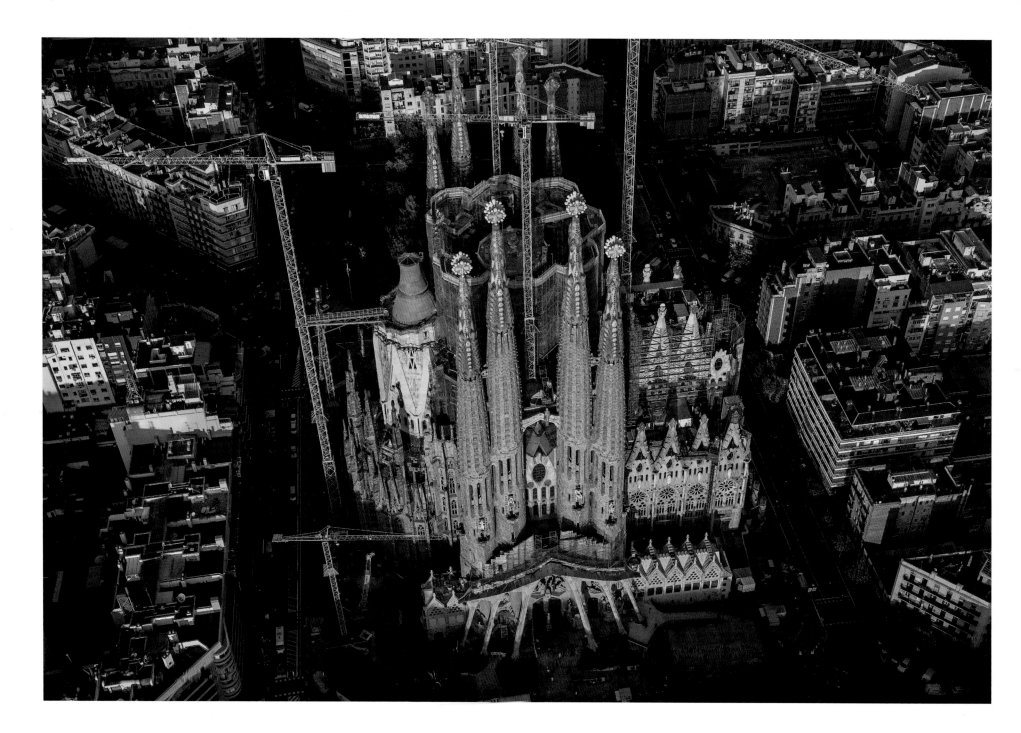

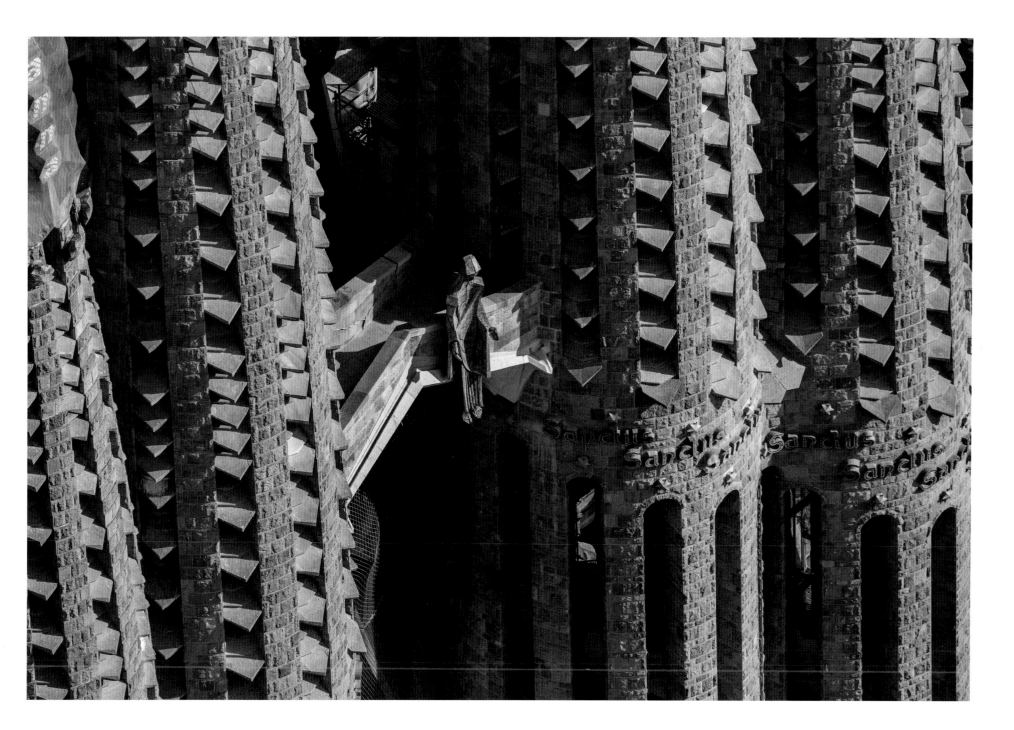

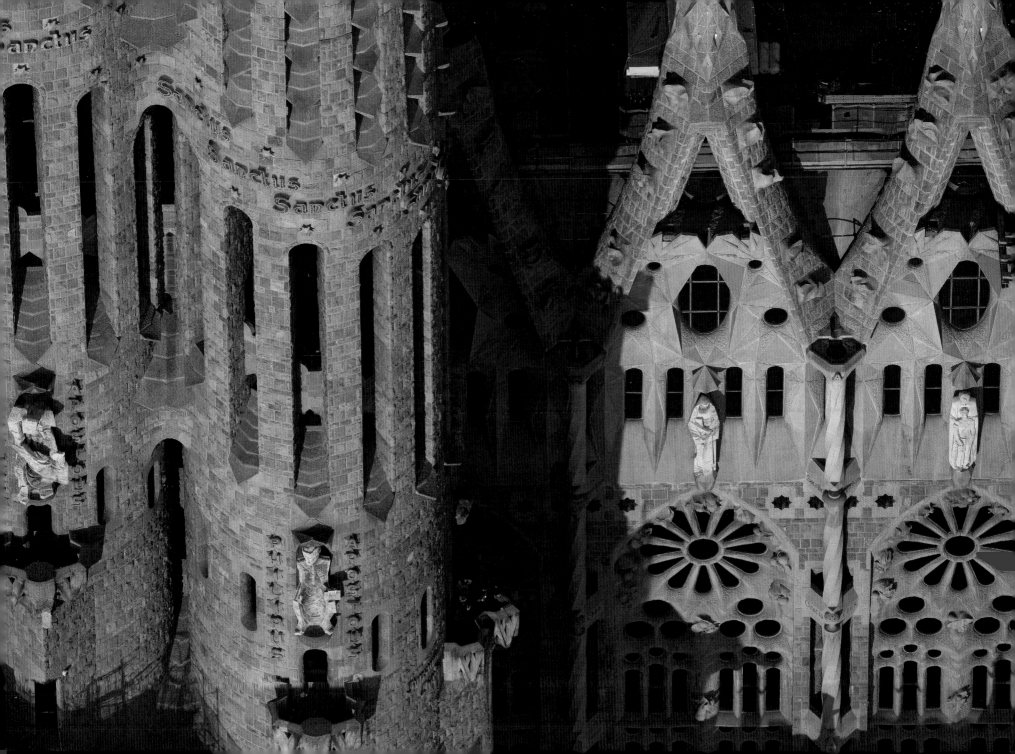

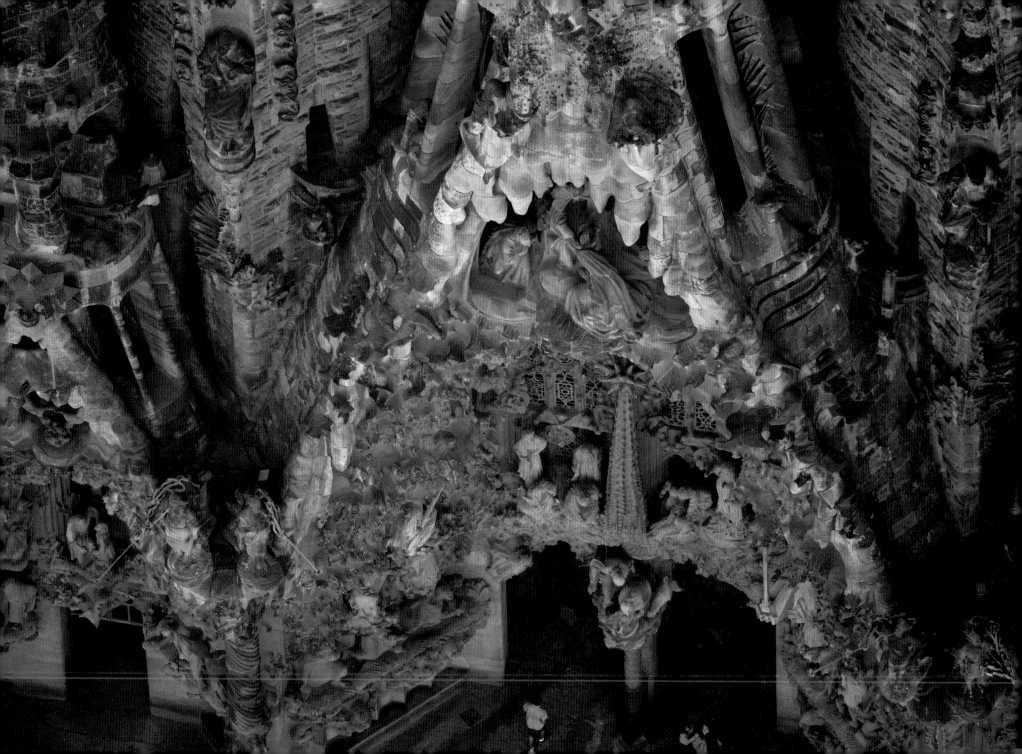

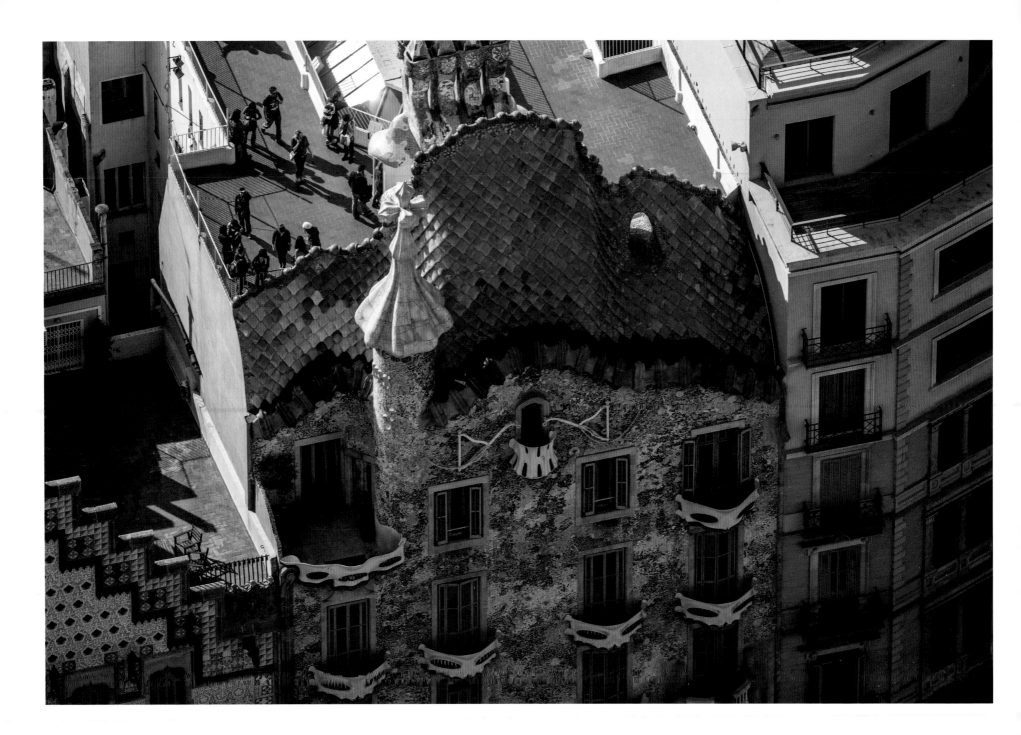

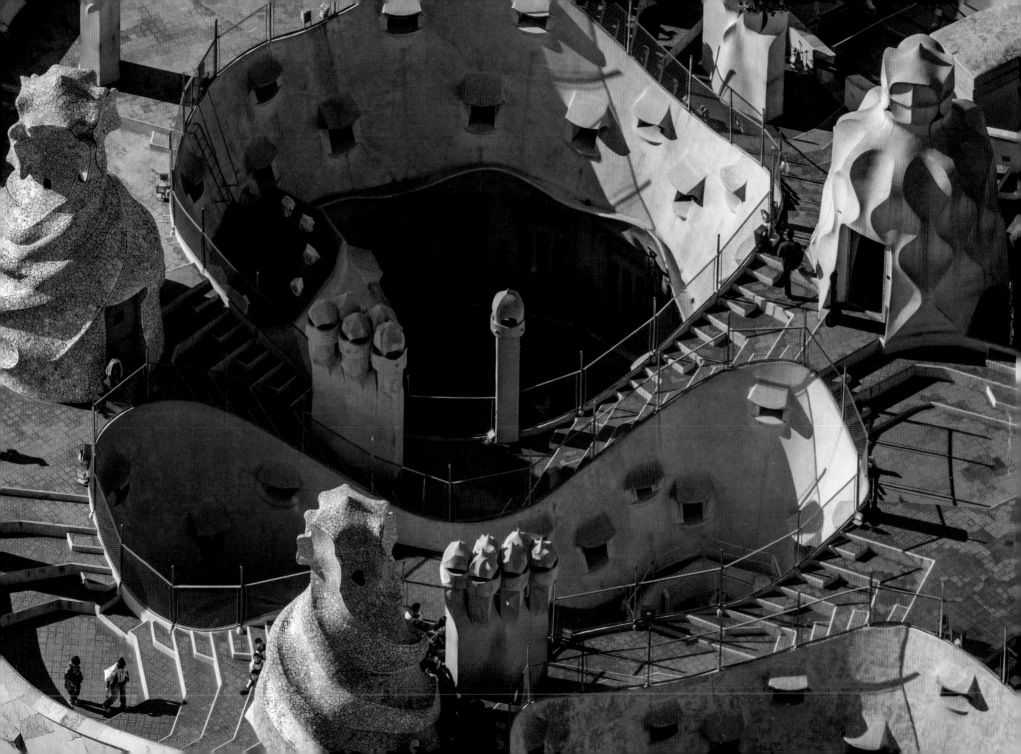

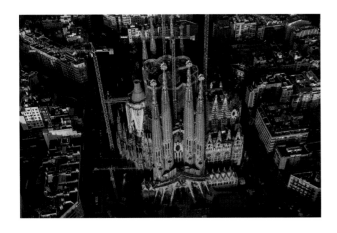

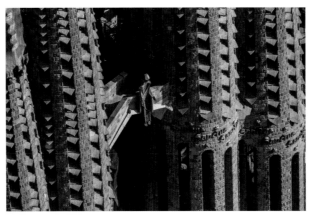

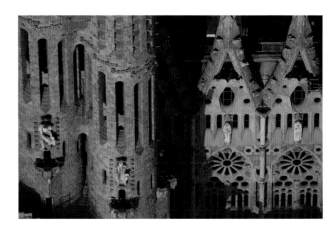

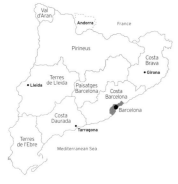

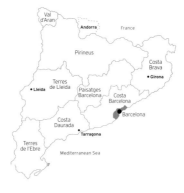

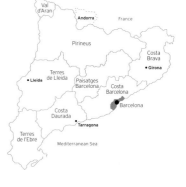

SAGRADA FAMÍLIA
41º 24' 12" N, 02º 10' 27" E

More cranes and scaffolding than spires: this is the impression we get when we contemplate the exterior of the Temple Expiatori de la Sagrada Família. Thanks to the enormous interest aroused among visitors to Barcelona (over three million per year) in the church designed by Antoni Gaudí, work continues because as an expiatory church, its construction may be funded only through alms. Gaudí worked on the Sagrada Família from 1883, when he was entrusted with the commission, until 1926, the year of his death. During the last fifteen years of his life he devoted himself exclusively to the project. To judge from the current pace of work, it is reckoned that the church will have been completed by around 2026. In 2010 the main nave was finished and the basilica was consecrated and opened for worship, hitherto restricted to the crypt, an earlier work by Francesc de Paula del Villar, whose Neo-Gothic project was eventually rejected by the church sponsor, Josep M. Bocabella, who turned instead to Gaudí, at that time only 31 years old. The architect radically modified the project and opted for modernista canons.

THE SAGRADA FAMÍLIA BELL TOWERS
41º 24' 12" N, 02º 10' 27" E

Gaudí saw the completion of only one of the eighteen bell towers he had designed. Even so, he left three more practically finished and the entire bottom part of the church completed. Throughout the 43 years during which he worked on the project, he experimented with possible solutions and introduced innovative building forms. The entire church is an architectural laboratory which has continued as such until the present day, incorporating new artistic trends and new building techniques, although invariably respecting the initial basic project, clearly expounded in many partial plans and scale models, despite that fact that much of Gaudí's material was lost during the fire that occurred during the Civil War. The entire church, each pillar, each window, is a huge allegory. The spires symbolise the twelve apostles, the four evangelists, the Mother of God and Jesus Christ (the tallest of the spires, 170 metres in height, just short of that of Montjuïc, 'because the work of man must never attempt to surpass that of God', to quote Gaudí himself). The Sagrada Família has been a World Heritage Site since 2005.

THE ARCHITECTURAL ORDERS
OF THE SAGRADA FAMÍLIA
41º 24' 12" N, 02º 10' 27" E

The Sagrada Família is a modernista building. Although it is also neo-Gothic. Or perhaps it is neither exactly one thing nor the other: it is a Gaudinian building. Gaudí observed a number of Gothic canons and modernista forms when he designed his project, which differed from all other churches. It would be a waste of time to attempt to ascribe it to a specific architectural order. Among other unique features, he endowed the belfries with written texts, made from ceramics. Recently, the images and sculptural groups by Josep M. Subirachs have been added, which also defy any form of classification.

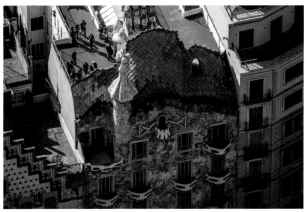

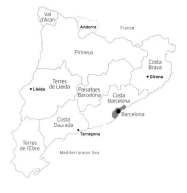

SAGRADA FAMÍLIA, THE NATIVITY FAÇADE
41º 24' 12" N, 02º 10' 27" E

The Sagrada Família has three façades: the Glory Façade, which is the main one, the Passion Façade and the Nativity Façade, the first to be built. All three exemplify the rich symbolism Gaudí applied to his church. The Nativity Façade has three porticos, each of which represents one of the theological virtues: Faith and Hope on the sides and Charity in the middle. Over the mullion of the central panel is a succession of sculptural groups, beginning with a representation of the Nativity (with the Adoration of the Magi and the Adoration of the Shepherds at the side) and surmounted by the Coronation of Our Lady.

CASA BATLLÓ
41º 23' 30" N, 02º 09' 54" E

As befitting a bourgeois city, characterised by more trading than political activity, in Barcelona's *Eixample* there are more blocks of dwellings than monuments or major institutional buildings. However, these blocks are truly outstanding, and this is their prime architectural virtue. One of the most remarkable of all is Casa Batlló, on Passeig de Gràcia. In 1904 Josep Batlló Casanovas, an industrialist devoted to the textile sector, decided to demolish a house he had purchased on the avenue and to build an entirely new one. He entrusted Antoni Gaudí with the project, and the architect persuaded Batlló just to 'recycle' the existing building. Fruit of the in-depth refurbishment operation was an entirely different building, one of the most remarkable in Barcelona. The façade entirely clad with ceramics, the magnificent skylights, the rich decoration in wood and the wrought iron work dazzle visitors to the building, one of the true emblems of Barcelona *Modernisme* which is now a museum to itself (with over six-hundred thousand visitors per year).

CASA MILÀ ('LA PEDRERA')
41º 23' 43" N, 02º 09' 43" E

The last work that Antoni Gaudí executed before devoting himself entirely to the Sagrada Família was Casa Milà. Pere Milà Camps was an industrialist and conservative politician who loved to be the centre of attention. Fascinated by Casa Batlló, he commissioned Antoni Gaudí to construct another building on Passeig de Gràcia. The work was completed in 1912, after many conflicts and discrepancies between Milà, the architect and the municipal authorities. Besides being *modernista* in style, the building is highly modern from the constructional point of view, with a façade that functions as a curtain wall *avant la lettre*. The skylights and the ventilation respond to bioclimatic criteria while vertical transport is entrusted to lifts, the stairs being exclusively for utilities. Particularly outstanding are the flat roofs, with chimneys and ventilation shafts crowned in highly original fashion. As in the case of other works by Gaudí, catenary arches and paraboloids are present in many Casa Milà structures.

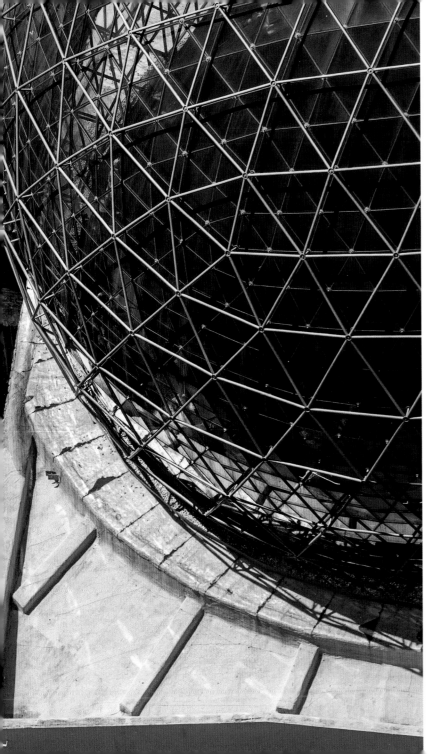

HALFWAY UP

RELIEFS THAT DESCEND
FROM THE NORTH

The Catalan coastal plain is of highly modest dimensions. From the beach, it is impossible to look inland without finding a mountain range that immediately blocks the horizon. This is due to the existence of the Catalan Coastal System, comprising the Serralada Litoral and the Serralada Prelitoral, two mountain ranges that lie parallel to the coast with an area of plains of varying width in between. A twofold barrier of mountains, therefore, runs through Catalonia from south-west to north-east at only a short distance from the sea, never further than 50 or 60 kilometres as the crow flies.

The Serralada Litoral is interrupted here and there, above all around Tarragona, where it practically disappears. It is characterised by a number of robust orographical features such as the Montgrí, the Gavarres, Montnegre, the Serra de Marina, Collserola and Garraf. The Serralada Prelitoral, on the other hand, has no major interruptions. It has several considerable massifs, with altitudes that exceed one thousand metres in many places. The most notable are the Guilleries, Montseny, Sant Llorenç de Munt, Montserrat and the Prades, Montsant and Pàndols ranges, which link with the Ports de Tortosa-Beseit in the far south.

The Serralada Prelitoral connects with the Pyrenees through another mountain system, stretching from the south-east to the north-west, called the Serralada Transversal. This is formed by a set of mountains with peaks also in excess of one thousand metres, including Puigsacalm, the Serra de Finestres, Bassegoda and the Serra de la Mare de Déu del Mont, as well as the entire system of volcanoes in the La Garrotxa region.

This remarkable set of mountains, with their corresponding plains in between, constitutes the spinal column of that part of Catalonia that looks towards the sea. European landscapes are able to penetrate far into Catalan territory thanks to these mountains, which guarantee the ideal local climatic conditions to enable this incursion into Mediterranean latitudes. A considerable part of Catalonia's great landscape diversity is thanks to this circumstance. Thus, halfway up the slopes of all these more or less coastal ranges oak forests and beech woods thrive, while grapes and almonds are cultivated on the plains. Northern Europe reaches the southern Mediterranean by straddling the littoral mountain ranges.

THE CHARCOAL FORESTS

With the advent of the Industrial Revolution, Catalonia began to function with coal from Asturias and Wales. Ship after ship from the ports of Jijón and Cardiff (some also from Newcastle) reached the port of Barcelona laden with soft coal and anthracite. This was nothing particularly new, however, since Catalonia had been exploiting coal for centuries; not mineral coal, however, but charcoal, obtained specifically from evergreen oaks.

Most Catalan evergreen oak forests are in the Sistema Costaner and the Serralada Transversal mountains. For centuries they supplied the country with the fuel it needed. Evergreen oak wood, which is hard and compact, may be partially burnt to eliminate water and other substances from the trunk. And what remains is light, black material of high calorie content, relatively pure carbon and little else. This charcoal was coal par excellence in medieval, renaissance and baroque Catalonia until mineral coal began to be imported from elsewhere.

In the forest, charcoal makers piled up the evergreen oak logs tightly together, covered the heap with earth and set fire to the wood, which became transformed into charcoal having burnt only partially, due to the lack of oxygen. There was no need to fell the trees, it was sufficient to prudently cut them back so that they would regenerate from the trunk. Indeed, the evergreen oak readily sprouts again from the trunk or the stump, which means that the forest mass regenerates much more quickly than if the trees are planted from seed. On the other hand, what remains are many shoots and few thick trunks, which is an advantage when it comes to obtaining timber a few years later for the next period of charcoal making.

Charcoal cannot be made from pines. What pines provide is firewood, which was used for bread ovens, lime kilns (lime was medieval cement) or any kind of furnace that needed to be lit and to burn quickly. In all cases, pines and oaks provided the energy needed. Catalan littoral forests have invariably been exploited more for firewood than for timber. Consequently today, now that they are no longer transformed into charcoal or firewood, they succumb so easily to forest fires. Luckily, great extensions have either been unaffected by fires or else have regenerated after them, as they did after charcoal extraction.

SANT FELIU DEL RIU | 42º 17' 46" N, 02º 35' 38" E

The small twelfth-century Romanesque church of Sant Feliu del Riu stands in the midst of a dense evergreen oak forest in the River Llierca valley, at an altitude of 540 m, near Sadernes in the Alta Garrotxa.

THE MEDITERRANEAN TRILOGY

In the mid-XIXth century the phylloxera plague began to spread through France. Phylloxera is an almost microscopic American sap-sucking insect that attacks vines. In the space of only a few years, vast tracts of French vineyard were completely destroyed. This unfortunate occurrence nonetheless opened up an opportunity for Catalan wine growers, whose vineyards underwent extraordinary expansion between approximately 1870 and 1895. Less than two-hundred thousand hectares of vineyard increased to a total of four-hundred thousand, that is, the figure doubled. Most of them were on the plains or the gentle slopes of littoral and pre-littoral Catalonia.

This 'wine rush' led to many forests being converted into cultivable land. Where pines and evergreen oaks had once stood terraces soon began to appear on which vines were planted. Such euphoria was short-lived, however, because phylloxera reached Catalonia in 1879 and began to devastate vineyards, both old and new, beginning in the Empordà, naturally. By 1890 practically no vineyards remained in northern Catalonia and the scourge began to spread southwards. By 1905 all Catalan vineyards had been destroyed. Forests began to recover their former territory, although still today, over one century later, terraces are easily distinguishable in many Catalan coastal pine woods.

The vineyards were replanted, this time with high-quality European grape varieties grafted onto American phylloxera-resistant rootstock (the insect attacks the roots). All today's Catalan vineyards, like their counterparts elsewhere in Europe, are of this mixed nature. For a long time now, vineyards have become totally regenerated in those areas really favourable to wine growing, which in the case of Catalonia are located in the Empordà, partially in the Maresme and, above all, in the littoral and pre-littoral regions of southern Catalonia, with major incursions into some inland zones.

The rest of the agricultural land in pre-littoral Catalonia is given over partially to irrigation farming though mainly to dry farming, devoted above all to olives, almonds and cereals, normally cultivated in poor, stony soils. In this way the traditional Mediterranean trilogy is completed (vineyards, olive groves and wheatfields), the staple diet in the entire basin: wheat bread, olive oil and wine. These are the food-producing landscapes that stand side-by-side with the energy-producing pine and evergreen oak forests.

FIELDS IN LA CREU DE CODINES | 41º 57' 58" N, 02º 18' 23" E

Processes of erosion cause the bare rock to completely emerge in some places in Catalonia, a phenomenon known in Catalan as codina, hence the name of the town La Creu de Codines.

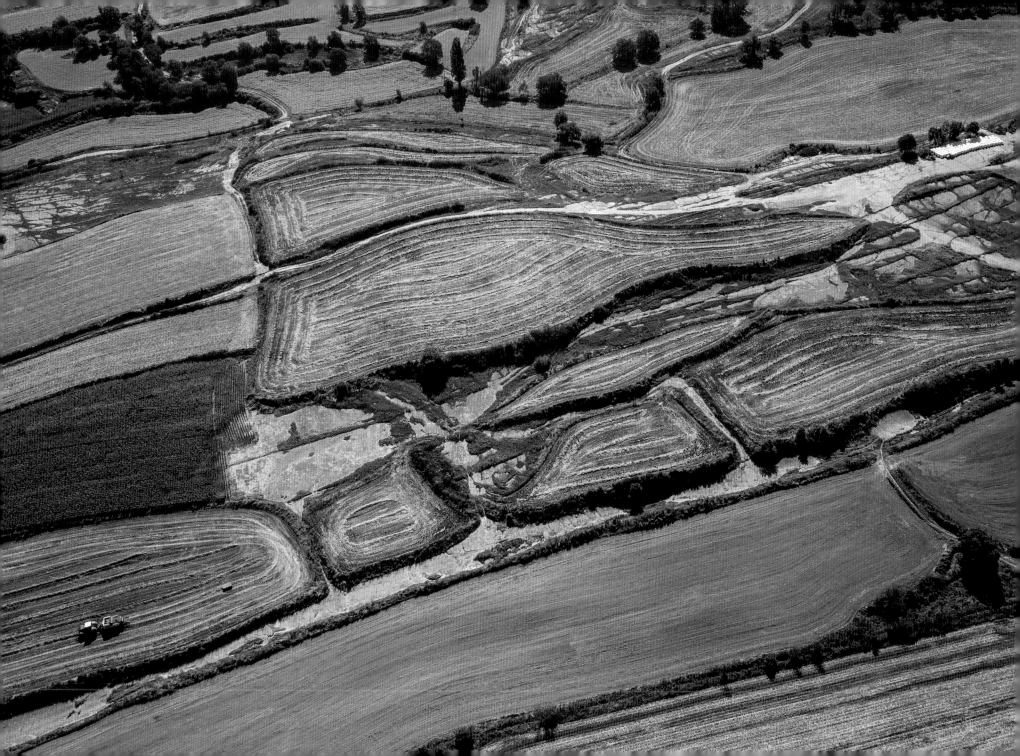

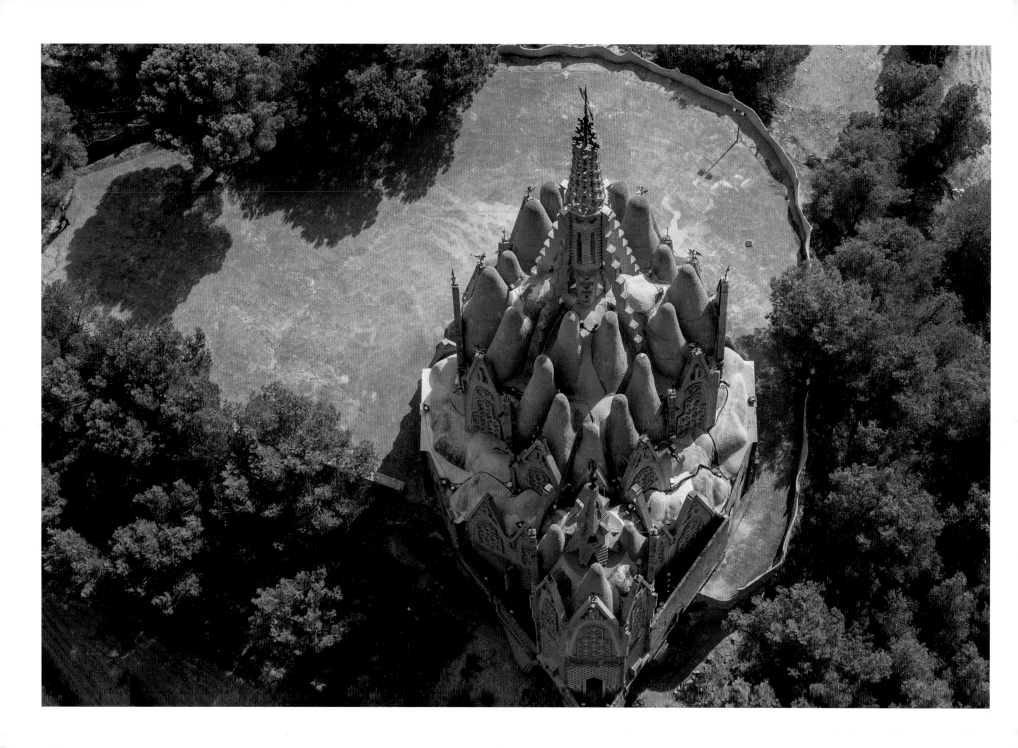

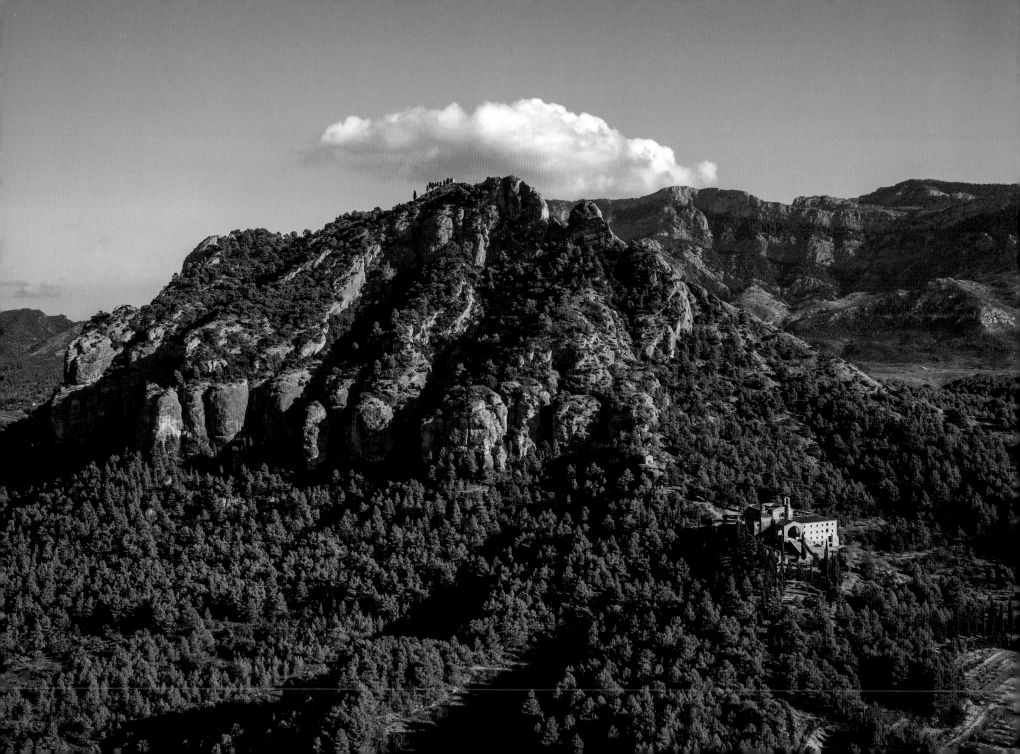

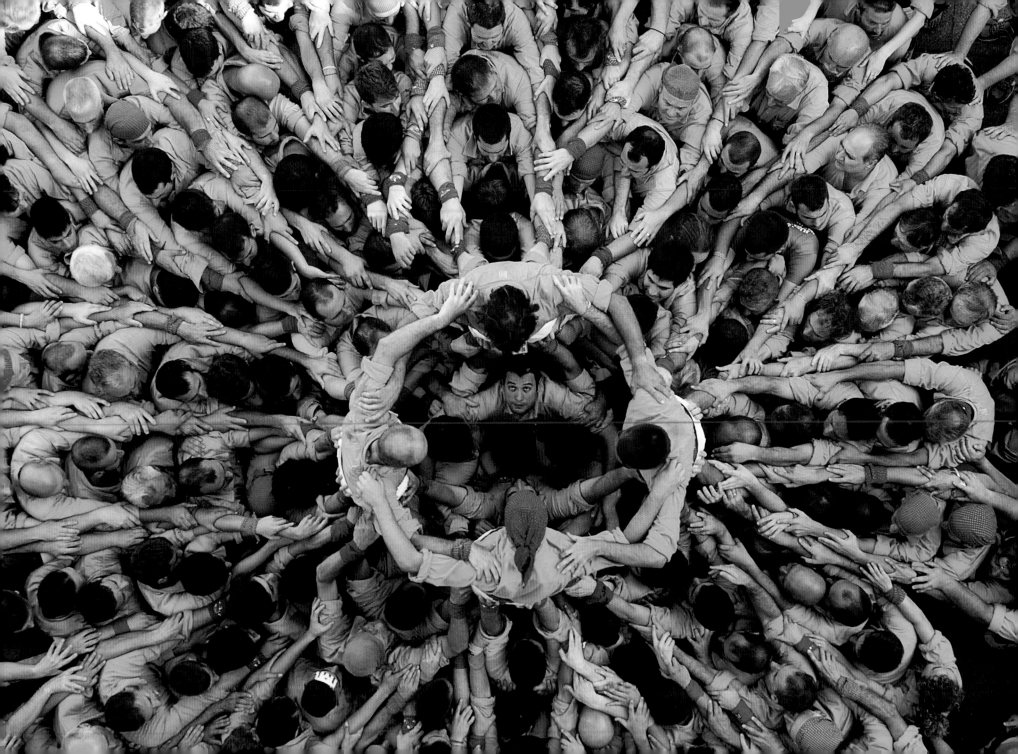

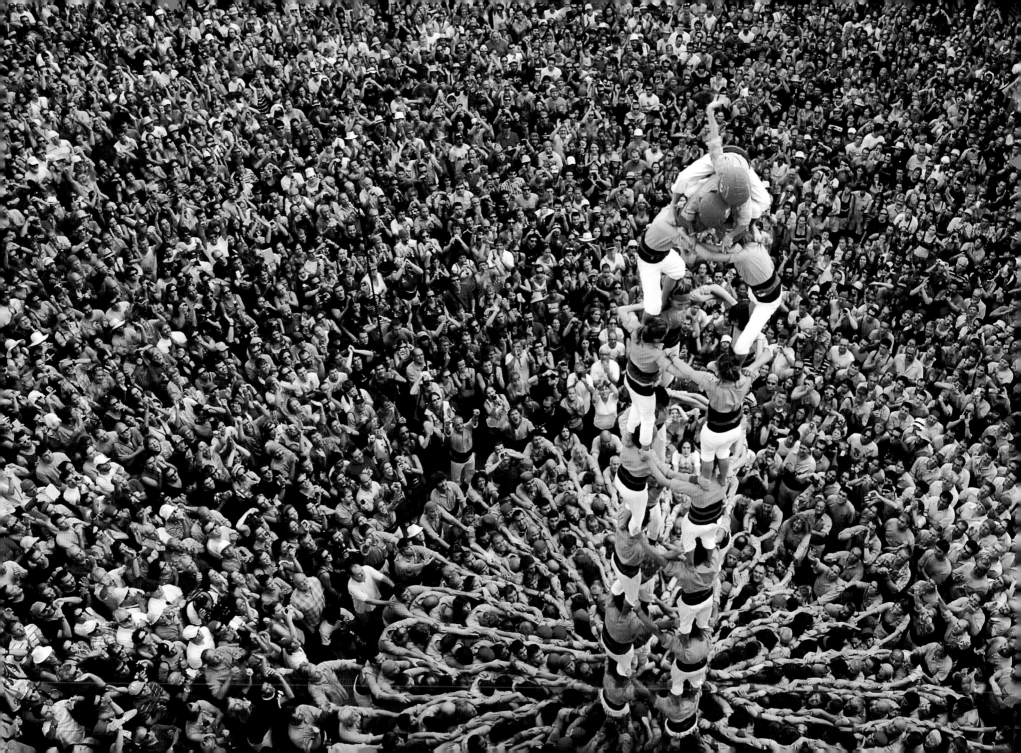

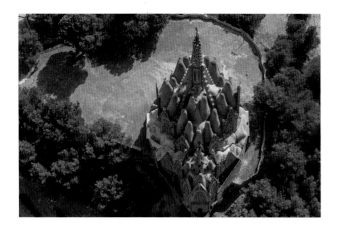

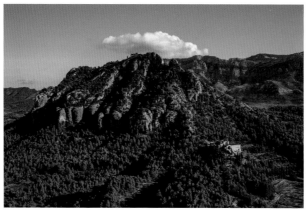

MARE DE DÉU DE MONTSERRAT DE MONTFERRI
41º 16' 07" N, 01º 22' 11" E

Half a century before the arte povera movement emerged in Italy, the young Catalan architect Josep M. Jujol already revealed an astonishing ability to convert all kinds of rubble into art. Some of the brilliant works commonly attributed to Antoni Gaudí are in fact by Jujol, who collaborated in the decoration of some of Gaudí's creations (with furniture, carpentry, paintings and so on). The most famous case is undoubtedly the meandering benches in Park Güell, fruit of Jujol's genius, which transformed all the broken ceramics and bottles he found into multicoloured trencadís. In 1926 he was commissioned to build a sanctuary dedicated to Our Lady of Montserrat in Montferri. Using concrete and masonry he created an aston-ishing building reminiscent of the unusual forms of the mountain of Montserrat. The work remained unfinished and deteriorated by the passage of time until it was consolidated and completed in 2000.

CONVENT DE SANT SALVADOR D'HORTA
40º 57' 24" N, 00º 19' 54" E

When in 1543 the Franciscans founded a monastery in Orta (Horta de Sant Joan), at the foot of the Ports de Beseit, they decided to appro-priate the magnificent Gothic church that the Knights of the Order of the Temple had built in the XIIth century. They added monastic dependencies that conformed to renaissance canons and created a new architectural complex which they called the Monastery of Santa Maria dels Àngels. Between 1547 and 1559 Salvador Pladevall resided there who, canonised as Sant Salvador d'Horta, eventually lent his name to the monastery. On the Puig de Sant Salvador, the ruins now stand of the renaissance friary and, in perfect condition, the splendid Gothic church, unmistakable by virtue of its spacious galilea (a porti-coed reception atrium). Horta de Sant Joan became famous thanks to the long sojourns Pablo Picasso spent there between 1898 and 1899 and in 1909. 'Everything I know I learnt in Horta', the painter once said.

CASTELLERS: HUMAN TOWERS
41º 20' 49" N, 01º 41' 53" E

'Strength, balance, courage and good sense!', this is the motto of the *castellers*. And this is precisely what is needed to erect the *castells*, the ephemeral human towers of up to ten storeys, in the construc-tion of which as many as three-hundred people may be involved, some two-hundred in most cases, both men and women. The tradition began as a feast-day entertainment in the XIXth century, or possibly earlier, in southern Catalonia, and it is now a mass phenomenon that arouses genuine passions. There are over sixty troupes (known as colles) of *castellers* in the whole of Catalonia, each one with thousands of fol-lowers, who compete amicably though vehemently with each other at weekly gatherings. Declared part of the Intangible Cultural Heritage in 2010, the human towers are regarded by Catalans as an integral part of their cultural identity, are transmitted from one generation to the next and provide a sense of continuity, social cohesion and solidarity.

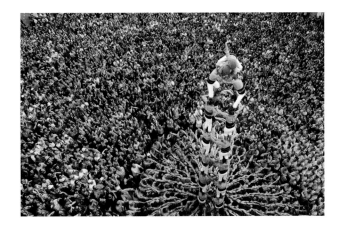

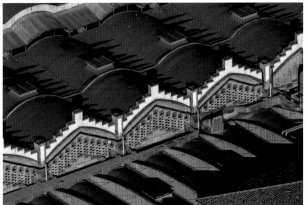

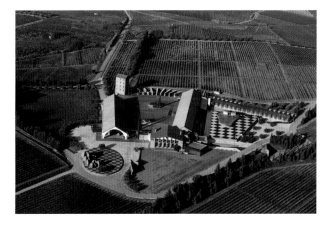

CASTELLERS IN VILAFRANCA DEL PENEDÈS
41º 20' 49" N, 01º 41' 53" E

There are three kinds of *castells*: the pilars (pillars--one person per storey), the torres (towers--two people) and the *castells* proper (three, four or even five people per storey). Construction begins with a pyramidal base, called the pinya. Next, the people who constitute each of the storeys climb up on top, in an extraordinary exercise of strength and balance, until the *castell* is eventually crowned by the *enxaneta*, normally a little boy or girl. To watch how the *castell* grows to the sound of the *gralla* (a kind of high-pitched wind instrument similar to the shawm) and the shouts of encouragement from the *cap de colla* (troupe leader) is a thrilling, unforgettable experience.

THE CATHEDRALS OF WINE
41º 26' 06" N, 01º 47' 50" E

Commissioning great architects to build wine cellars is by no means a new phenomenon. On the contrary, at the beginning of the XXth century, long before oenological culture became widespread, the cooperative cellar movement emerged in Catalonia, of municipal or regional scope, in which farmers brought their harvested grapes to contribute to a collective wine-making process. This initiative took root above all in southern Catalonia, where outstanding modernista cellars were built, which came to be known significantly as cathedrals of wine. Further north, leading vineyard owners also commissioned sumptuous cathedral-like cellars. Such is the case of the sparkling wine (cava) producers of the Penedès. Here the characteristic naked brick architecture flourished, such as at Caves Codorniu, comparable to the industrial architecture that emerged at the beginning of the Industrial Revolution.

VINEYARDS AND WINE CELLARS IN THE PENEDÈS
41º 26' 37" N, 01º 48' 55" E

In the Mediterranean, for centuries wine was a modest domestic product, like bread or home-made cheese. Peasant farmers cultivated the vine (Vitis vinifera) and made wine at home which they consumed themselves; only part of the produce was kept aside for third parties. The wine-making process was an empirical one and the results varied. And although honesty was guaranteed, quality was certainly not. All this changed with the advent of oenological knowledge. Now wine-making, despite the extreme physical, chemical and biological complexity of the process, is controllable and predictable. As a result, both domestic wine-making and small-scale producers are largely a thing of the past. In Catalonia, as elsewhere, highly technified wine cellars have emerged whose sophistication is expressed through an avant-garde architectural image, as in the case of Juvé & Camps. New wine landscapes have appeared alongside refined architecture in the midst of meticulously tended vineyards.

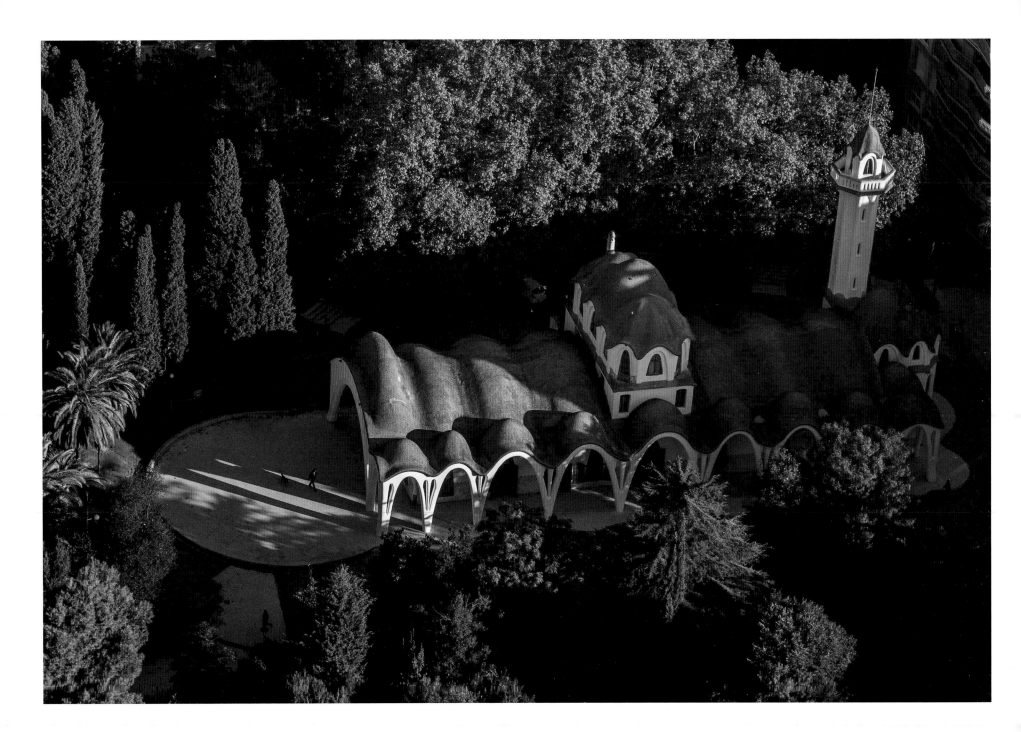

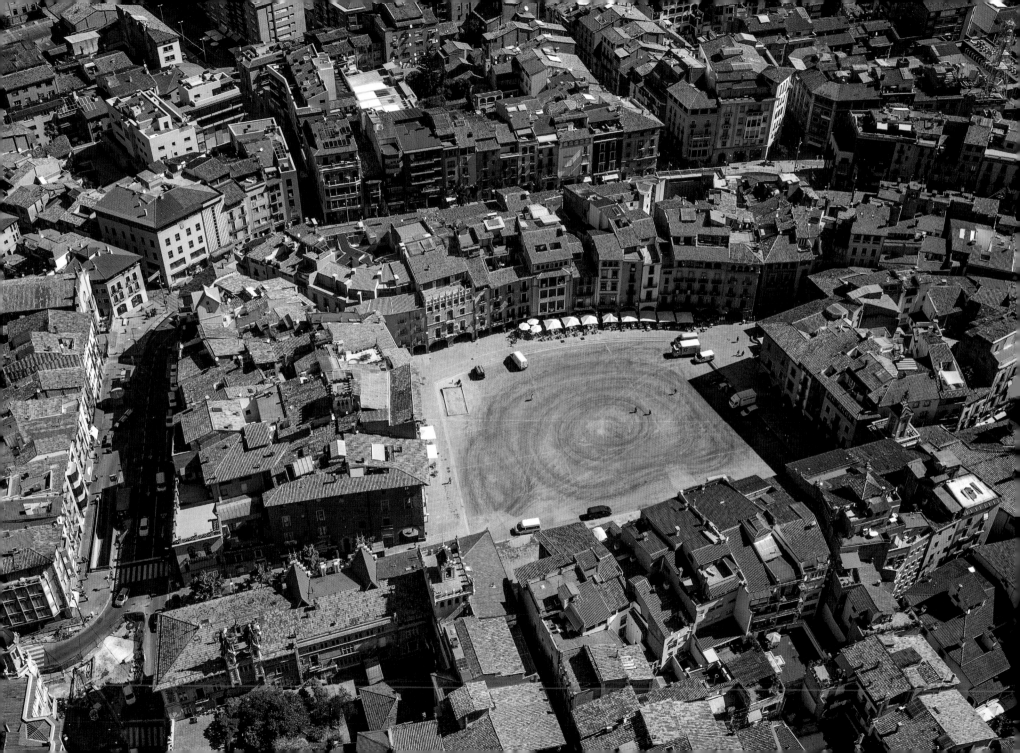

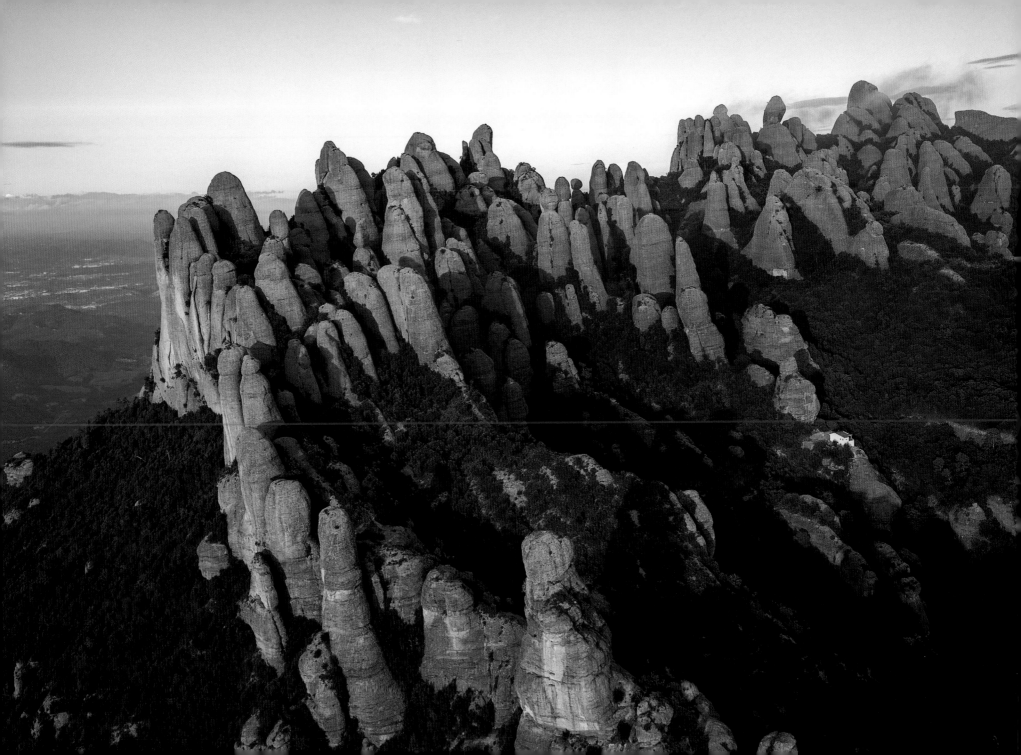

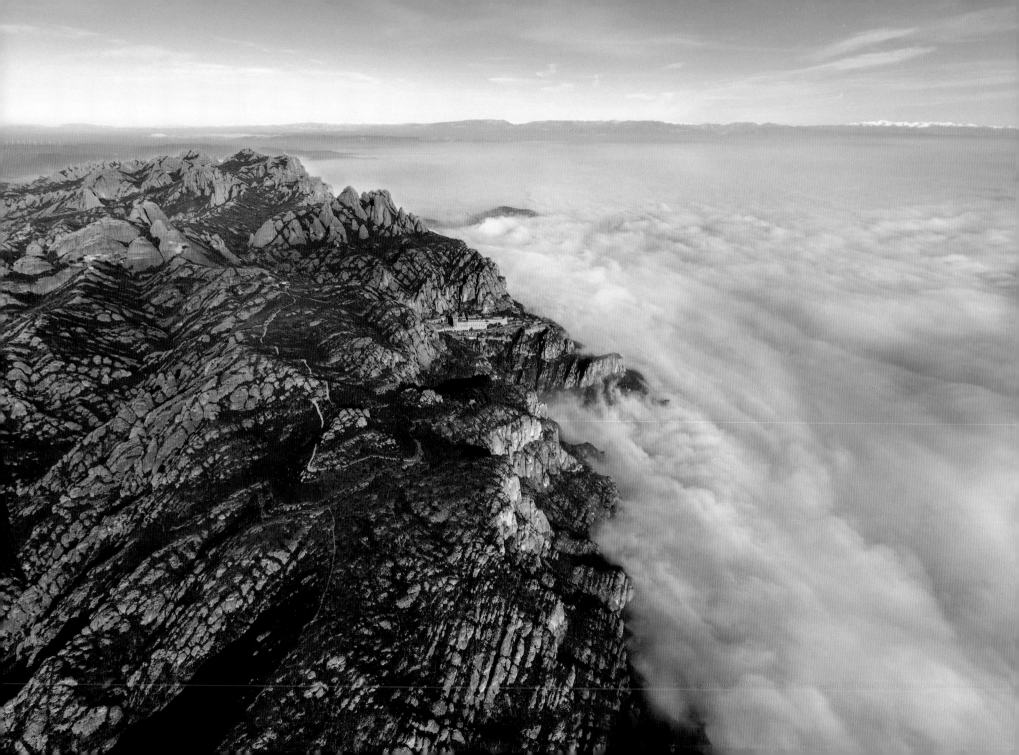

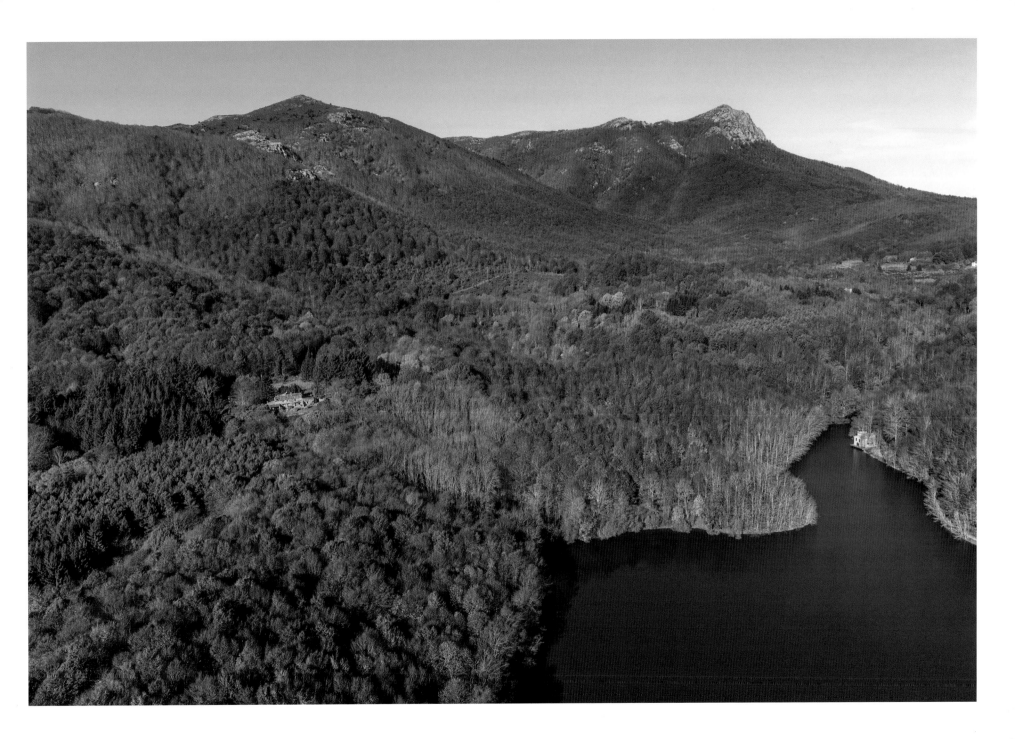

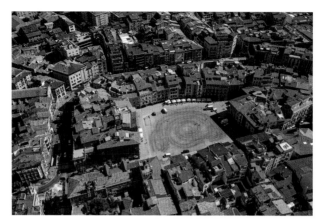

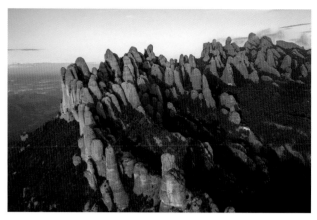

MASIA FREIXA, TERRASSA
41º 33' 46" N, 02º 00' 15" E

In the XIXth century, Terrassa and Sabadell monopolised most of the Catalan textile industry, above all in the woollens sector. The small manufacturers of the XVIIIth century gave way to the large-scale stream powered plants. And architecture did more than just supply facilities for this industry: it created specific building types, often associated with the skilful use of masonry in walls and roofs (the Catalan vault, for example). Many factories from the period are veritable works of art. Josep Freixa, an industrialist from Terrassa, was responsible for a unique case in this respect. In 1896 he commissioned architect Lluís Muncunill to build a set of factory naves, although shortly afterwards he decided to convert them into his family home. Thus, between 1907 and 1914 Masia Freixa was constructed, a magnificent house dominated by parabolic arches and waving roofs in the midst of spacious gardens, the only modernista residential building that resulted from recycling a factory. In 1959 the house and gardens became the public Parc de Sant Jordi.

VIC
41º 55' 49" N, 02º 15' 15" E

Catalan urbanism has recently been marked by the controversy between the advocates of 'soft' squares and those of 'hard' squares (with vegetation or only paved, respectively). In Vic they chose the midway path: an unpaved square though without vegetation. It is a multi-purpose plaza, the site for an animated weekly market and a host of other events. Perhaps the most famous is the Mercat del Ram, a major fair of medieval origin devoted basically to the agricultural sector which takes place each year during the weekend corresponding to Palm Sunday. In any case, the Plaça de Vic is precisely that: a genuine plaza, that is, an open space encompassed by a closed ring of buildings. This is the heart of a city whose history dates back two thousand years, when the Romans and Iberians called it Ausa and the Visigoths Ausona, the natural capital of a *comarca* (small geographical and administrative division encompassing a number of municipalities) justly named Osona. Its history is inseparable from that of Carolingian Catalonia.

THE NEEDLES OF MONTSERRAT
41º 35' 30" N, 01º 50' 16" E

By virtue undoubtedly of its imposing relief, Montserrat has often been associated with the dramatic scenarios generated by the imagination of Richard Wagner. Montserrat is a geological anomaly, or a unique natural phenomenon at the very least, a formation of sedimentary calcareous strata, the remains of marine deposits dating back some 55 million years to the Eocene Period. The erosive action of water as it filters through the crevices and breaks up the rock, in combination with that of the wind, gradually modelled these conglomerates to acquire their bizarre form, hard to associate intuitively with natural processes. Indeed, these almost freakish reliefs seem to be the work of a thoroughly irrational sculptor. The massif soars up to a height of 1,236 metres from a plain that barely reaches 500 metres above sea level.

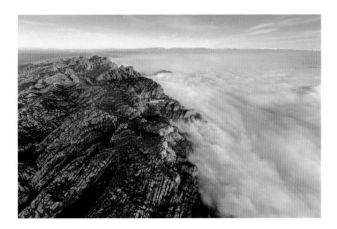

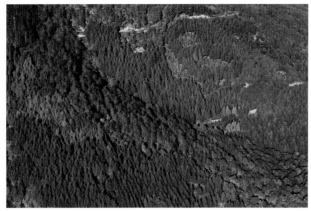

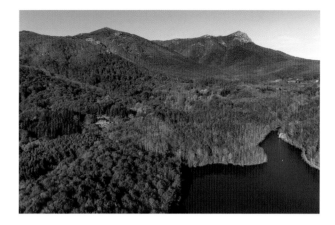

MONTSERRAT ABBEY
41º 35' 30" N, 01º 50' 16" E

The morning fog, which clings to the sheer cliffs of Montserrat, endows the mountain with an eerie atmosphere. The massif, beneath a sunny blue sky, emerges from the sea of clouds that floods the Llobregat valley, rising above the overcast conditions below. These mists, though they do not always produce rainfall, deposit tiny drops of water on the slopes, giving rise to a kind of forest vegetation one would never expect on rocky terrain. Indeed, the ledges where soil has managed to settle are covered with luxuriant evergreen oak woods, a dense, impenetrable Mediterranean forest; meanwhile, pine woods predominate in the more sun-drenched areas. Unfortunately, a series of recent forest fires have caused havoc in these woods. Even so, where the soil remains, the evergreen oak forest soon recovers its former luxuriant presence. A famous sanctuary, linked to the Benedictine Abbey founded in the IXth century, enhances the renown of this mountain, a veritable national symbol for the Catalan people.

THE FORESTS OF MONTSENY
41º 46' 15" N, 02º 27' 56" E

Some five million people live at a distance of less than one hundred kilometres from Montseny. The massif may therefore be described as a high mountain on practically everyone's doorstep. Its extensive forest area covers a total of around 30,000 hectares, from which human settlements are almost entirely absent, except for the occasional hamlet and isolated manor-farmhouse or masia. Since the foot of the mountain stands at barely 300 metres above sea level, all the habitats needed to support Mediterranean, Euro-Siberian and Subalpine vegetation are present here. Therefore we find evergreen oak, cork oak and pine forests in the foothills, oaks, beeches and firs in the high mountain and Subalpine scrubland on the peaks. Local fauna species include the wild boar, fox, genet and dormouse. This natural park was declared a UNESCO Biosphere Reserve in 1987.

LES AGUDES AND SANTA FE DEL MONTSENY
41º 46' 15" N, 02º 27' 56" E

Montseny is one of Catalonia's most popular massifs. Standing at a considerable altitude (1,705 metres at the summits of El Turó de l'Home and Les Agudes), it is located only a short distance away from most of Catalonia's main population nuclei. Consequently, Montseny became emblematic of Catalan excursionisme, a sporting and cultural movement which emerged at the end of the XIXth century with the aim of discovering all Catalonia's natural treasures, particularly in the mountains. Montseny was the ideal place for initiates. Over the years, it has become easily accessible by road, which has further increased its popularity. At 1,080 metres above sea level a rivulet was dammed to create the Santa Fe reservoir, one of the beauty spots that attract most visitors.

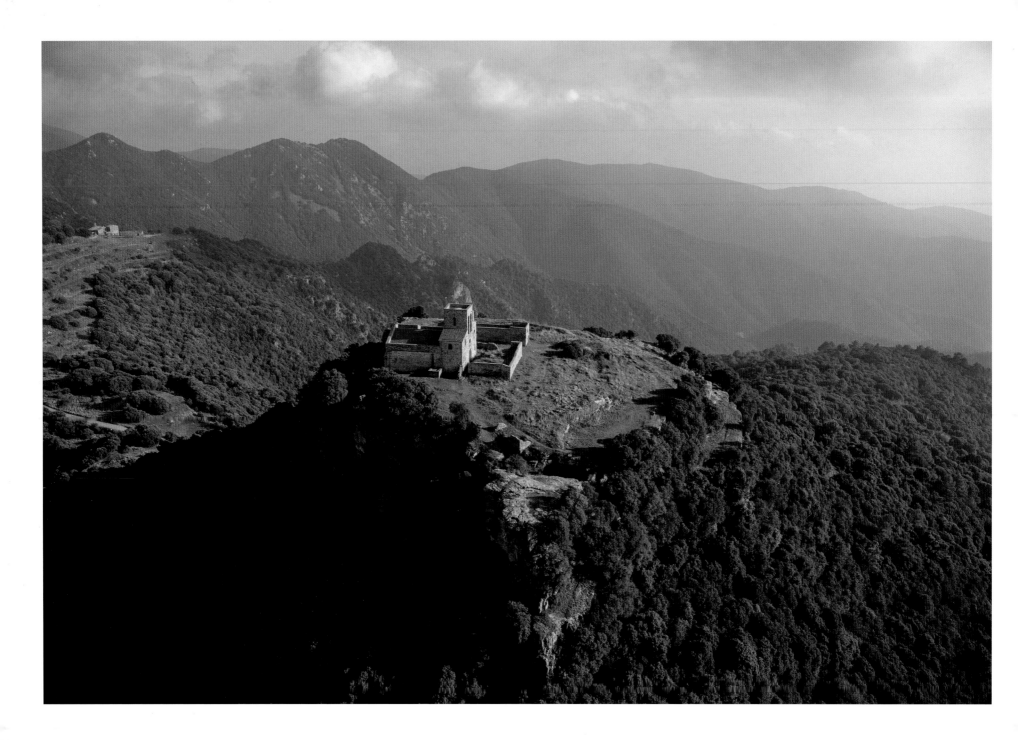

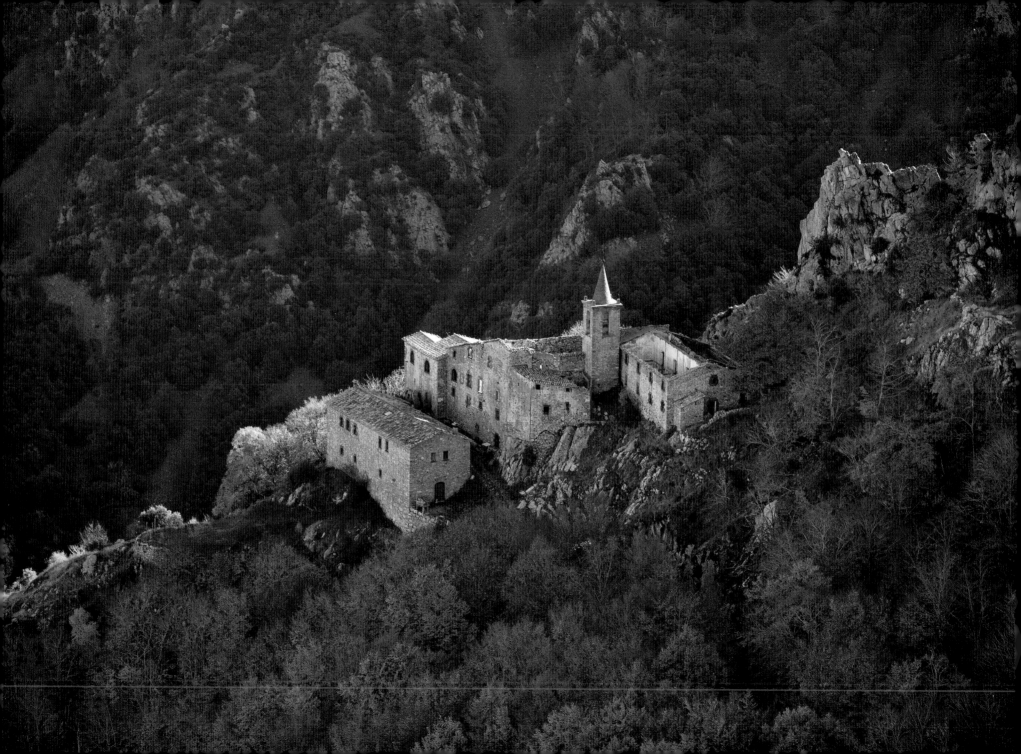

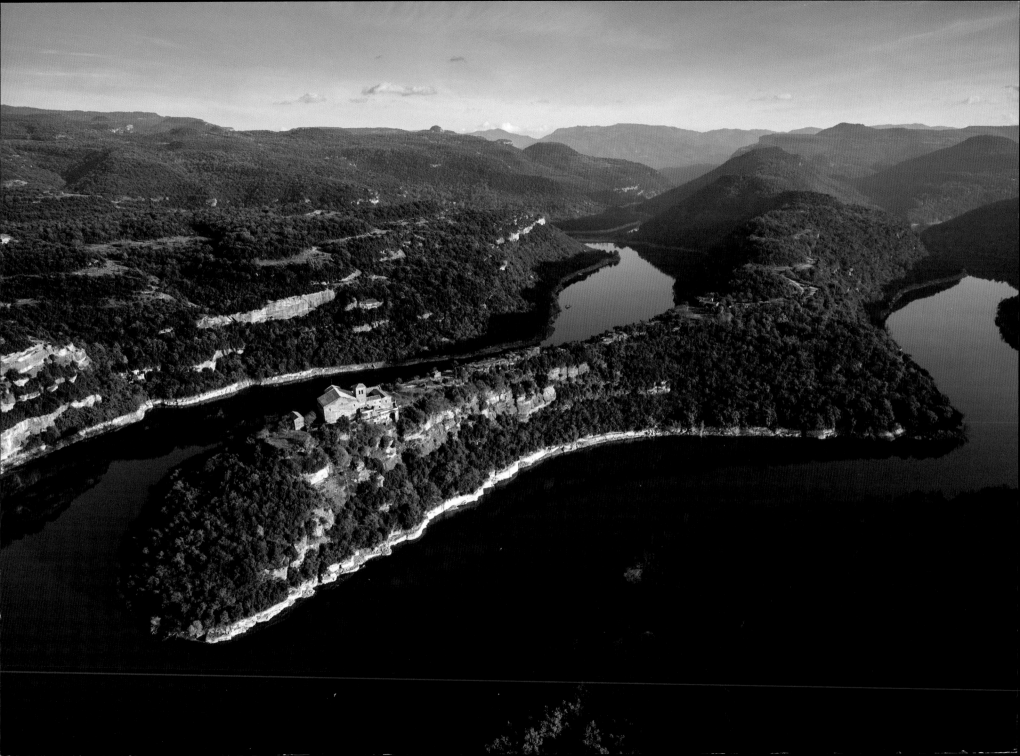

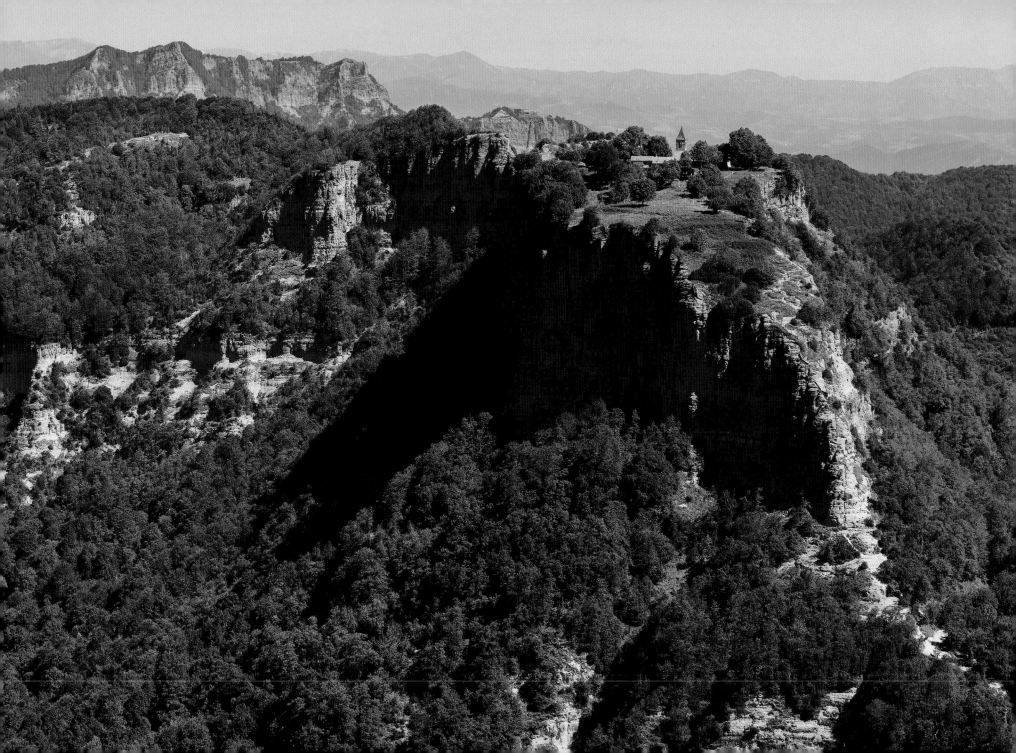

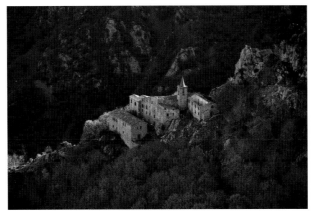

SANTA MARIA DE TAGAMANENT
41º 44' 50" N, 02º 17' 45" E

At the end of the XIXth century a vigorous sporting and cultural move-ment emerged in Catalonia known as *excursionisme*, which consisted of rediscovering the country's hinterlands which had become for-gotten by industrial society, the population having largely emigrated to the towns and cities. Initially, everything was a 'discovery'; later, a number of routes became firmly established. Among the most popular of these was the Montseny massif and, in particular, one of its foothills, Tagamanent. This beauty spot, within easy reach of most *excursionistes*, is crowned by the ruins of a castle, inside which stands the Church of Santa Maria, currently in good conditions though disused. The complex dates back to the Xth century, although it has undergone many modifications over the ages.

SANT SEGIMON SANCTUARY
41º 49' 18" N, 02º 21' 17" E

Sigismund, King of the Burgundians who became converted to Chris-tianity, was murdered by Chlodomer, King of the Franks, in 524. As a result, he soon became venerated as a saint and in Carolingian times worship of him spread to Catalonia, where it remained for centuries. Between the XVIIth and XVIIIth centuries a sanctuary was built in his honour in the heart of the Montseny massif, at an altitude of 1,230 m on a practically inaccessible site. During the 1936-1939 Civil War, the sanctuary was plundered and the adjoining hostel abandoned. The complex is now undergoing reconstruction. Thanks to a new road, it is now possible to reach the sanctuary easily for the first time in its history. The sanctuary of Sant Segimon is an interesting example of post-industrial society's eagerness to recover elements from its past. Furthermore, the site has provided the name for an exquisite wild flower, *herba de Sant Segimon* (Saxifraga vayredana), which is found only on Montseny.

THE SAU RESERVOIR
41º 58' 08" N, 02º 24' 34" E

Sant Romà de Sau is a ghost church. It appears, vanishes and reap-pears when you least expect it to. In 1962 it became submerged beneath the waters of the Sau reservoir, on the River Ter, together with the picturesque village over which it presided. The village has disappeared completely, but the belfry of the XIth-century Roman-esque church staunchly lives on. When the reservoir is full, only the tip of the spire emerges, an architectural element added relatively recently. In periods of low water, however, the entire belfry and what remains of the church emerge; in fact, it is even possible to reach them on foot. The Sau, Susqueda and El Pasteral chain of reservoirs not only serves hydroelectric purposes but also supplies water to most of the Barcelona area, 75 km to the south-west.

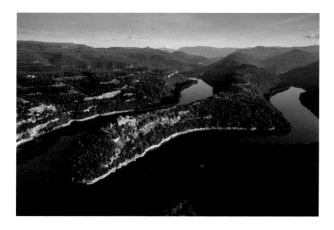

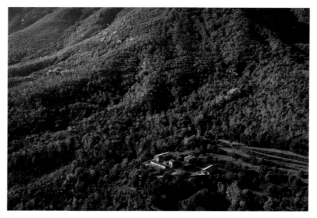

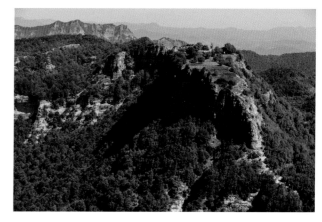

SANT PERE DE CASSERRES MONASTERY
42º 00' 05" N, 02º 20' 26" E

Towards the end of the IXth century, and taking advantage of the natural shelter afforded by a pronounced curve in the middle stretch of the River Ter, the Viscounts of Osona decided to build a castle on the site. Over one century later, in 1006 Viscountess Ermetruit of Osona, with the approval of her husband Count Ramon Borrell of Barcelona, donated the castle to the Benedictines so that they might convert it into a monastery. This was the origin of Sant Pere de Casserres (first as a Benedictine priory and later a Jesuit property), until it was secularised at the end of the XVIIIth century. The surviving church, of considerable dimensions for the time, was consecrated in 1050. It is a characteristically Benedictine Romanesque building with a secluded cloister, recently rebuilt from original elements. Construction of the Sau reservoir, at the far end of which stands Sant Pere de Casserres, further accentuated the isolation of the monastery, which is accessible from a single picturesque road.

LES GUILLERIES
41º 50' 15" N, 02º 26' 21" E

Joan de Serrallonga was a notorious outlaw whose misdeeds became legendary during the early XVIIth century. He was born in Viladrau, in the subcomarca of Les Guilleries, at that time an area of impenetrable forest land which is still among the densest of its kind in Catalonia. Serrallonga, whose real name was Joan Sala, knew these woods like the back of his hand and in their vastness he always found an abundance of hideaways. Like him, other bandits ravaged the farmsteads in the area, tiny population nuclei scattered throughout the woods in which people eked out a living through subsistence agriculture on small plots around their homes. Some of these farmsteads still exist today, many of which now engage in rural tourism. Indeed, the beauty of deciduous forests in the shaded areas and evergreen species on the sunny side enchants visitors.

CABRERA SANCTUARY
42º 04' 24" N, 02º 24' 28" E

Few places remain in Catalonia that cannot be reached by car. All villages and the vast majority of hamlets, farmsteads and sanctuaries are perfectly accessible by road, although there are exceptions, one of which is the Cabrera sanctuary. Totally surrounded sheer cliffs, the sanctuary stands on a table-top of just over one hectare at an altitude of almost 1,300 metres, a kind of Mediterranean-scale tepui. The sanctuary dominates the magnificent landscape of the entire Serra d'Aiats, from the Vic plain to the Olot valley, which makes it worth the effort to climb up there on the steps cut into the rock in 1952 or else by following a very steep path. The sanctuary and its adjacent lodge are truly charming, though humble, constructions which in the XVIIth and XVIIIth centuries replaced the former castle and church, which collapsed during the earthquake that devastated the area in 1428.

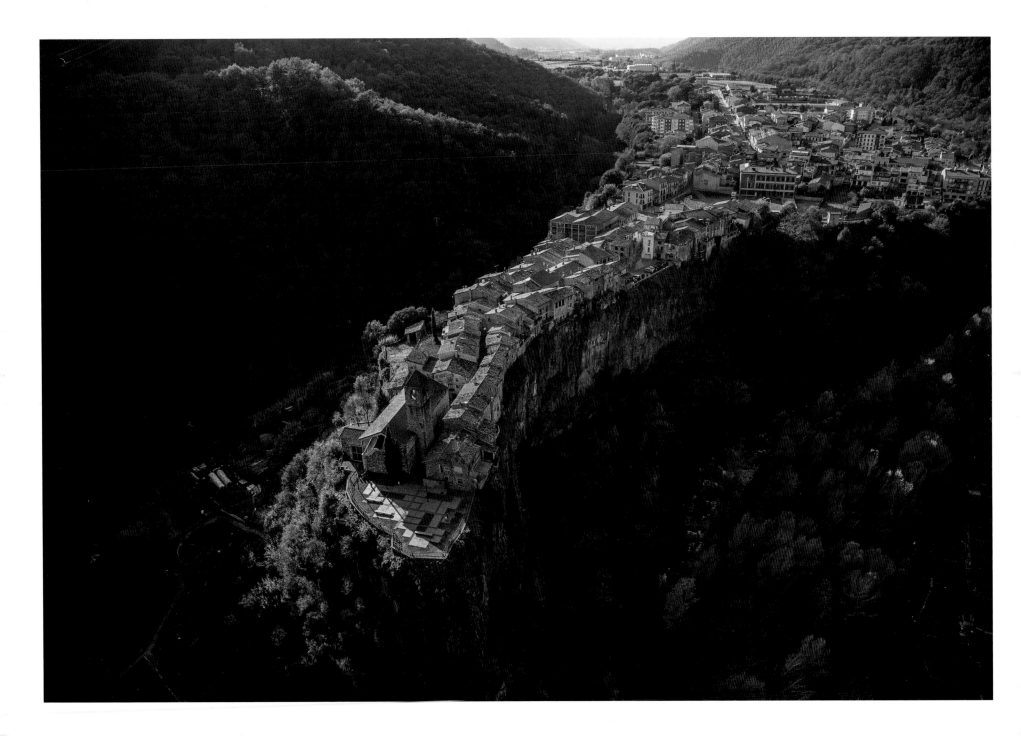

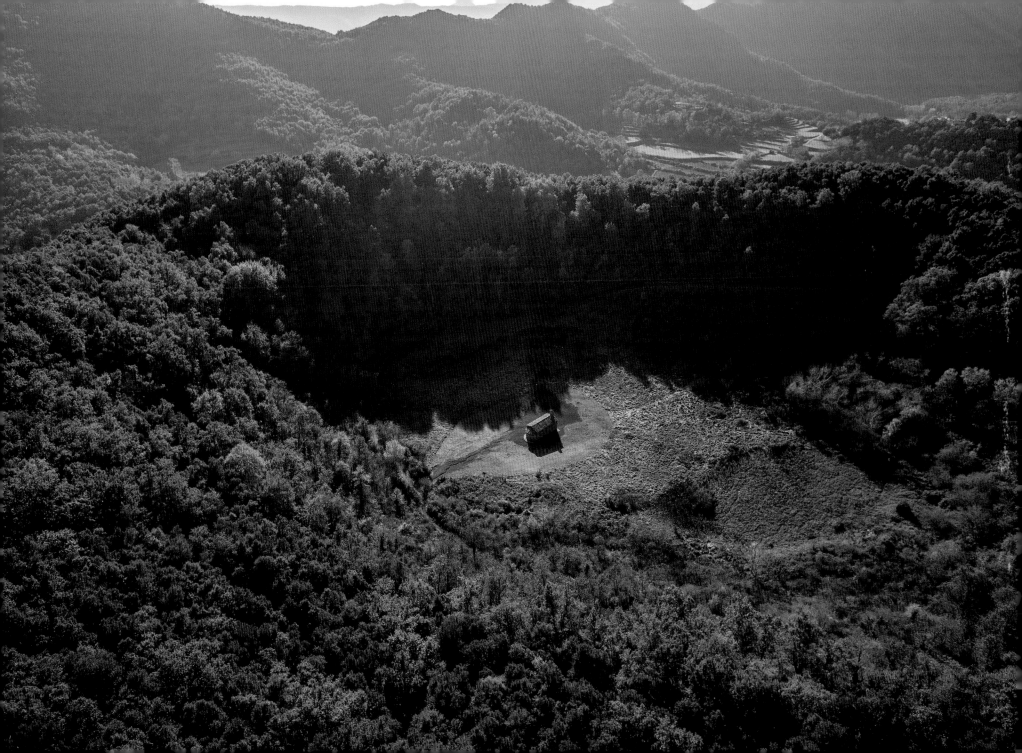

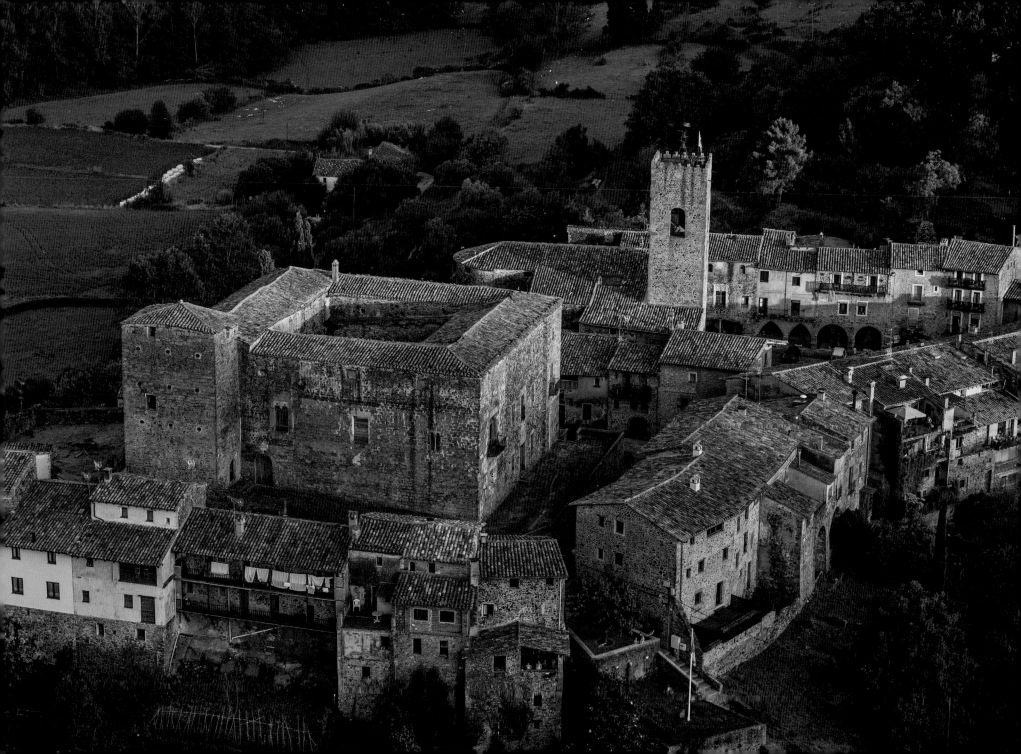

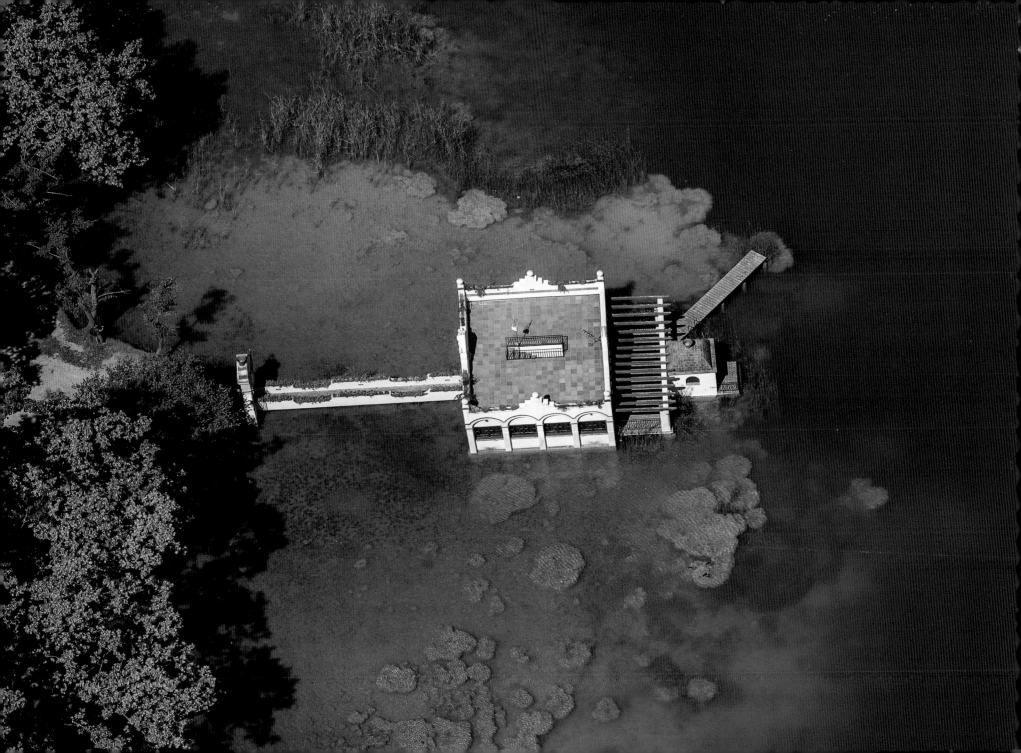

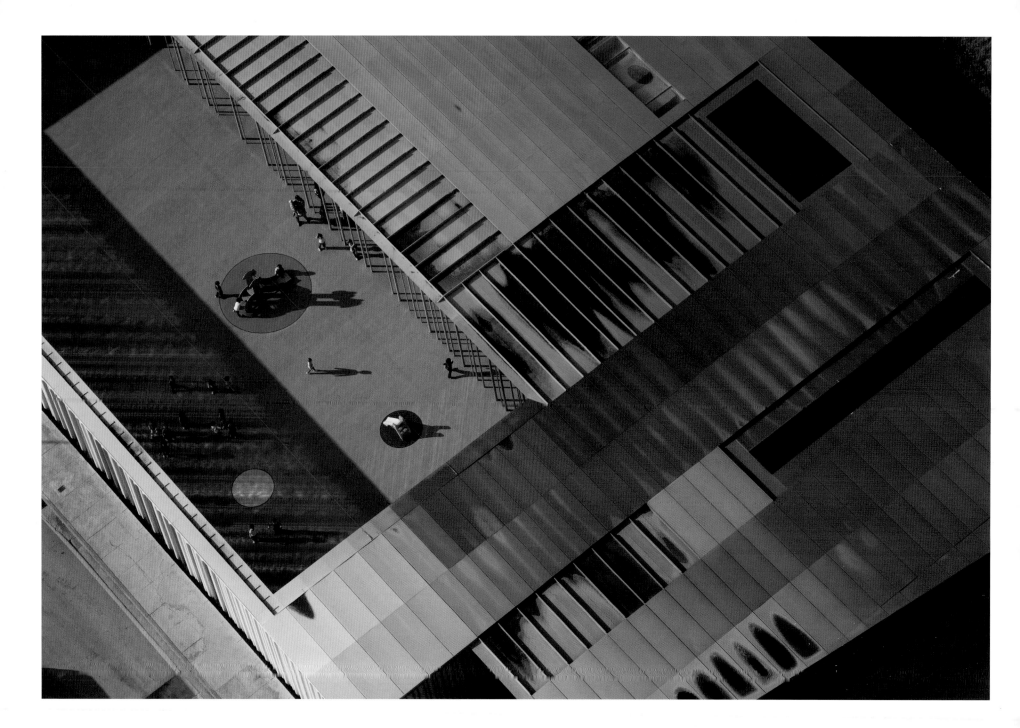

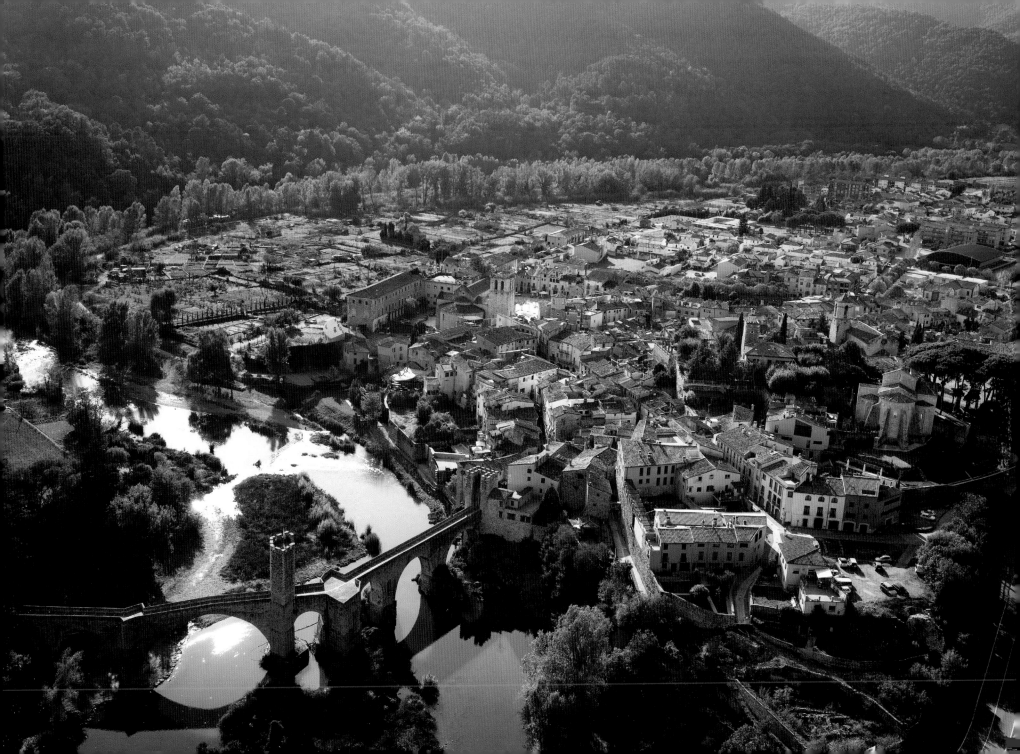

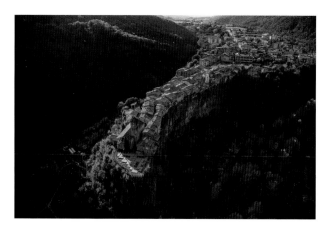
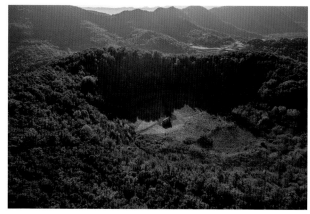
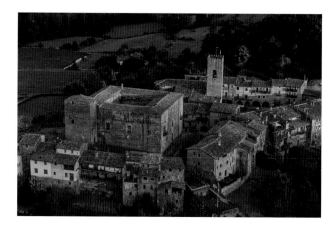

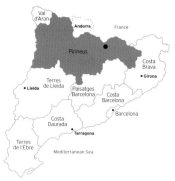
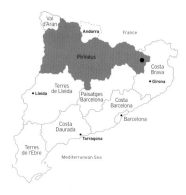
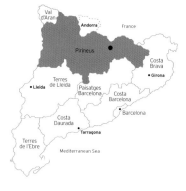

CASTELLFOLLIT DE LA ROCA
42º 13' 17" N, 02º 33' 03" E

Around 200,000 years ago, volcanic activity was intense in the comarca of La Gar-rotxa. Two lava flows, separated by a period of 25,000 years, gave rise to a set of remarkable basalt columns which thanks to erosion caused by today's Fluvià and Toronell rivers are now thoroughly exposed to view. The result is a truly natural castle which, in the Middle Ages, made a naturally protected human settlement possible: Castellfollit de la Roca. And although the village was destroyed by an earthquake in the XVth century, people eventually went back there. Today around one thousand inhabitants live in the centre of one of Catalonia's smallest townships: only 0,73 km^2 in area. However, its grandeur cannot be measured quantitatively, since it lies in the matchless beauty of its colonnades —fifty metres tall and over one kilometre long— and its location at the confluence of two rivers.

SANTA MARGARIDA VOLCANO
42º 08' 29" N, 02º 32' 29" E

In what is the present-day comarca of La Garrotxa, volcanic eruptions occured during the period from 300,000 (and as far back as 700,000) to 10,000 years ago. Forty-or-so cones have remained, some with clearly visible craters despite the vegetation that has gradually colonised the area over the ages. One of the most recent episodes, which took place 11,000 years ago, gave rise to the best preserved of all the local craters, pertaining to the Santa Margarida volcano. Fruit of that eruption is a cone that rises some eighty or ninety metres from the plain, reaching an altitude of almost seven-hundred metres above sea level. The crater has a perimeter of around two kilometres. On the crater floor a small Romanesque church was built, Santa Margarida de Sacot, which was severely damaged by the seismic movements that affected the comarca in the XVth century, though it has now been reconstructed. The Santa Margarida volcano, like the rest of the cones and solidified lava flows in the area, forms part of the Parc Natural de la Zona Volcànica de la Garrotxa.

SANTA PAU
42º 08' 40" N, 02º 34' 18" E

Santa Pau is a volcanic town. All the buildings in the old centre are of stone obtained from the surrounding extinct volcanoes: Rocanegra, Puig Subià, Simó and others. This endows them with a dark, severe air, though they are captivating at the same time. In the Santa Pau valley, on either side of the River Ser, people have been living for millennia, since just after the last volcanic eruptions that took place some ten thousand years ago. The town of Santa Pau, however, was built later. It is a typical medieval urban nucleus, fruit of the agglutination of existing scattered hamlets. The historical centre, which dates back to the XIIIth and XIVth centuries, is presided over by the massive presence of the castle, a historical possession of the local minor nobility. The parish church, the magnificent arcaded square and several tortuous streets complete the urban complex. A considerable part of the Parc Natural de la Zona Volcànica de la Garrotxa, including the Santa Margarida volcano, belongs to the municipality of Santa Pau.

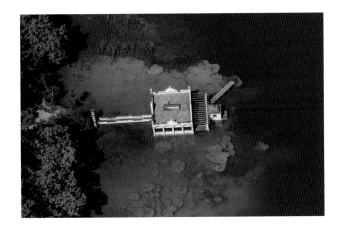

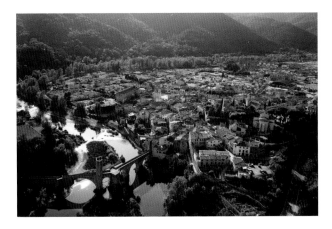

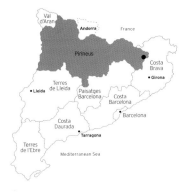

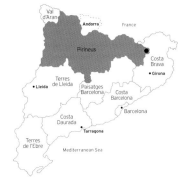

BANYOLES LAKE
42º 07' 30" N, 02º 45' 17" E

There are no big lakes in Catalonia; on the other hand, there is a considerable number of small ones, most of which are in the Pyrenees. The largest is Banyoles Lake, with a surface area of some 112 hectares. It is not these modest dimensions that make it notable, however, but rather its karstic origins. Banyoles Lake actually consists of two basins that have merged together, the deeper of them plunging down to a depth of 62 metres. Unlike in the majority of lakes, the water does not enter at the surface but at the bottom. The lake is the overflow of a large karstic system (subterranean caves and cavities gouged out by multi-secular dissolution of the calcareous rock). The rainfall that gathers in the surrounding ring of mountains runs into the cavities and eventually emerges in the lake, in fact in a system of lakes, the most important of which is the one at Banyoles. Back in Neolithic times, seven thousand years ago, some palaphytic settlements already existed beside the lake; today, only a few fishing structures stand on the water.

CONTEMPORARY ARCHITECTURE IN BESALÚ
42º 12' 09" N, 02º 42' 00" E

Hard by medieval Besalú stands the El Petit Comte kindergarten, a radically modern building designed in 2005 by RCR Arquitectes, the internationally renowned Olot architecture studio run by Ramon Vilalta, Carme Pigem and Rafael Aranda. They like to say that theirs is a landscape architecture, the textures and colours of which are often those of its immediate surroundings. With El Petit Comte they sought to create an interplay of light, reflections, superimpositions and colours, a way of creating a space in which the gaiety of children combines with the gaiety of architecture, a space which, like children, counters the severe adult world with naive impertinence. The result is a singular building which, nonetheless, may rarely be seen from the air.

BESALÚ
42º 12' 09" N, 02º 42' 00" E

Eight different arcades, in zigzag formation, cross the River Fluvià and provide access to the town of Besalú. This is one of the most emblematic bridges in Catalonia as well as one of the oldest, longest suffering and most transformed. The first records of it date back to the XIᵗʰ century, and since then, numerous extensions and modifications have changed its appearance. Even so, it still preserves its original bearing as an imposing fortified Romanesque bridge. Besalú was the capital of one of the first Catalan counties, in Carolingian times. The bridge, the Monastery of Sant Pere, several medieval palaces and churches, such as those of Sant Vicenç and Sant Julià, and the Jewish baths, embedded in a medieval urban layout, attest to this comital past. Sieges and wars have given way to a quiet town, an important tourist centre on the Fluvià and the Capellades, the two rivers that supplied the name of the original Roman town: Bisoldunum.

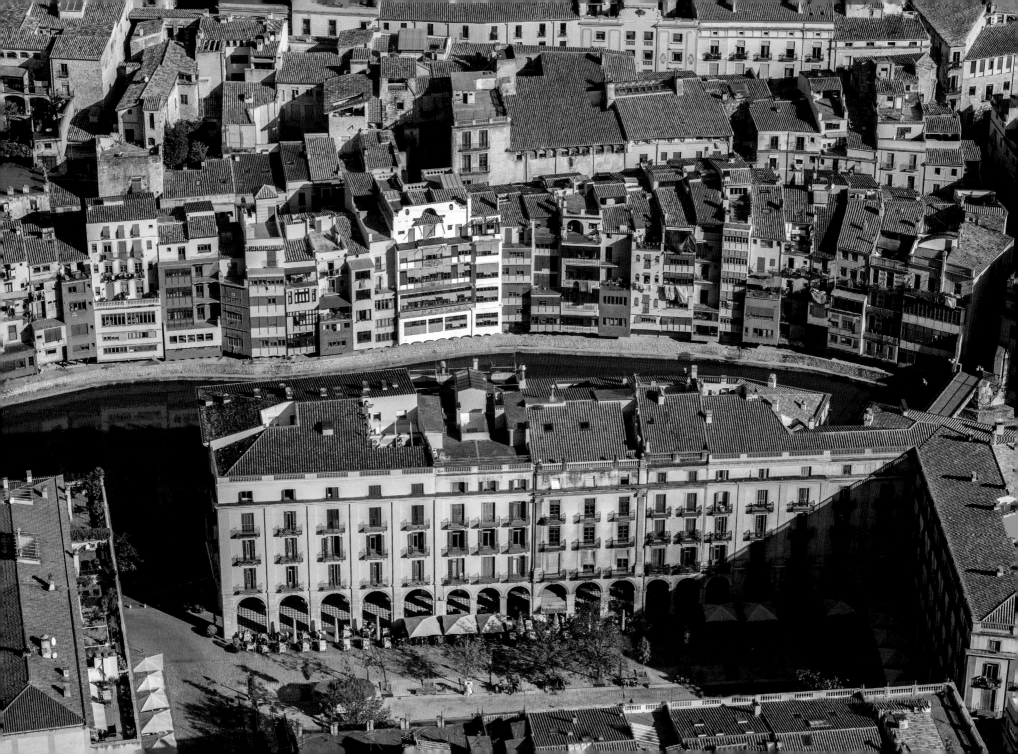

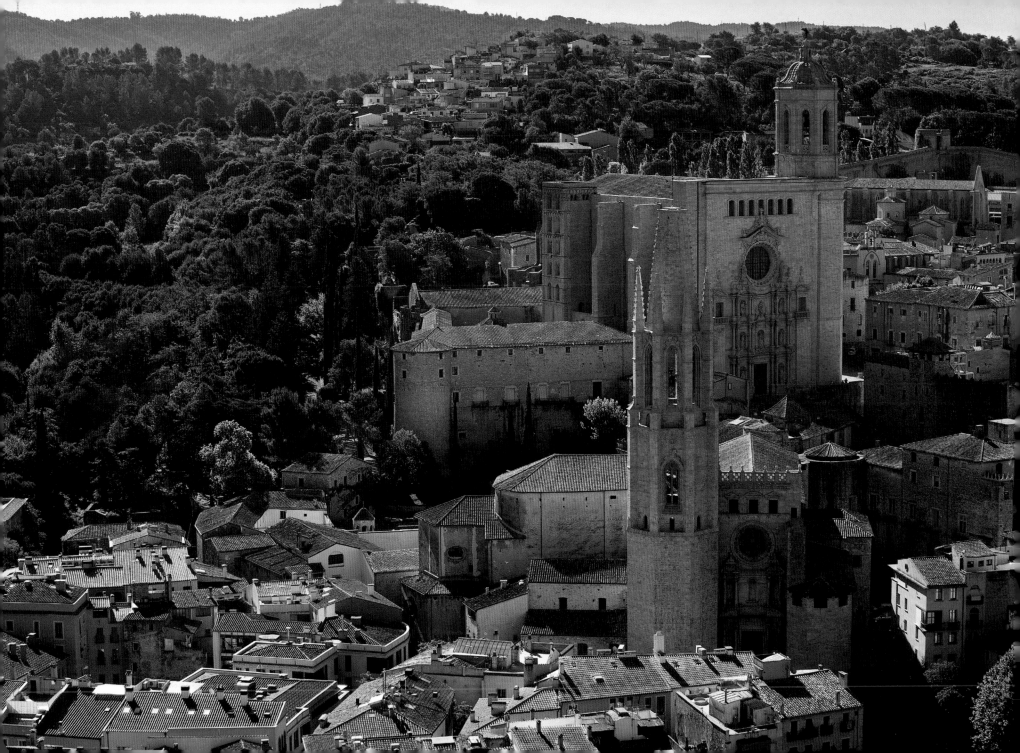

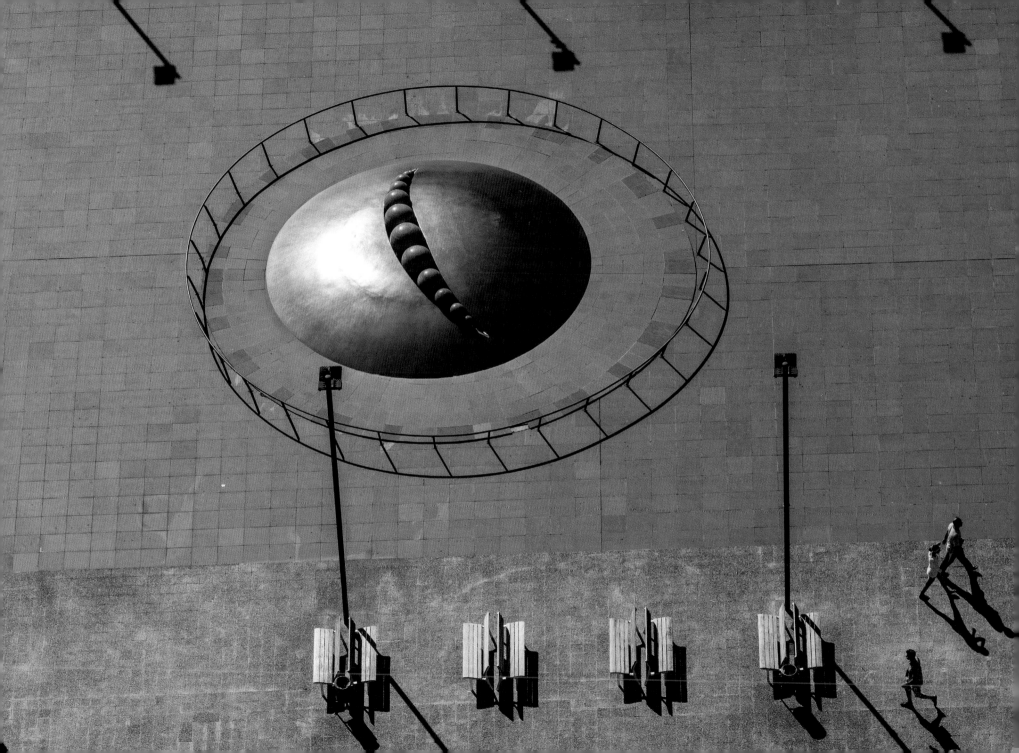

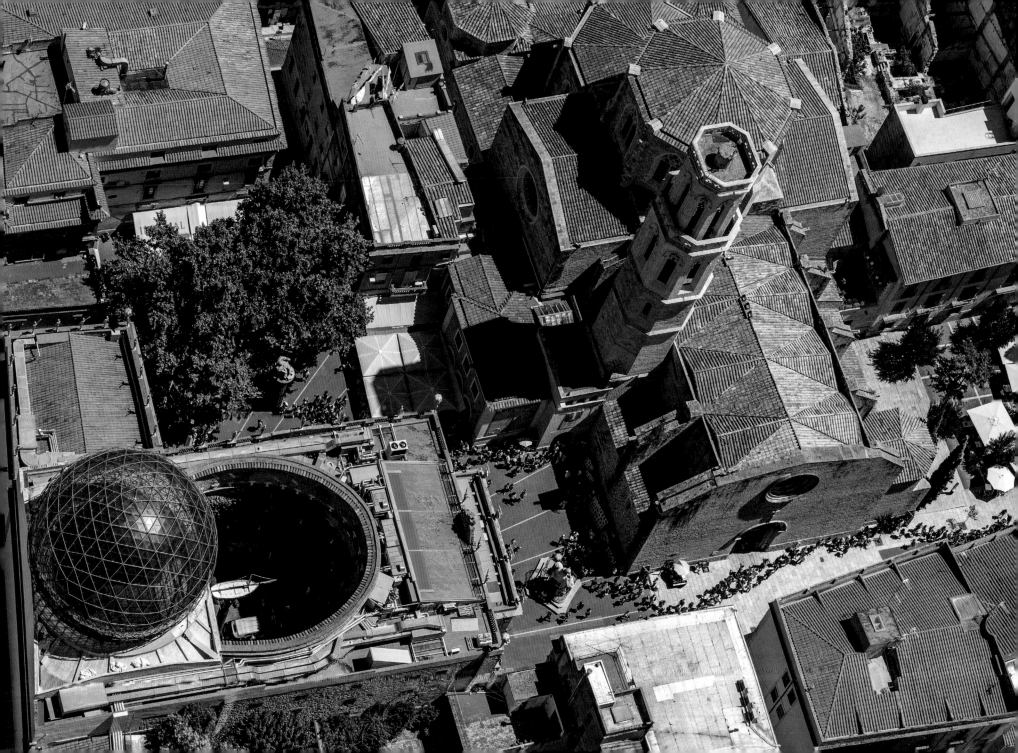

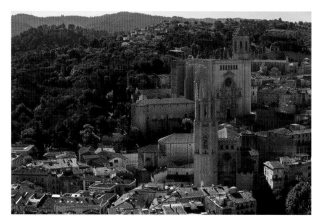

RIVER ONYAR, GIRONA
41º 59' 09" N, 02º 49' 25" E

Girona stands at the confluence of four rivers: the Ter, the Onyar, the Güell and the Galligants. The most important of these is the Ter, which leaves the city having been fed by the other three, although it is the Onyar that crosses the city from one end to the other. Nonetheless, Girona turns its back on the Onyar, as many cities formerly did with their rivers, which were regarded as mere transporters of often polluted water. For this reason, it is not the front façades of the riverside buildings that look over the water but their rears, which are unsophisticated from the architectural point of view. Tastes change, however, to the point where urban rivers are now becoming increasingly cherished. Hence the fact that Girona has restored these rear façades and given them a facelift, and the resulting coloured mosaic is now one of the city's most attractive features. The narrowness of the old houses on the right bank contrasts with the dimensions of their XIXth-century counterparts on the left bank.

THE BASILICA OF SANT FELIU AND GIRONA CATHEDRAL
41º 59' 18" N, 02º 49' 29" E

Felix, born in Scillium (Carthage) and converted to Christianity, was martyred in the city of Gerunda, today's Girona, victim of the persecution decreed by the Emperor Diocletian in 303. Consequently, when Girona still lacked a cathedral, the city's main church was that of Sant Feliu (or Sant Fèlix), a basilica that dates back to the earliest Christian times (a number of Palaeo-Christian sarcophagi are embedded in its walls). Today's fine Gothic building —which houses the Gothic tomb of Sant Narcís, patron saint of the city— was constructed in the XIVth century on the ruins of an earlier Romanesque structure. Almost right by its side, on a site further up and at the head of an imposing staircase, stands the Cathedral of Santa Maria, also Gothic (XIVth-XVth centuries), though with a Romanesque belfry and cloister (XIth century) and a baroque belltower and façade (XVIIth-XVIIIth centuries). Its single nave is the widest Gothic nave in the world: 22.98 m.

SANT GREGORI
42º 00' 05" N, 02º 44' 32" E

Sant Gregori is a small town in Girona's urban hinterland, fruit of the fusion between several tiny population nuclei: Sant Gregori itself, the main nucleus, together with Talaià, Domeny, Ginestar and others. Its total population stands at around 3,500. In the near vicinity of Girona there are a number of townships of similar characteristics which were once perfectly distinguishable from the city proper although now they have either become absorbed into the urban continuum or else constitute residential green zones. In search of this combination of open space and urban proximity, in 1980 an institution devoted to caring for the mentally challenged settled in Sant Gregori. Gradually, it has constructed a set of buildings and facilities in which respect for the environment and creation of the landscape form part of an educational strategy. Today, the centre occupies a spacious complex characterised by innovative architecture.

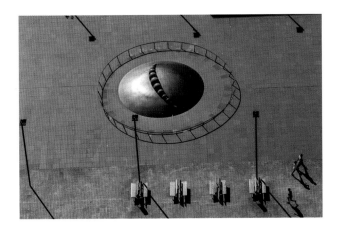

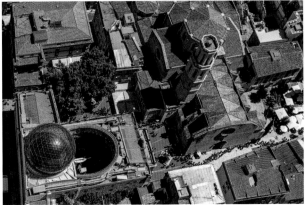

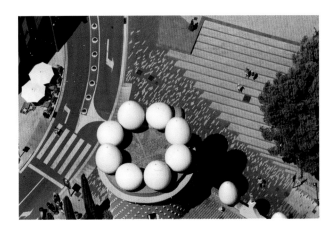

PLAÇA DE VICENS VIVES, GIRONA
41º 59' 13" N, 02º 49' 21" E

Old Girona, known as the Barri Vell, stands to the right of the Onyar. This splendid Roman and medieval quarter preserves Europe's most important Carolingian walls. The opposite side, on the other hand, constitutes the site for a modern urban extension, regardful of contemporary aesthetic trends, with many of its public spaces adorned with avant-garde decorative elements. A striking example would be *Aelon*, a piece sculpted in 1992 by Badalona artist Gabriel Sàenz Romero, an enigmatic steel, grey stone and black granite composition that stands in Plaça de Jaume Vicens Vives. Over the ages, Girona has had time enough to combine different artistic and architectural styles, having been founded around 77 BC as a humble military *oppidum* on the Undarius (Onyar) by the famous Roman general Pompey the Great. It underwent Germanic, Visigothic and Moslem invasions until it became Carolingian and, eventually, Catalan. It is now one of present-day Catalonia's most interesting and dynamic cities.

SANT PERE DE FIGUERES
42º 16' 05" N, 02º 57' 34" E

At the end of the IInd century BC, Roman troops who had made landfall at the ancient Greek colony of Emporion built a small settlement in an inland marsh area, which they called Joncaria. It was razed to the ground by the Franks in the IIIrd century AD, but its former inhabitants built a new settlement in the near vicinity, hard by the Via Augusta, which remained until it was sacked and destroyed by the Moors. It was reborn with the peace of Charlemagne and, by the beginning of the IXth century, the town of Ficerias had come into being, which would eventually become medieval Figueres, built around the Church of Sant Pere, construction of which began in the Xth century. Sant Pere still constitutes the centre of the city, capital of the Alt Empordà. In the XIXth century, the Teatre Municipal was built alongside the church.

MUSEU DALÍ, FIGUERES
42º 16' 05" N, 02º 57' 34" E

The old Teatre Municipal of Figueres, built in 1850, was partially destroyed in 1939 at the end of the Spanish Civil War. And so it remained until, after a laborious refurbishment operation conducted between 1961 and 1974, it became the Teatre Museu Dalí. The Museum houses part of Salvador Dalí's oeuvre, although the artist felt that the main exhibit was the theatre itself. Indeed, on the ruins from the past Dalí created a surrealist building, a metaphor of his entire career. It is now one of Catalonia's most visited museums. Salvador Dalí was born in Figueres in 1904 and died there in 1989; he is buried in the Museum itself. In fact, he spent much of his life in the Alt Empordà, specifically in Figueres, the capital of the comarca, Portlligat and Púbol. One of the most universal Catalans spent many of his days as a kind of recluse in the Empordà.

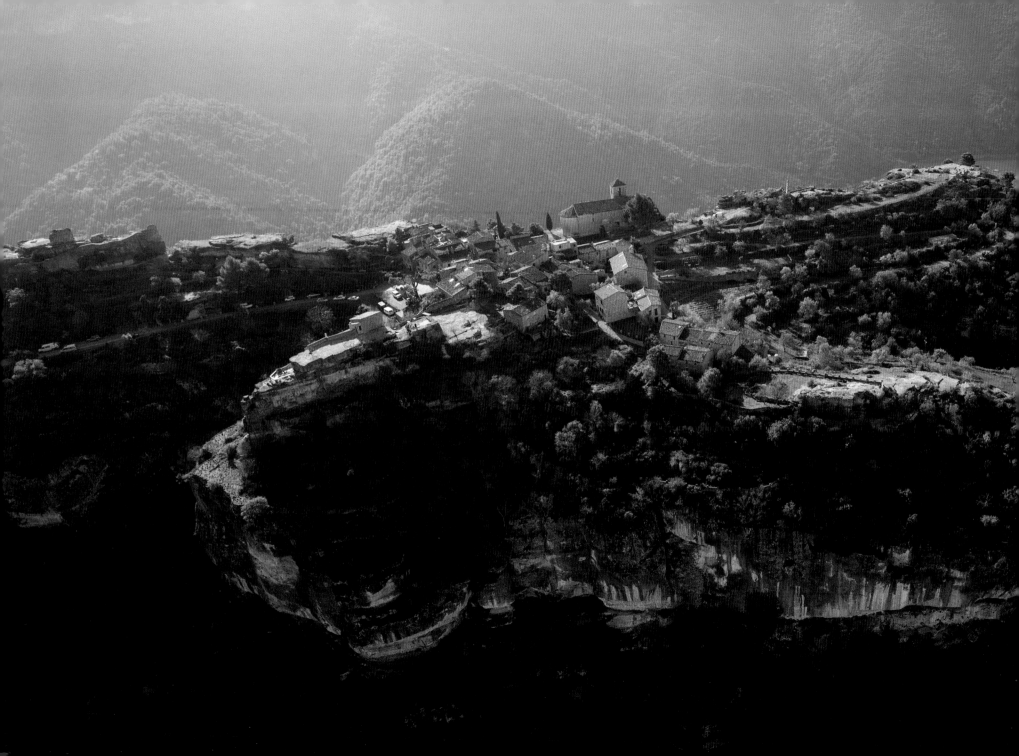

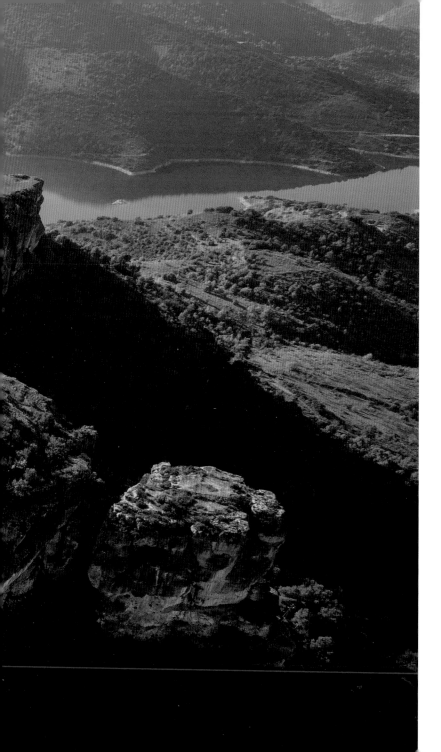

INLAND

IN APRIL, ONE DROP
IS WORTH A THOUSAND

In Middle Europe irrigated land is a rare phenomenon, simply because it is unnecessary. Rain falls regularly on the cultivated fields, both in the depths of winter and at the height of summer. The climate is more benign in the Mediterranean in terms of temperatures, which are mild all year round, though not in terms of rainfall. The Mediterranean climate is characterised by relatively wet springs and autumns, whereas the winters, and above all the summers, tend to be extremely dry. Consequently, the cultivated fields of the Mediterranean must be watered.

However, water is not always available for irrigation purposes. In such cases there is no alternative but to renounce vegetable plots and fruit orchards in favour of other species better adapted to Mediterranean summer droughts. These species include olive and almond trees, vines, and wheat and barley. These winter cereals, called thus because they are sown precisely in the winter, grow in the spring, when rain is plentiful, and die laden with grain when summer comes, right at the beginning of the dry season. The spring rains are therefore crucial to cultivation of these crops, as the old adage goes: 'a l'abril, cada gota val per mil' (In April, one drop is worth a thousand).

Inland Catalonia, south of the Pyrenees and west of the Serralada Prelitoral, the so-called Depressió Central, is particularly prone to the extreme conditions of the Mediterranean continental climate. The winters are bitterly cold with permanent frost. And the summers are very hot and dry. The vegetation, therefore, suffers from serious hydric stress. Furthermore, the terrain is uneven, except on the great central plain of the Segrià and Urgell regions. Thanks to the efforts of generation after generation, however, these problems were partially overcome with the construction of terraces supported by dry-stone walls and by diverting water from the River Segre into irrigation canals on the central plain.

Today, any satellite image of these plains will reveal how they have been transformed into gardens. Dry-land cereals have been ousted by maize and olive or almond trees by sweet-fruit orchards or alfalfa. Irrigated lands have changed the face of continental Catalonia. Even so, a broad mountainous periphery remains unaltered, ever on the lookout for scarce spring rains.

TERRACES IN THE RIBERA D'EBRE REGION | 41º 13' 19" N, 000º 37' 27" E

Contour lines appear on the agrarian landscape of southern Catalonia in the form of dry-stone walls that support narrow terraces of cultivable land.

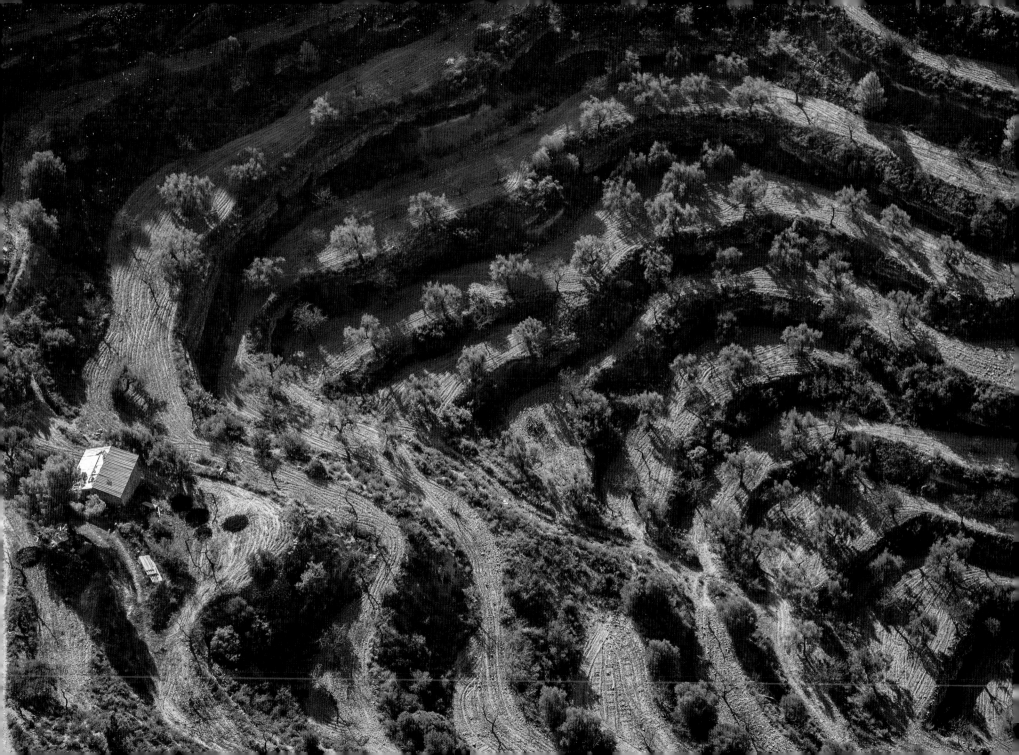

HIDDEN TREASURES

Inland Catalonia coincides largely with what is referred to as Catalunya Nova, that is, the lands of Al-Andalus (the taifas of Lleida and Tortosa) reconquered by the Catalan counts between the XIth and XIIIth centuries. The restructuring and re-Christianisation of these territories was entrusted largely to the Cistercian monasteries, particularly those of Poblet, Santes Creus and Vallbona. Of these, splendid Gothic constructions remain, in combination with other civic and religious buildings, such as the Seu Vella (Old Cathedral) in Lleida and Bellpuig de les Avellanes friary, in the county of Urgell. It makes sense to describe inland Catalonia as Cistercian.

However, alongside these recognised treasures of religious architecture, inland Catalonia hoards a vast scattered treasure in the form of farming architecture. In order to create relatively flat fields on sloping land, the relief had to be modified. The terrain subsequently became filled with thousands of kilometres of dry-stone walls and a variety of rural constructions, such as refuges, cisterns and so on, made from stones fitted together without the use of mortar or any other fixing element. This meant meticulously selecting each stone so that it would combine with others in a stable way, thereby transforming a heap of rocks into a solid wall. This gargantuan task, fruit of the efforts of generation after generation, has resulted in a singular agrarian landscape so well integrated into the natural environment that it is hard to imagine that the hand of man was involved.

Where the soils were particularly stony or poor, the idea of converting them into cultivated fields was ruled out and the natural vegetation was left to itself. This gave rise to another kind of landscape, composed of irregular fields surrounding these stony 'islands' populated by shrubs and low-growing evergreen oaks. This fostered a high degree of ecological stability, with primitive nature thriving on tracts of land between cultivated fields.

Until only a few years ago, all these dry-farming lands, stone walls and rocky places between sown fields were regarded with indifference or even contempt. However, more sensitive souls have discovered the beauty of this agricultural terrain and its great historical and heritage value. The whole of inland Catalonia is a vast landscape treasure, concealed from discourteous or insensitive eyes. It is well worth discovering.

FLOCK OF SHEEP | 42° 02' 40" N, 000 42' 21" E
Large flocks of sheep, Mediterranean livestock par excellence, roam the dried-up pastureland of inland Catalonia, grazing also on the grass that manages to grow sparsely among the stubble.

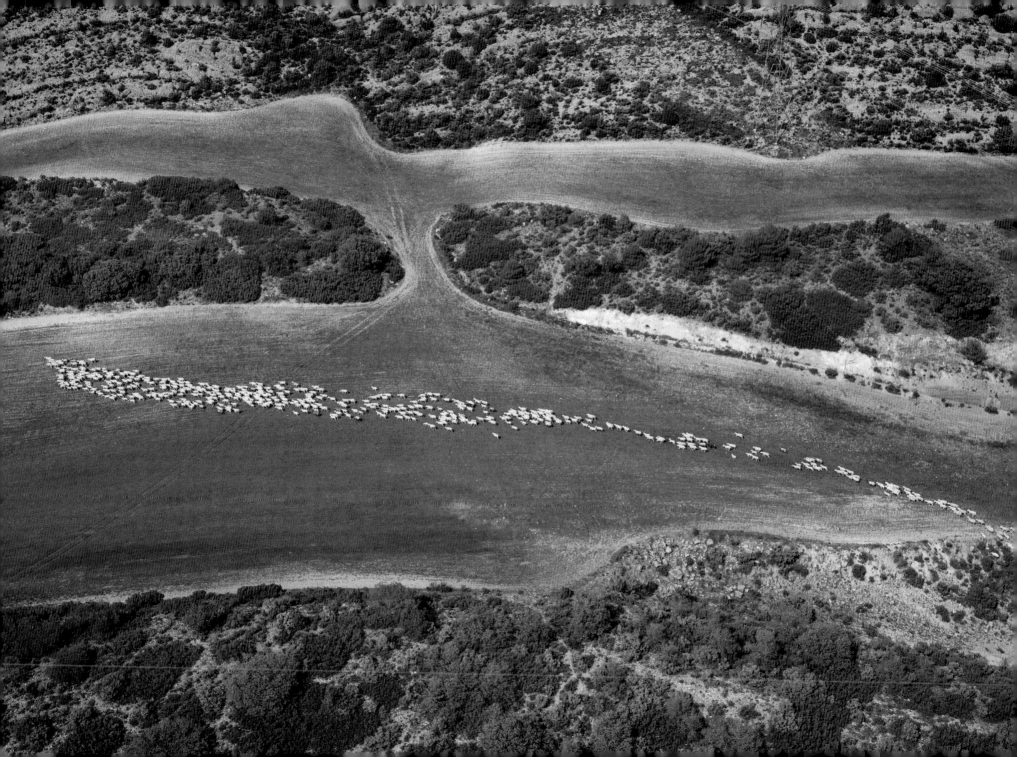

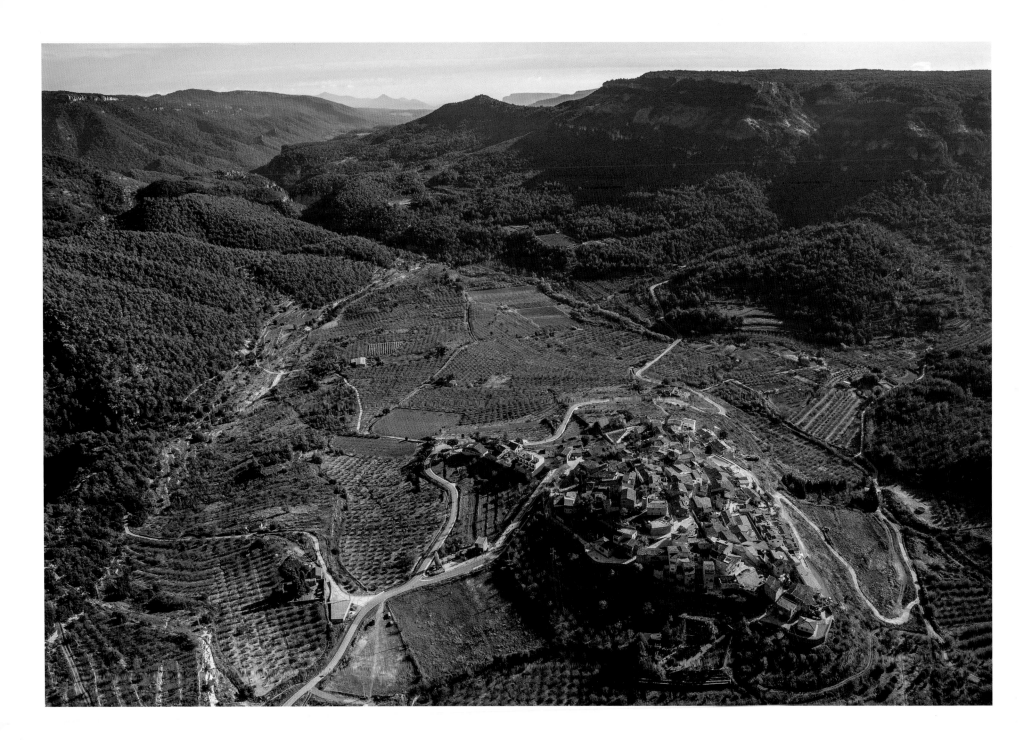

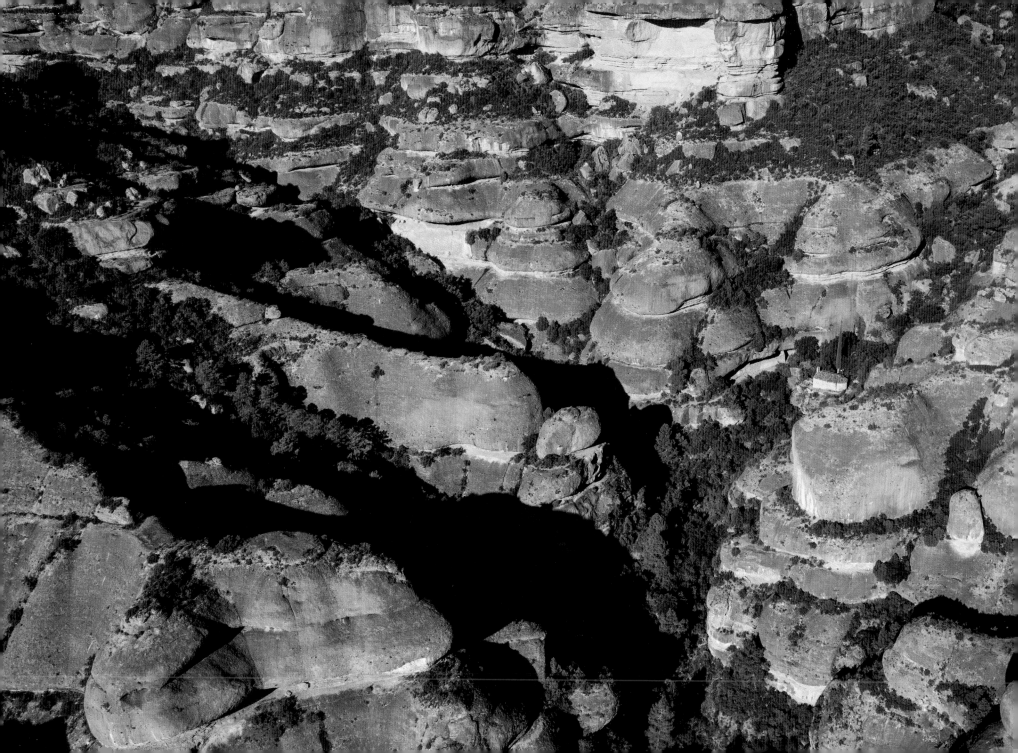

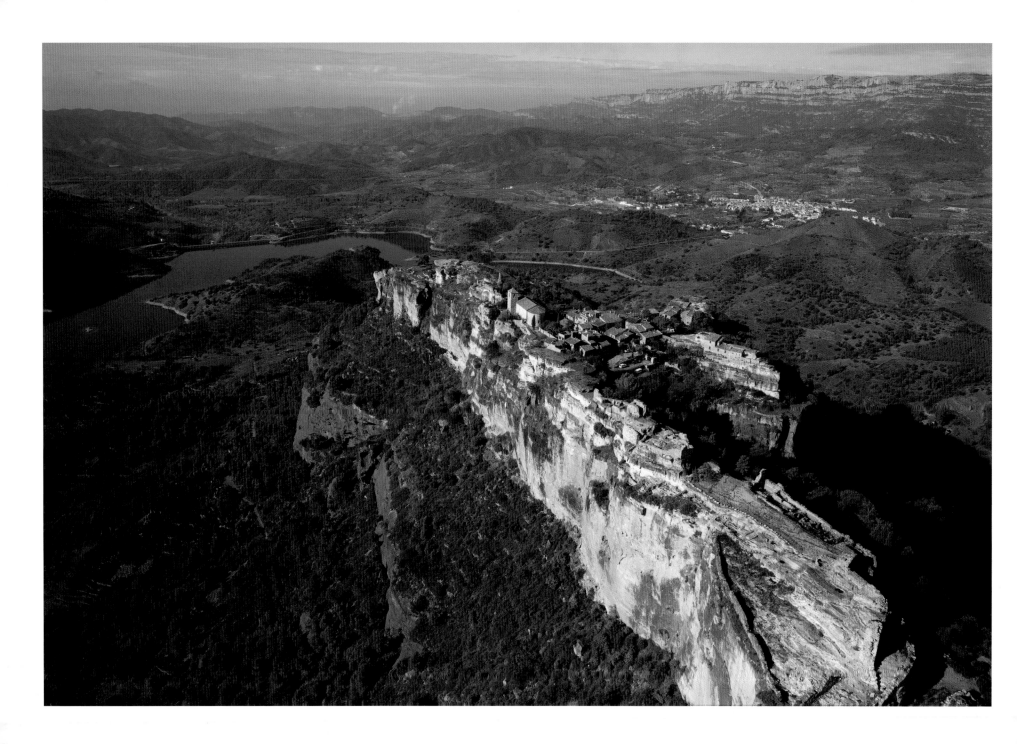

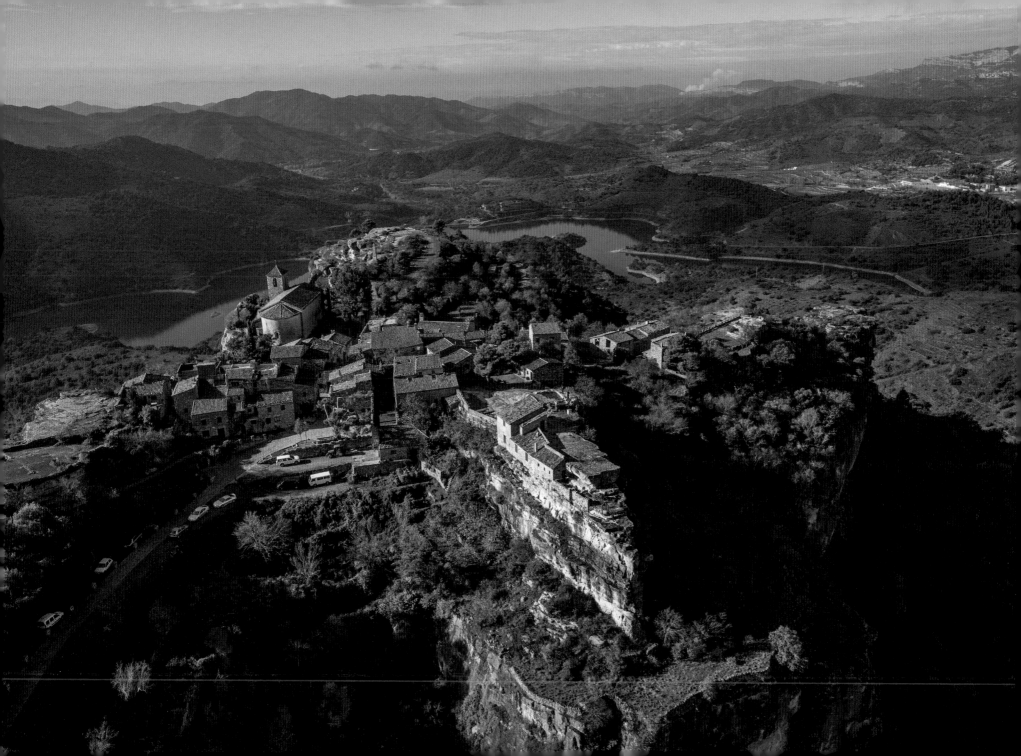

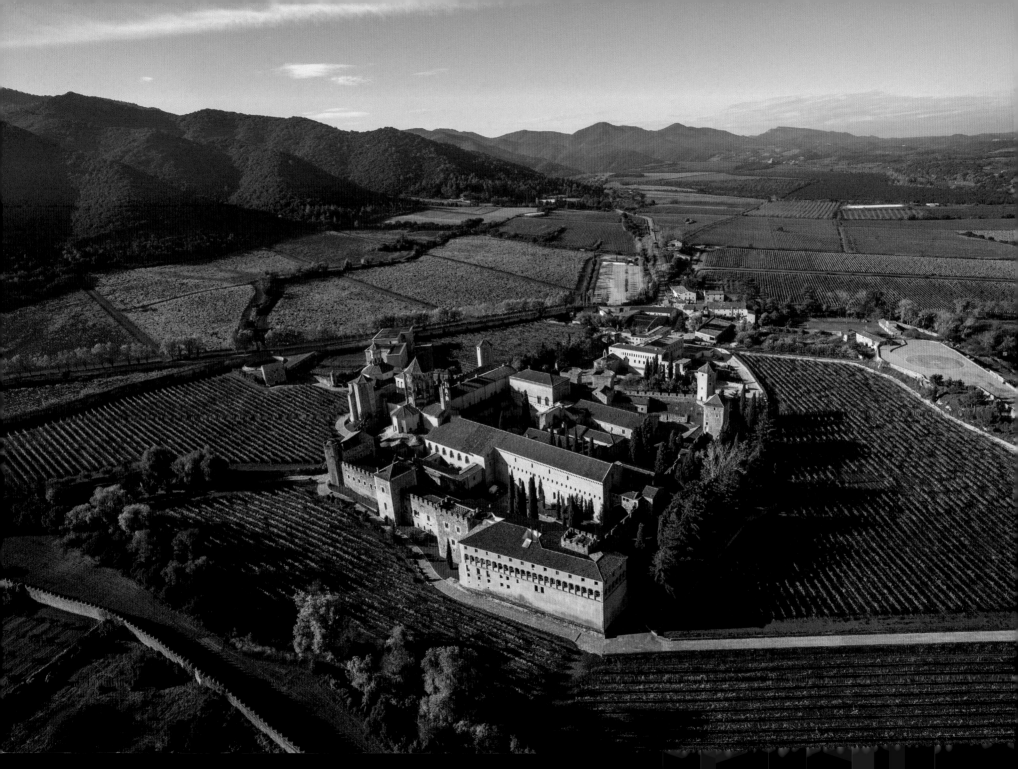

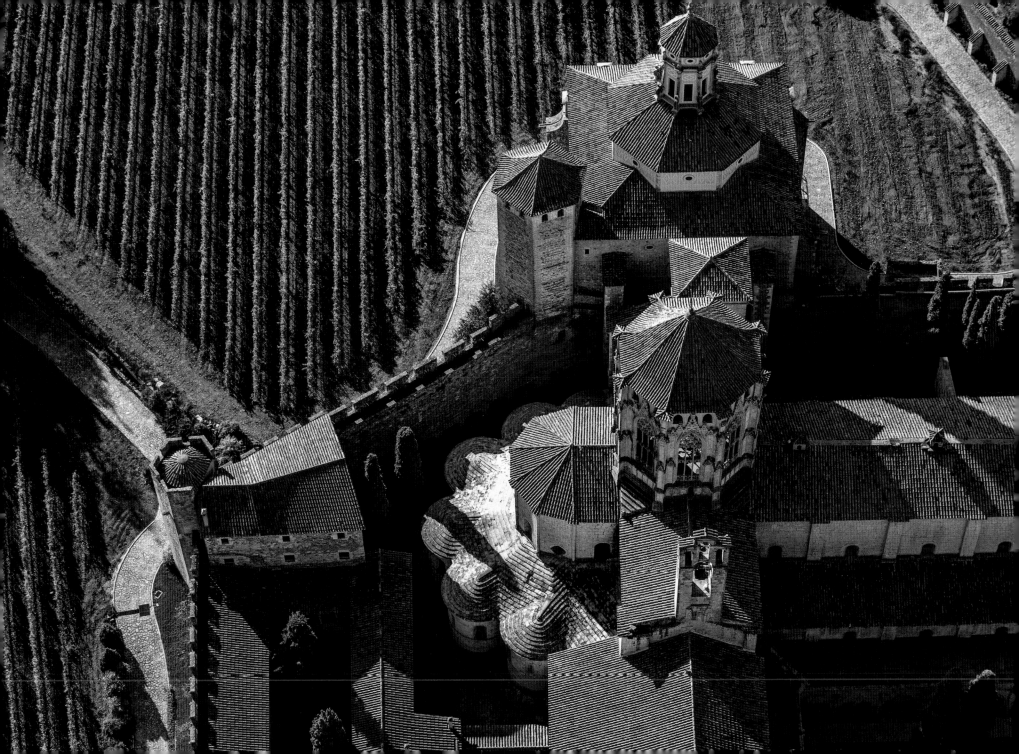

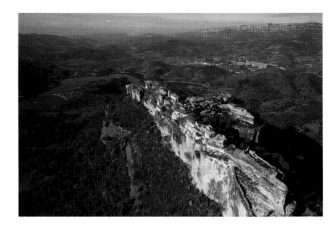

CAPAFONTS
41º 17' 43" N, 01º 01' 37" E

Over fifty natural springs may be found in this municipality, all linked to the basin where the River Brugent has its source (Font de la Llúdriga, Font Nova, Font de les Tosques, etc.). It need not surprise us, therefore, that the first people to settle in the area gave it the name Capite Fontium ('Head of the Springs'), from which the present-day toponym Capafonts derives. The village stands on top of a hillock in the Prades mountains, which rises in the midst of a small, intensively cultivated plain –an extension of the valley, in fact– which has provided the village with its source of income over the centuries. The first documentary reference to Capafonts is found in the Prades population charter granted by Ramon Berenguer IV in 1159, shortly after he had reclaimed the area from the Moors. Isolated from the conflicts and disputes that raged in neighbouring areas, Capafonts has lived peacefully for centuries in its tiny mountain universe, surrounded by forests and cheerful waters.

RELIEFS OF MONTSANT
41º 19' 03" N, 00º 49' 31" E

The Serra del Montsant is a spectacular calcareous massif halfway between the plains of Lleida and the Camp de Tarragona. The range is dominated by rocky outcrops that often form long cliffs. The nature of the rock, consisting of sedimentary conglomerates, favours erosion processes that have modelled a dreamlike landscape reminiscent of Montserrat. On gentle slopes or on ledges where soil may accumulate, ilex, pines and even sub-Mediterranean oaks grow. Water courses flow through deep gullies, the most famous of which is the Fraguerau ravine, gouged out by the River Montsant. This is a branch of the Sant Bartomeu gorge and takes its name from a tiny XIVth-century Romanesque hermitage hidden among the rocks opposite a grotto in which, or so tradition has it, Fra Guerau Miquel lived in seclusion during the mid-XIIth century. This is not the only hermitage on the massif; on the contrary, many such small chapels still stand there in solitary silence.

SANDSTONE AND CALCAREOUS ROCK IN SIURANA
41º 15' 28" N, 00º 55' 56" E

Around 240 million years ago, sedimentation processes that took place during the Triassic Period led to the accumulation of white calcareous rock on earlier wine-coloured sandstone beds, also from the Triassic. The calcareous rock belongs to a period that geologists call the Muschelkalk, while the lutite and red sandstone strata, otherwise known as red beds, are from what is known as the Buntsandstein period, a German term that means literally coloured (bunt) sand (sand) stone (stein). Erosion by rivers has exposed this striking accumulation of strata in many places, although nowhere may it be appreciated as clearly as in the area of Siurana de Prades, further enhanced by the presence of the village, perched on top of the Muschelkalk limestone.

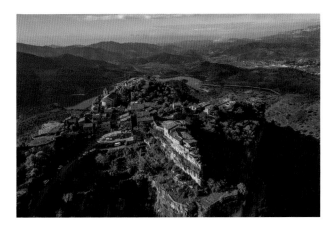

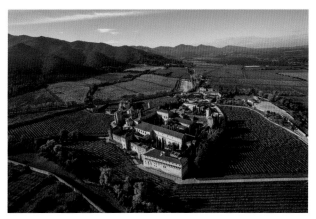

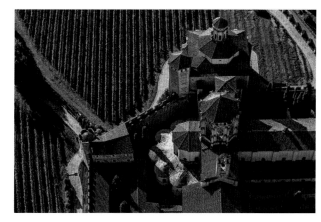

SIURANA DE PRADES
41º 15' 28" N, 00º 55' 56" E

In 1146, Ramon Berenguer IV, Count of Barcelona, completed his conquest of the Moorish taifa of Tortosa, with the exception of two redoubts: the castles of Prades and Siurana, which held out until around 1153 (nobody knows exactly when they surrendered). One need only contemplate the geographical location of Siurana castle to realise why it was so difficult to seize; it was a veritable eagle's nest. All that remains of the fortress are a few walls, right beside the present-day village of Siurana de Prades, equally perched on the cliff at an altitude of 737 metres above sea level. At its feet, stretching out beyond the River Siurana, lies an extensive landscape of mountains and valleys. In 1973 a dam was built on the river, thereby giving rise to the Siurana reservoir.

POBLET MONASTERY
41º 22' 55" N, 01º 05' 08" E

Members of the Order founded by Benedict of Aniane (known as 'black friars' by virtue of the colour of their habits) spread throughout the Marca Hispanica during the reign of Louis the Pious in the IXth century. The Benedictines were the great organisers of rural areas, since each monastery acted as the nucleus of the lands either granted to them by the counts or which they acquired by other means, invariably in accordance with principles of rational land use. In a way, what we know today as Catalunya Vella, which coincides largely with the Carolingian marches, is fruit of the Benedictine concept of territory. A couple of centuries later, however, the monarchs of the House of Barcelona placed their trust in the 'white friars' (that is, reformed Benedictines or Cistercians), whom they entrusted with the task of organising the territories gradually reconquered from Al-Andalus, in other words, Catalunya Nova. Thus the great Cistercian abbeys of southern Catalonia came into existence, pre-eminent among which is that of Poblet. Still today, Poblet presides over and structures the vineyards and forests that lie around the monastery.

THE POBLET MONASTERY CHURCH
41º 22' 49" N, 01º 05' 00" E

The Cistercians built their monasteries in accordance with precise basic principles linked to their lifestyle, which consisted of communal prayer and work in the fields. It is for this reason that we speak of the Cistercian style, a very sober way of building without any superfluous ornamentation. Poblet Monastery is an excellent example of this. It was founded in 1150 on lands hard by the mountains of Prades that Ramon Berenguer IV had recently reconquered; so recently, in fact, that the first monks, from the Abbaye de Fontfroide (Narbonne), were unable to occupy their new home until 1153, when the last Moorish redoubts of Prades and Siurana finally surrendered. The present-day monastic complex, one of the most important in Europe, was built during the XIIIth and XIVth centuries, though some additions were made later. An outstanding feature is the exquisite church, where most of the Catalan monarchs of the period are buried. In 1991 Poblet was declared a UNESCO World Heritage Site.

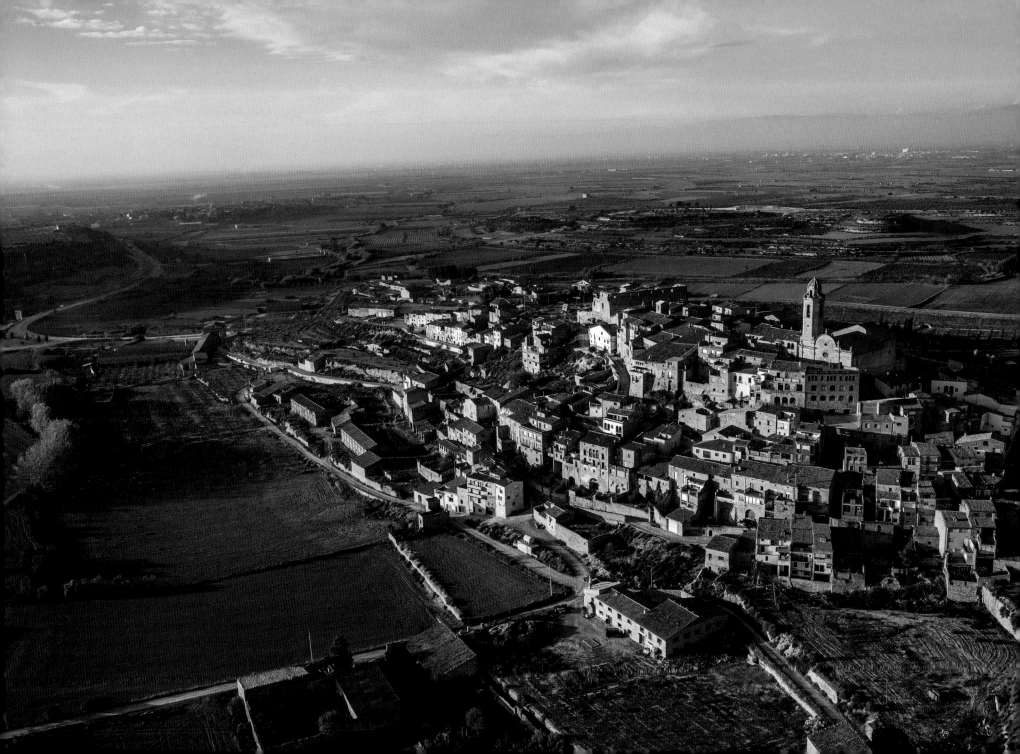

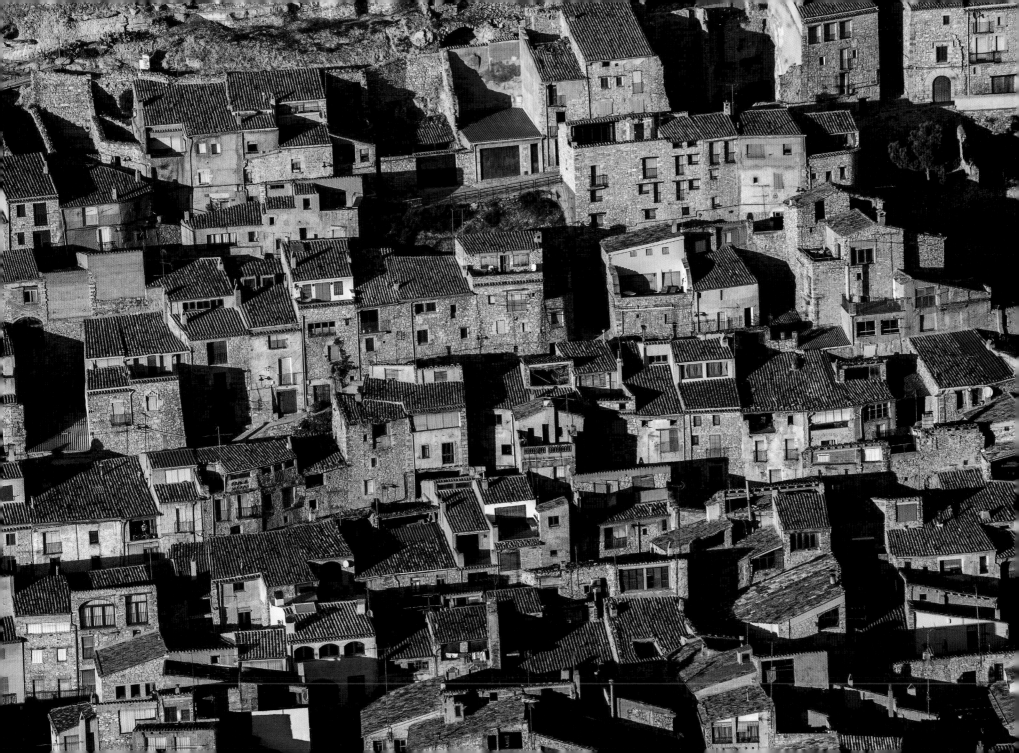

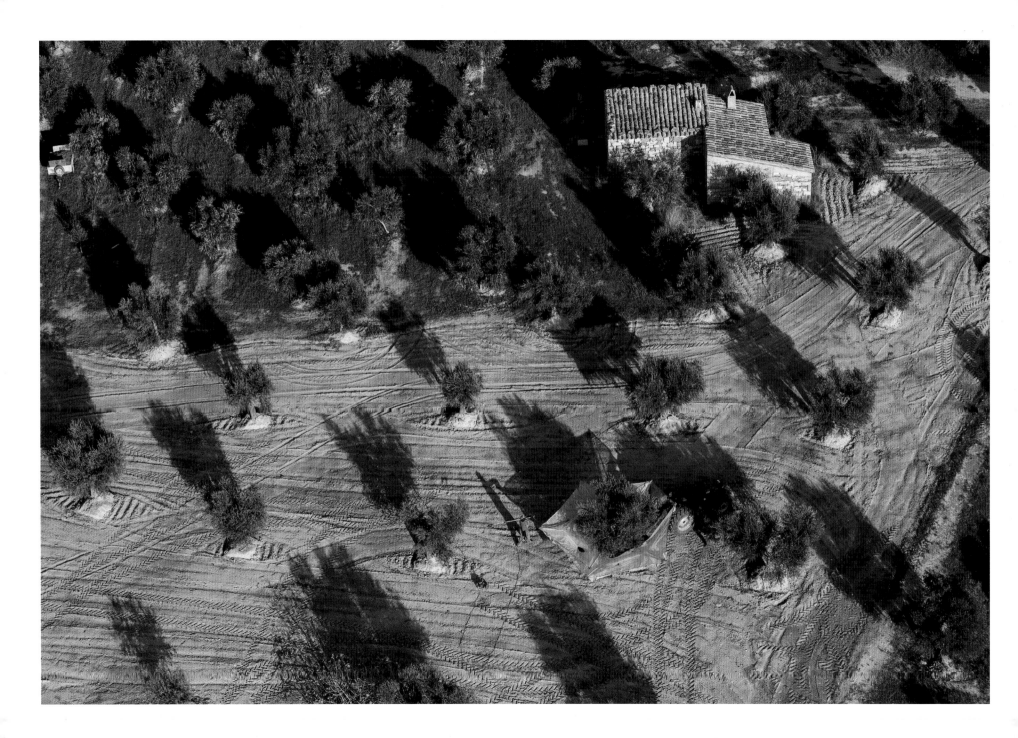

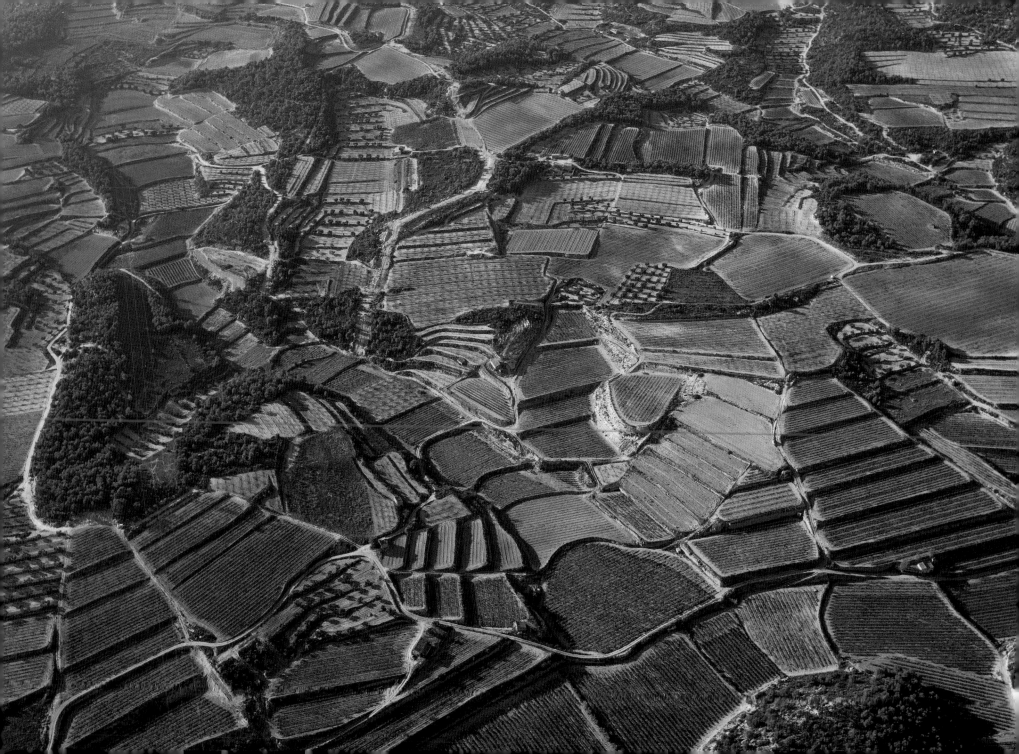

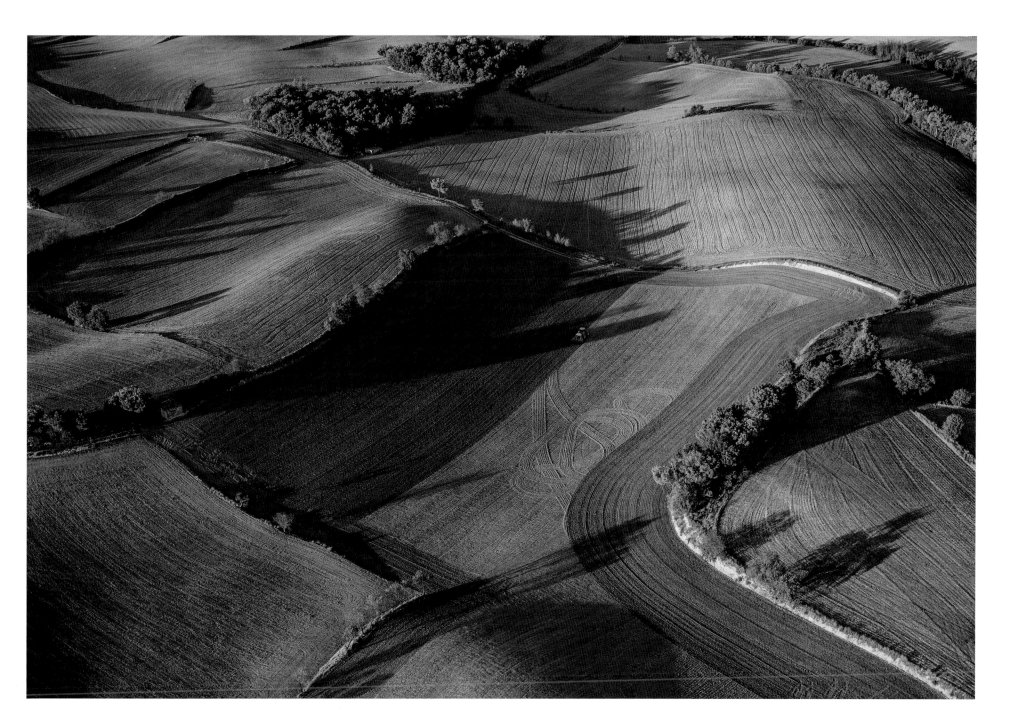

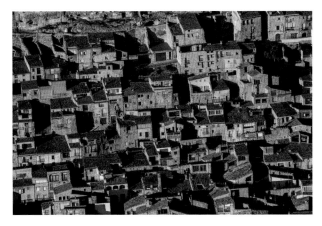
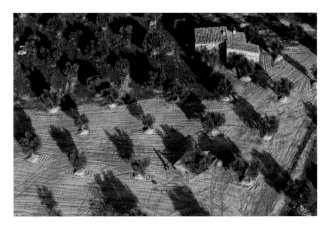

MALDÀ
41º 33' 01" N, 01º 02' 21" E

North of the Serra del Montsant and the Prades mountains, a plain stretches out, the largest in Catalonia. Since maritime influence is totally lacking in this area, the climate is continental, with much colder winters and much hotter, drier summers than on the Catalan coast and pre-littoral. The small town of Maldà stands on one of the hillocks that emerge discreetly from the plain, through which the humble River Corb flows. The first documentary reference to Maldà is in the last will and testament that Ramon Folc de Cardona drew up in 1040. He bequeathed Maldà to Vicenç de Cardona, provided the latter built a castle there. So he did, and there it still stands, although it was partially destroyed during the First Carlist War (1833). Maldà has so far made its living out of dry farming; however, the new Segarra-Garrigues canal will soon radically change this situation and, conceivably, transform the wheatfields into irrigated land. Maldà will come to know another, very different, landscape.

GUIMERÀ
41º 33' 52" N, 01º 11' 08" E

No less continental than that of Maldà is the climate of Guimerà, a delightful town in the comarca of Urgell. Unlike Maldà, however, Guimerà does not crown a hilltop; rather, it is built up a steep hillside. The houses seem to be piled on top of each other, hence the facetious name 'Nou de Copes' (Nine of Goblets) by which the locals refer to their town, since it reminds them of the heaped-up goblets on the playing card of the same name in the Spanish pack. Whatever the case, Guimerà is a gem of medieval architecture and urban planning. It has a Gothic church from the XIVth century and a castle from the XIth, with a splendid tower and much of its grounds encircled by walls from the same period. Numerous arcades and house-bridges transform its narrow streets into a kind of stone blond lace-work. In 1975 it was declared a Historical and Artistic Complex and later, in 1993, a Cultural Asset of National Interest.

ARBEQUINA OLIVE TREES
41º 21' 50" N, 00º 26' 01" E

It withstands both the arid conditions of summer and the bitter cold of winter, and it tolerates better than any other cultivated tree a certain degree of soil salinity. It may therefore be forgiven for its relatively low productivity. Furthermore, its fruit yields what no other Mediterranean tree is able to provide: prime quality oil. Consequently, it has been revered since Classical Antiquity. I am talking, of course, about the olive tree (*Olea europaea europaea*). All olive trees cultivated today share the same common ancestor, the wild olive (*Olea europaea sylvestris*), a shrub that still thrives in many small forests in the southern Mediterranean. Innumerable varieties have been obtained, adapted to a variety of uses. In Catalonia the most widely cultivated variety is the arbequina, which produces a tiny olive (only one centimetre in diameter), from which extraordinarily high-quality oil is obtained.

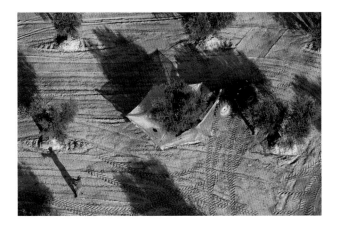

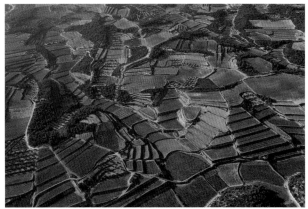

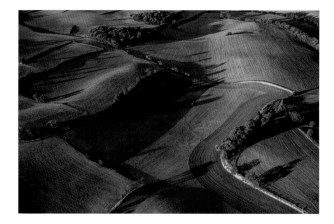

OLIVE TREES IN LES GARRIGUES
41º 21' 50" N, 00º 26' 01" E

In the comarca of Les Garrigues, as in other neighbouring *comarques* in the relatively arid Catalan interior, cultivation of the olive tree is of great importance. Activity is at its most intense in the winter. Olives ripen in the autumn, when their initial green turns first to purple and then to black: the time for harvesting has come. A mesh or sacking is spread out around each tree to collect the olives as the farmers cause them to fall. In former times this was an exacting manual operation consisting of 'combing' the branches or striking them with staffs. Today, however, a tractor-driven mechanical arm shakes the tree, which may not be so bucolic, though it is certainly much more effective. One way or another, the precious fruits are sent from the trees to the mills, where they are transformed into the world's most highly prized oil.

DRY FARMING IN BATEA
41º 05' 30" N, 00º 20' 44" E

Until the major irrigation canals were built from the mid-XIXth century onwards, the whole of inland Catalonia was given over to dry farming. The main crops were winter cereals, above all wheat (*Triticum aestivum*) and barley (*Hordeum vulgare*), the olive tree (*Olea europaea*), the almond tree (*Prunus dulcis*) and the vine (*Vitis vinifera*). However, with irrigation came the cultivation of garden vegetables and sweet fruits, although extensive areas are still devoted to dry farming. In the more mountainous areas, as here in Batea, in the Terra Alta comarca, the fields are laboriously built terraces held in place by dry-stone walls, a succession of small plots given over either to vines, olives or almonds, which give rise to landscapes that constitute veritable works of agricultural filigree.

WHEATFIELDS IN TALAVERA
41º 35' 27" N, 01º 21' 30" E

On the other hand, when the relief consists of gently undulating terrain, terraces give way to more extensive fields, also separated by dry-stone walls, as in these Talavera wheatfileds in the comarca of La Segarra. Prevailing landscape standards have for many years preferred these kinds of fields, which are regarded as banal. Nothing could be further from the truth, however, since they form compositions of breathtaking beauty, above all when the low-lying late afternoon or early morning sun enhances the relief and colours of the earth as well as the artistic values of this agricultural matrix, invariably dotted by clumps of woodland that serve as a refuge for both the local fauna and for farm workers when the midday heat becomes unbearable.

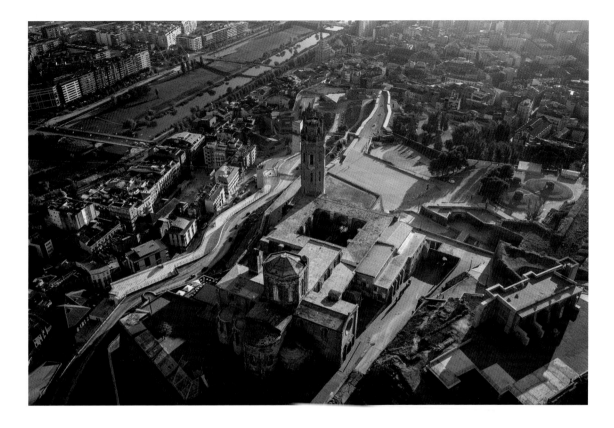

THE SEU VELLA IN LLEIDA
41º 37' 01" N, 00º 37' 32" E

Lleida is described as the 'capital of Catalonia in Terra Ferma', that is, the capital of inland Catalonia. Back in the remote past, the Iberians had already established a settlement on what is now the Turó de la Seu, called Ildirda. In the I[st] century BC, the Romans made it their Ilerda and extended it to the River Sicoris, now the Segre. The Moorish troops took the city in 714, and Islamic Larida lasted until 1139, when Ramon Berenguer IV incorporated it into his domains. More or less conspicuous vestiges remain of all these events, though of greater importance are the later Christian buildings, especially the XIIIth-century Romanesque-Gothic cathedral, known as the Seu Vella, built on the site of the former *suda* or Moorish fortress, in turn constructed on the Palaeo-Christian church that stood there before the Moors invaded. In 1300, King Jaume II and Pope Boniface VIII established the Estudi General de Lleida, the oldest university in the Catalan-Aragonese Kingdom.

LA CLUA D'AGUILAR AND THE RIALB RESERVOIR
41º 59' 24" N, 01º 16' 40" E

The last of Catalonia's great reservoirs was built at Rialb, on the Segre, the dam for which is near the town of Ponts. Further upriver, its far end almost meets the Oliana reservoir dam, which lies between the mountains of Turp and Aubenç. Rialb generates hydroelectric energy as well as feeding the new Canal Segarra-Garrigues. It went into operation in 2000, after long, arduous negotiations with the local population. Indeed, the reservoir has had its effect on the riverside villages, which have lost much fertile agricultural soil, assuming that they themselves have not been engulfed by the waters. This is the case of the picturesque nucleus of La Clua d'Aguilar, most of whose arable land has been sacrificed. La Clua is an ancestral village, written records for which date back to the act of consecration of La Seu d'Urgell Cathedral in 893. At the top of the hillock on which the village was built stands the Romanesque church of Sant Sebastià, constructed in the XIIth century.

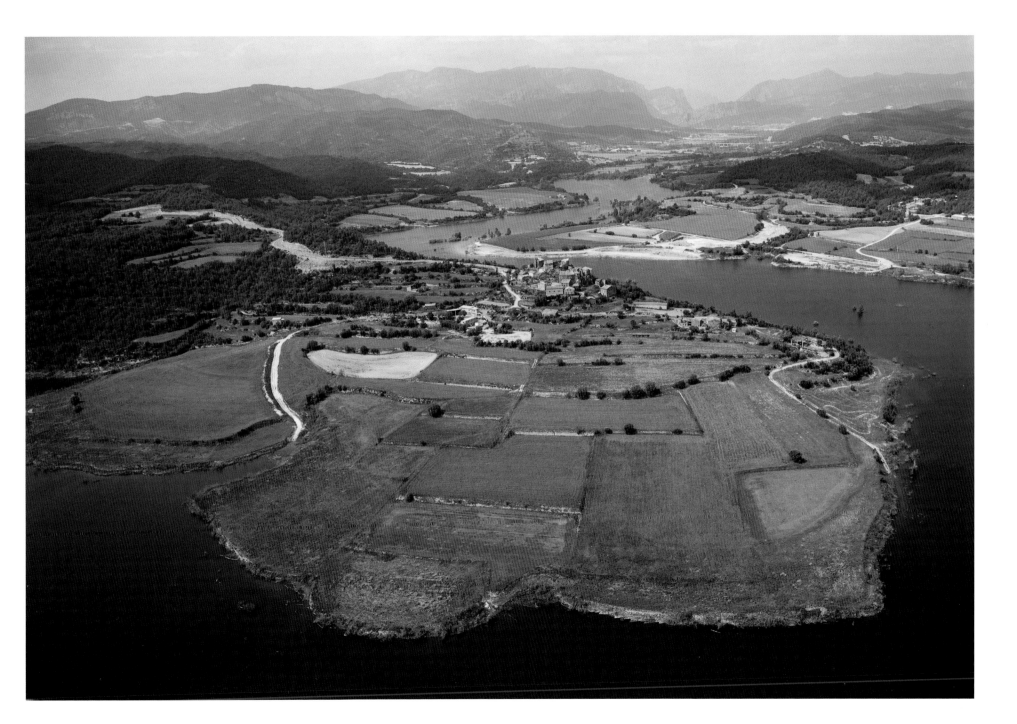

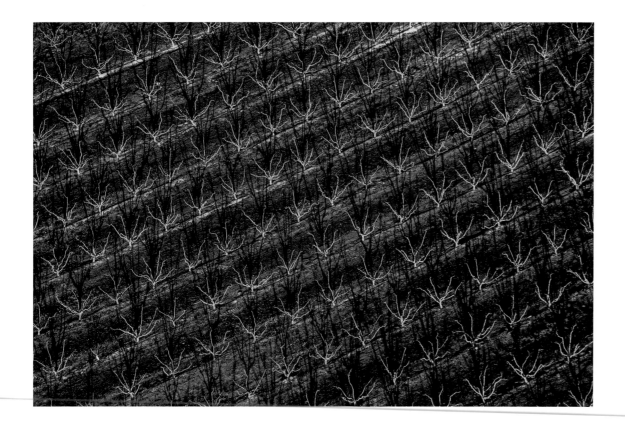

FRUIT-TREE ORCHARDS IN LLEIDA
41º 35' 58" N, 00º 37' 27" E (APROX.)

In 1862, after three centuries of frustrated projects, the main Urgell canal went into operation. Fields in the municipality of Agramunt, which until then had seen water only in the form of the scarce annual rains that fall in the area, were the first to be supplied from the River Segre. The water is transferred from the river at Ponts (343 m above sea level) and, by means of a system involving two main canals and four big irrigation channels, it is distributed by the force of gravity to an area of 70,000 hectares. The combination of the two canals (Principal and Auxiliar, the latter opened in 1932), the main irrigation channels and the innumerable secondary channels constitutes a network of around 6,000 kilometres that returns surplus water to the Segre at Montoliu de Lleida (127 m above sea level). This irrigation system has completely transformed both the physical and socio-economic landscape of the area. Where for centuries there were only wheatfields and dry-land crops, green vegetables and fruit orchards now thrive.

RIBA-ROJA RESERVOIR
41º 14' 48" N, 00º 21' 14" E

The construction of dams and reservoirs to regulate river-water flow is not restricted to irrigation purposes, since hydroelectric power generation is equally important or more so. Already by the beginning of last century Catalonia had become one of the first countries in Europe to produce electricity on a large scale by means of this process. There are over forty reservoirs in Catalonia, most of which are in the Ebre basin (the rivers Segre, Noguera Pallaresa and Ebre) and on the Ter and the Llobregat. Almost all these reservoirs are located in mountainous areas, which endows them with a narrow, meandering form many kilometres long, from the dam to the far end. Their construction has often led, unfortunately, to many villages and riverside allotments becoming submerged. This was the case of the Riba-roja reservoir, on the Ebre at the boundary between Catalonia and Aragon, which in 1967 entirely drowned the ancestral Aragonese village of Faió (see also the case of Sant Romà de Sau on page 130).

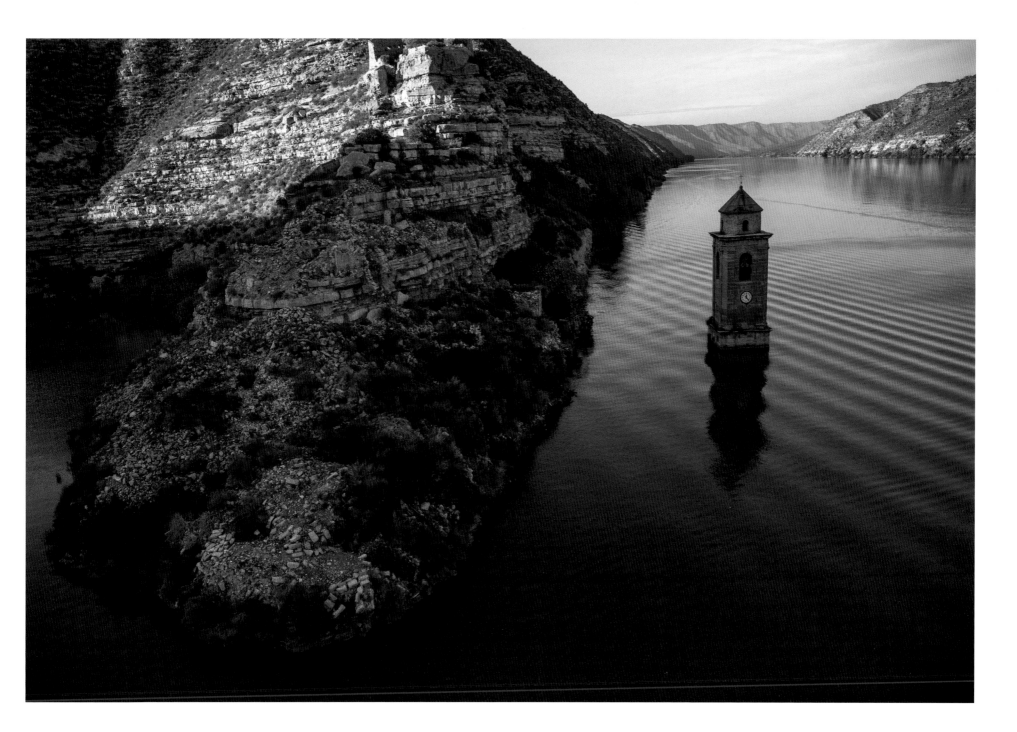

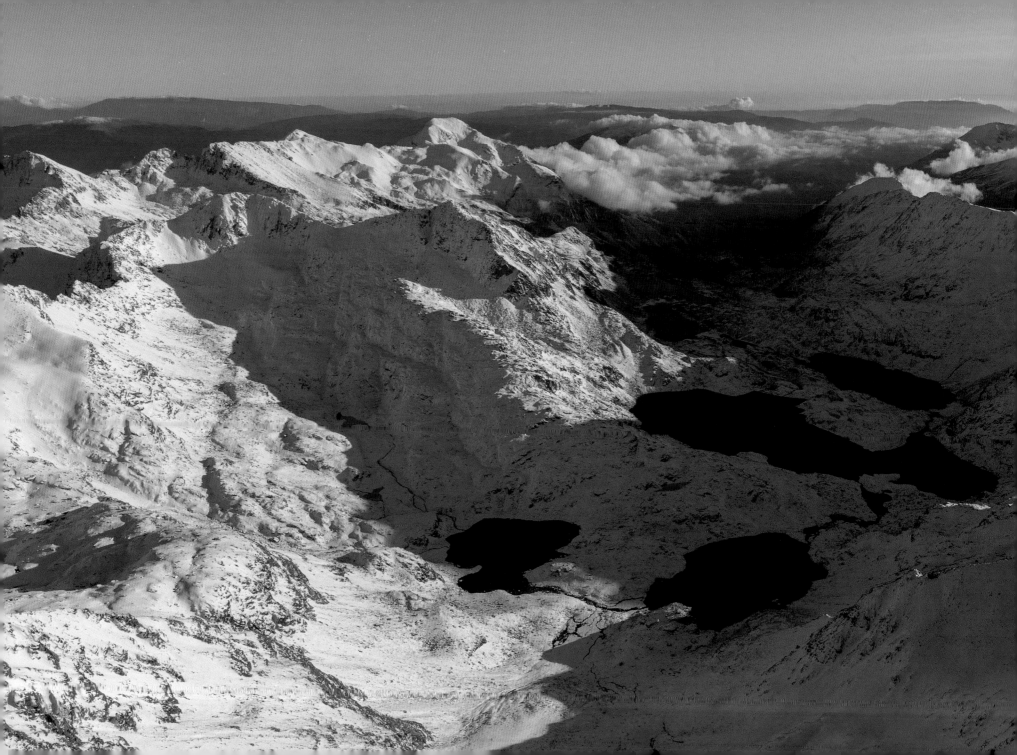

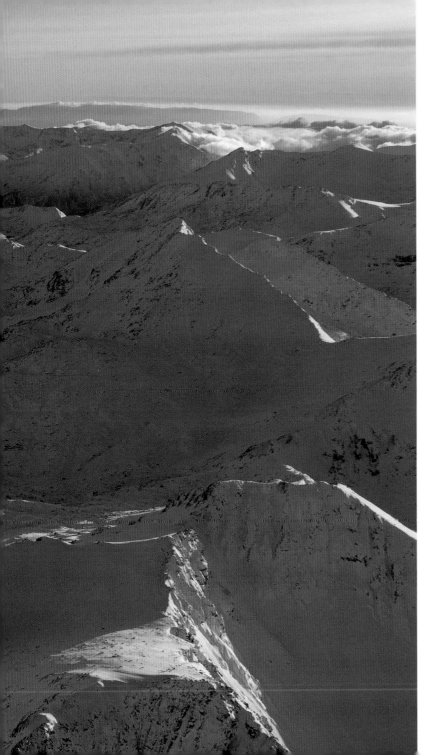

AT THE VERY TOP

WHERE ARE THE PYRENEES?

Where exactly are the Pyrenees? The question is not as absurd as it may seem. Hence the problems encountered, when it came to providing an answer, by the members of the geographical commission entrusted with the task of marking out in situ the limits of the agreements reached in the Treaty of the Pyrenees, signed in 1659 by representatives of Philip IV of Castile (III of Aragon) and Louis XIV of France at the end of the Thirty Years' War. The Treaty stipulated that the Pyrenees would mark the new frontier. The Pyrenees, however, are not a single range but a set of ranges that more or less form a chain that seems to melt away when it reaches the sea, both at the Cantabrian and Mediterranean ends. According to modern geomorphologists, on the eastern side the Pyrenees end at Mount Canigó, whence they continue seawards in the form of minor ranges such as Les Corbières and the Massif des Albères. The commission opted for the French criterion of choosing Les Albères as the frontier, which meant that the historical, even foundational, comarques of Roussillon, Vallespir, Conflent, Capcir and part of the Cerdagne were separated from Catalonia.

This set of mountain ranges and massifs stretches along the entire 430 kilometres that separate the Atlantic from the Mediterranean. They are ancient mountains which formed in the remote geological past (some 350 million years ago during the Hercynian Era), were subsequently razed to the ground by erosion and eventually became resuscitated some 60 million years ago thanks to the Alpide orogeny, which gave rise to the Alps and the Himalayas. The outcome of all this is an imposing relief of granitic rock and sedimentary matter that culminates in Aneto Peak (3,404 m) on the dividing line between Catalonia and Aragon. A differentiation is usually made between the Western Pyrenees, with altitudes of under two thousand metres, corresponding to Euskal Herria (the Basque Country) and Navarre; the Central Pyrenees, the highest, in many cases reaching altitudes of over three thousand metres, corresponding to Aragon and Catalonia (Hautes Pyrénées and Ariège, on the Occitanian side); and the less imposing and less clearly defined Eastern Pyrenees, which correspond to Catalonia.

On either side, the Pyrenees are lined by mountains that act as spurs, conventionally known as the Pre-Pyrenees. They are in fact more or less independent massifs that establish a kind of shelf between the great Pyrenean range and the plains from which it rises.

LA TOSA D'ALP | 42º 19' 10" N, 01º 53' 36" E

The Niu de l'Àliga refuge, near the peak of La Tosa d'Alp (2,536 m), one of the most emblematic summits in the Pre-Pyrenees, the birthplace of Catalan Alpine skiing, between La Cerdanya and El Berguedà.

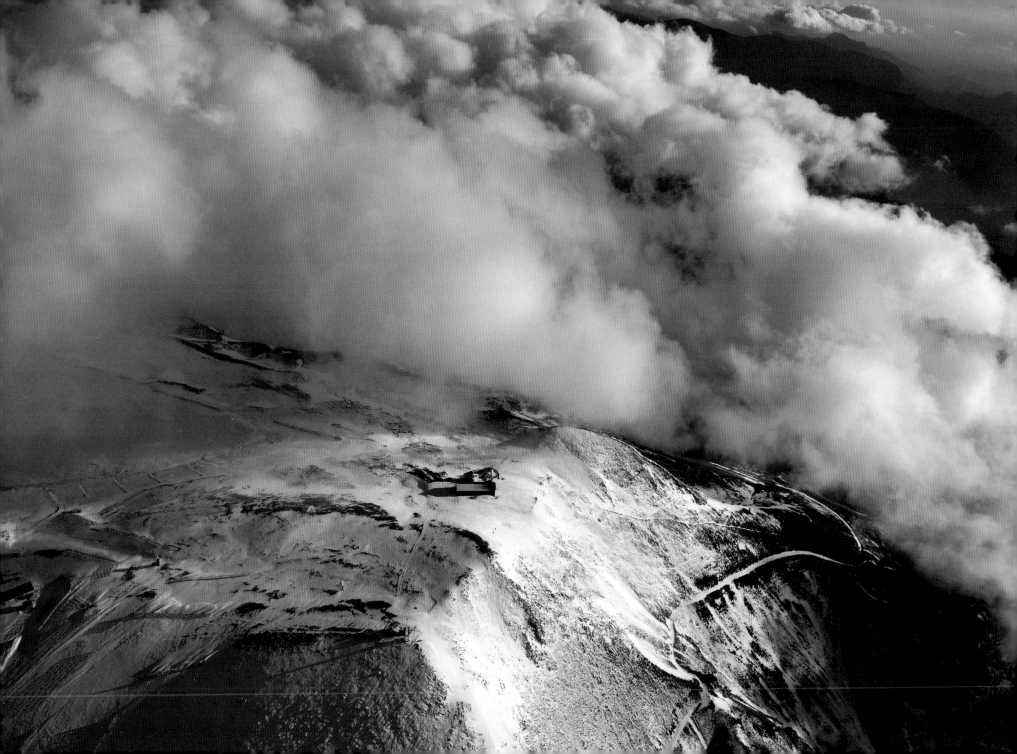

LATITUDE 42

The Pyrenees stretch from east to west in a latitudinal band that lies between 42° and 43° N, approximately the same that lies between Rome and Florence. Why do we find such different landscapes? Due to the altitude, of course. Indeed, the forests and meadows on the highest parts of the Pyrenees resemble the forests and the landes of Scandinavia.

To a considerable extent, the landscape depends on climate. The climate varies depending on the latitude, for which reason a landscape gradation exists from the equator to the poles: from rain forests to perpetual snows. Altitude causes a similar effect. The Pyrenees stretch from the sea to altitudes of up to over three thousand metres; it is as if they went from latitude 42° N, at Cap de Creus (if Les Albères are indeed the Pyrenees, as I commented on earlier) to latitude 60° N, corresponding to that of Oslo or even further north. In between, different landscape types succeed each other, the equivalents to those we would find if we travelled the whole of Europe from south to north. It is for this reason that we may bathe in the more or less Pyrenean coves of Cap de Creus, go skiing in Sant Joan de l'Erm or become lost in the beech forests of the Vall d'Aran.

The same relief that causes this situation is also responsible for another phenomenon: the landscape differences that depend on orientation. The slopes that face northwards, termed obaga in Catalan, receive less sunlight than those facing south, termed *solell*. The combination between different altitudes and sunny, shady or intermediate orientations gives rise to a huge gamut of environmental conditions and micro-climates, hence the highly varied Pyrenean landscapes. In general, the northern Pyrenees of Occitania are wetter and colder than their southern counterparts in the Basque Country, Aragon and Catalonia, although each valley is a world unto itself and each corner of the Pyrenees has a surprise in store.

At altitudes under one thousand metres, the Catalan Pyrenees are normally dominated by Mediterranean or Sub-Mediterranean climatic conditions, which means that evergreen oaks, pines, oaks and boxwood trees abound. Mid-European type vegetation, that is, beech woods, damp oak forests and red pine forests, predominates between approximately 1,000 and 1,700 m above sea level, while between 1,700 and 2,400 m black pines and Subalpine scrubland thrive. Further up, Alpine meadows and hyperborean landscapes prevail...

RIVULET AT THE CAVALLERS LAKE | 42° 36' 08" N, 00° 51' 35" E

Raging torrents that flow through Alpine meadows spattered with granitic blocks, the result of the action of ancient glaciers, characterise the high-mountain landscapes of the Pyrenees.

LIVING
IN THE PYRENEES

Catalonia was born in the Pyrenees. Inaccessible to foes who fought over possession of the lowland plains, the first Catalan counties established their strongholds in the Pyrenean range: Pallars, Urgell, Cerdanya... Sant Martí del Canigó is the cradle of modern Catalonia and Ripoll, in the high valley of the Ter, its first great cultural bastion. Catalonia hangs from the Pyrenees, which are inseparable from the Catalan imagination.

Everyday life is far from easy there, however. Craggy relief and extreme climatic rigour are somewhat incompatible with today's lifestyles. The Pyrenees therefore gradually became depopulated as last century progressed. On the other hand, they welcome an increasing number of tourists in the summer and of skiers and snow-lovers in the winter.

The traditional Pyrenean economy has invariably been based on stock raising, specifically on extensive exploitation of pastureland and fodder-yielding meadows, which ensured the availability of grass when the livestock could not go out to graze. Transhumance from the low-lying Sub-Mediterranean valleys to the Alpine meadows, or else from any point on the mountains to the gentle undulations of the Mediterranean littoral, marked the regular beat, throughout the year, of the Pyrenean stock-raising heart. Agriculture, on the other hand, was very modest and restricted to the needs of local consumption.

Very important also was timber exploitation, particularly of the fir and the different species of pine. The trunks of these trees, tied together to form primitive rafts called rais, were transported downriver to the sea or to the towns on the plain. In some areas intensive mining took place, of iron ore above all, together with its corresponding metallurgy and associated industries (forges, tool and arms factories, etc.).

All this gave rise to major transformation of the range, although never to the point of total anthropisation of the lowlands or the coast. Pyrenean villages and towns, embedded in valley floors or clinging to mountain slopes, never became populous. Many have become abandoned and remain as witnesses to former times, while others have become converted tom tourism. In any case, the mountain imperturbably remains.

HUTS IN THE PALLARS SOBIRÀ I 42º 31' 18" N, 1º 11' 18" E

In their surrounding highlands, many Pyrenean villages have groups of huts for temporary occupation during the summer, where shepherds take their flocks to graze on the local pastureland.

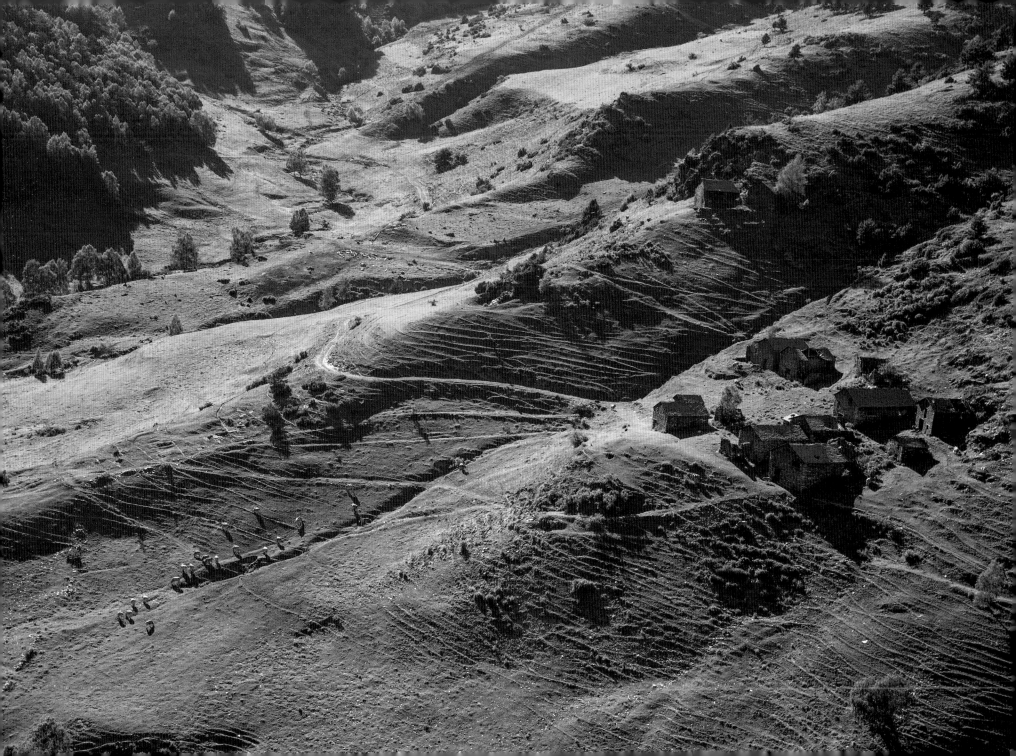

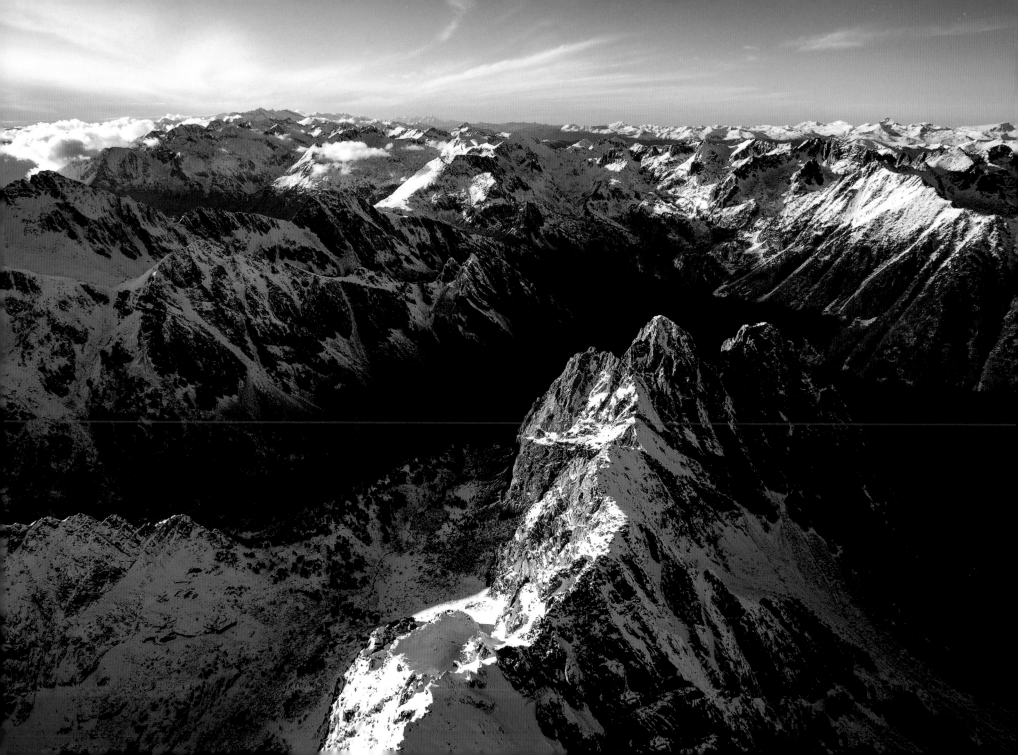

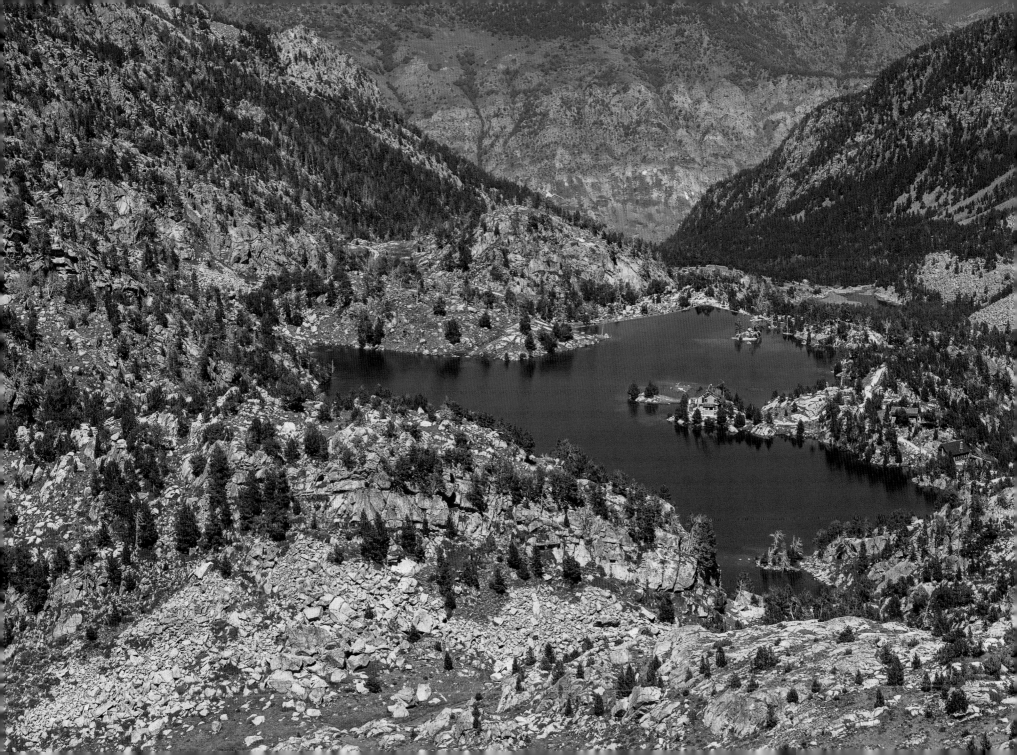

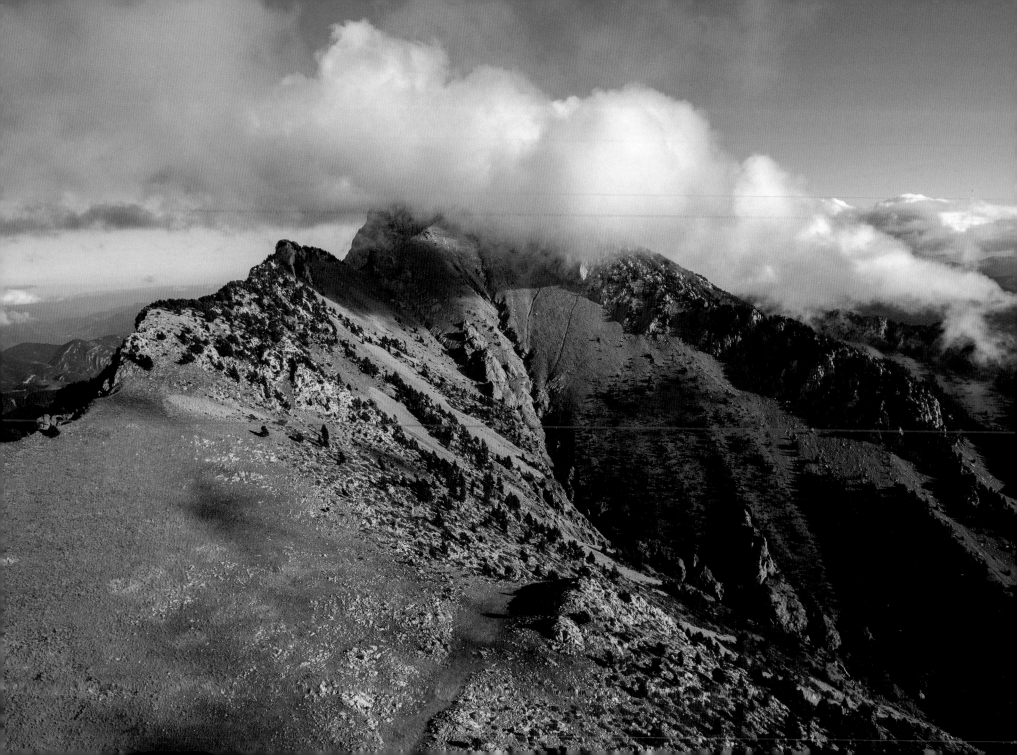

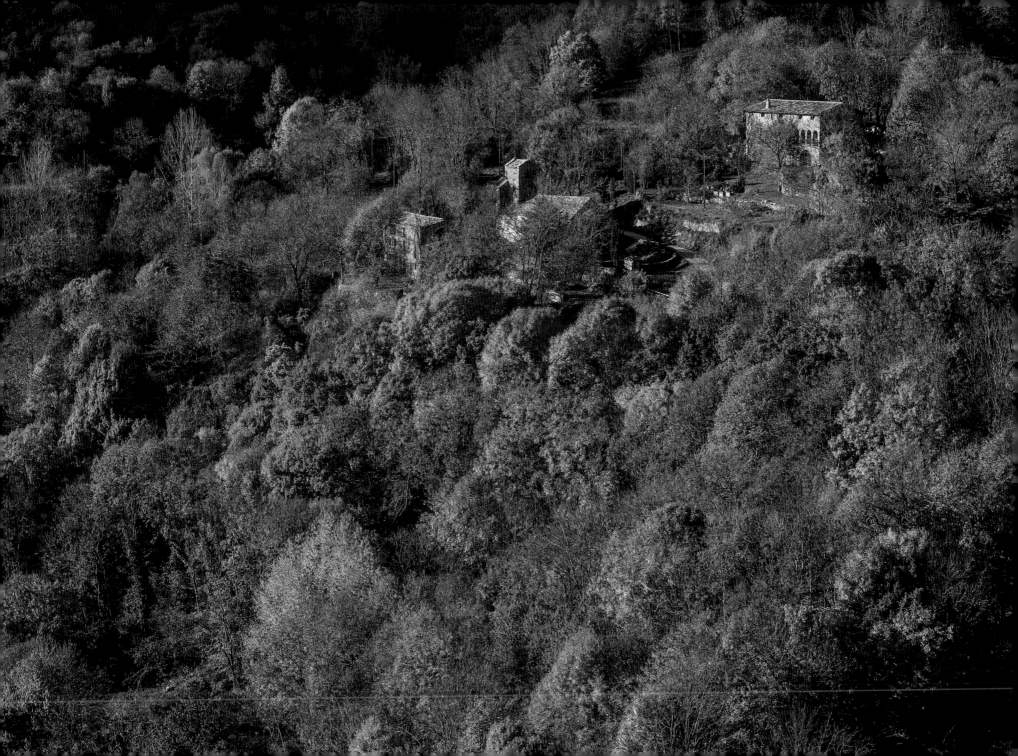

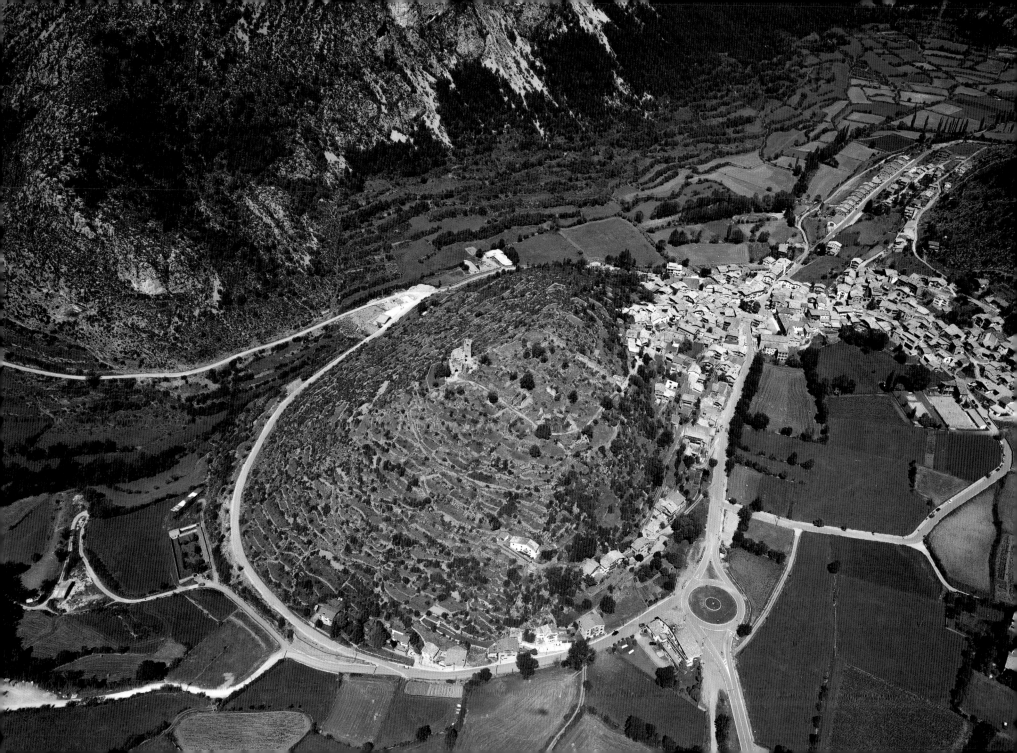

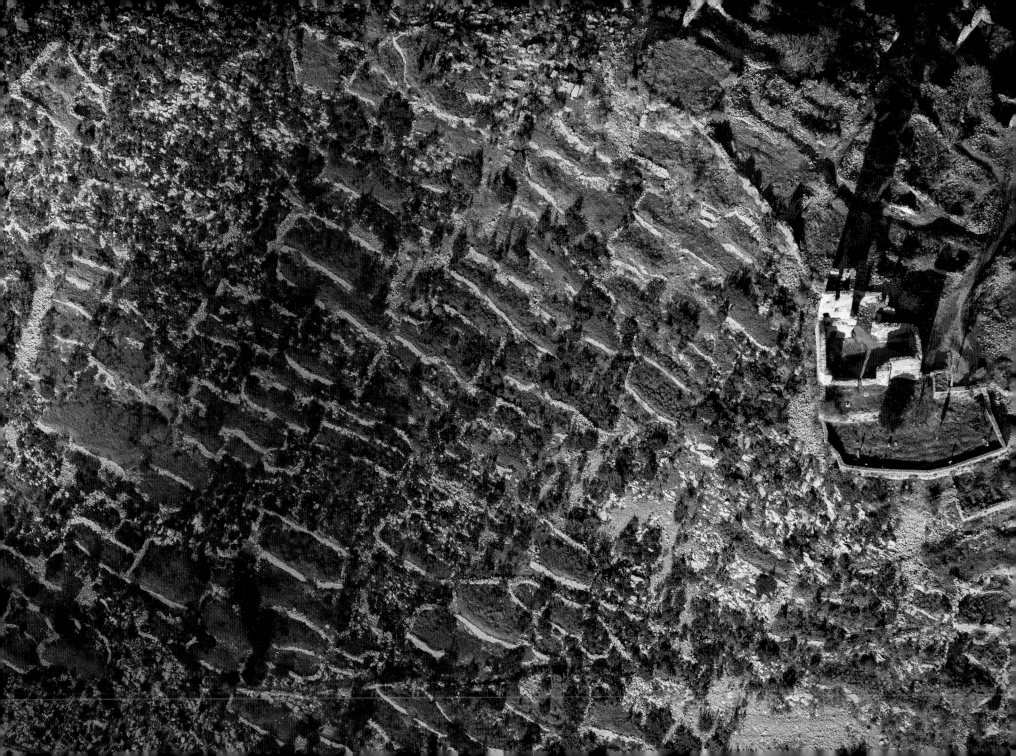

AIGÜESTORTES
42º 34' 30" N, 00º 57' 00" E

Only 165 km as the crow flies separate these snow-capped peaks from the beaches of the Costa Daurada; and less than 200 km away lies the coast of Cap de Creus. The difference in latitude is very small in the first case (only 1º 30') and non-existent in the second. The enormous climatic and landscape difference is caused by the variation in altitude. Indeed, these summits, in the heart of the Parc Nacional d'Aigüestortes i Estany de Sant Maurici (the only national park in Catalonia) stand at over three thousand metres above sea level, while the lowest parts, although snow-free, are well over one thousand metres in height. They fully correspond to the axial Pyrenees, that is, the core of the mountain range. Apart from the severe relief, what also attracts visitors' attention is the abundance of tiny glacial lakes, of which there are over two hundred. The backbone to the western area of the park is provided by the Sant Nicolau River, whose gentle watercourse is characterised by innumerable small backwaters, which generates a landscape of exceptional beauty that provides the area with its name, aigües tortes (twisting waters)

TRULLO LAKE, VALL D'ESPOT
42º 32' 46" N, 01º 02' 40" E

Running in the opposite direction to the River Sant Nicolau (which flows east-west in the Alta Ribagorça) lies the valley of Espot (from west to east in the Pallars Sobirà). The landscapes of both basins are very similar, equally grandiose and wild. Before the park was created, the waters of many of the small lakes were harnessed for hydroelectric purposes, like those of other lakes on the park periphery. Together they function as a vast system of communicating vessels, to the point where some of these lakes, perforated at the base and linked to other lakes lower down, may be emptied or refilled in the space of a few hours, depending on the needs of electricity generation. And although this causes ecological dysfunctions, it makes exceptional hydroelectric exploitation possible, with deliberate inclusion of reversibility: the water may either be allowed to fall in order to power turbines or else pumped back upwards so that it will be available to generate more electricity the following day when consumption levels are at their highest.

EL MOIXERÓ
42º 18' 02" N, 01º 49' 17" E

On either side of the Pyrenees there are mountain chains called the Pre-Pyrenees. Prominent on the northern side are Les Corbières, while on the southern side the Pre-Pyrenees are much more imposing, with a host of chained ranges. Forming part of the Catalan Pre-Pyrenees are major mountain systems such as the Montsec, Cadí, Moixeró, Boumort and Aubenç, separated from each other by ravines gouged out by the rivers that flow either to join the Ebre or else directly to the sea (the Noguera Ribagorçana, Noguera Pallaresa, Segre, Llobregat, etc.). El Moixeró, between the basins of the Segre and the Llobregat, is a prolongation of the Cadí, with which it is often confused (the road tunnel that runs through the Moixeró is called Túnel del Cadí, for example). It is an imposing, mostly calcareous massif over two thousand metres high at many points, covered with red and black pines, a few beech and fir forests, and Subalpine meadows on the summits.

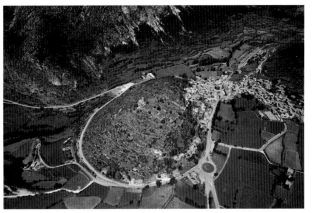

SANT MARTÍ D'OGASSA
42º 16' 18" N, 02º 13' 52" E

Catalonia is a Mediterranean country, latitudinally located in the dry sub-tropical strip of the northern hemisphere and characterised by a landscape of evergreen forests with the holm oak predominating. However, it is also a very mountainous country whose latitudinal hydric limitations are offset by altitude. Consequently, in the mountains it is normal to see deciduous and evergreen trees living side-by-side. The outcome of this is the spectacular palette of colours that characterises the autumnal landscape. Alongside the dark green of the evergreens appear the yellows, browns and reds of beeches, maples and oaks. Such a landscape may be contemplated around Sant Martí d'Ogassa, a humble church consecrated in 1024 by the famous Abbot Oliba, founder of the Monastery of Montserrat when he was Abbot of Ripoll. Sant Martí and the small rural nucleus over which it presides stand at an altitude of 1,320 m, on the slope of the Taga, one of the most popular pre-Pyrenean peaks.

GÓSOL
42º 14' 05" N, 01º 39' 36" E

The Pyrenean village of Gósol stood at the end of a stretch of the Chemin des Bonshommes, one of the routes which the Cathars followed as they fled from persecution during the crusade that for thirty-five years, during the XIIIth century, ousted them from their lands in Occitania. At that time Gósol was a fortified stronghold, standing 1,480 m above sea level, presided over by the Church of Santa Maria and by its ancient castle, whose keep is pre-Romanesque. The village was governed by the Galcerans de Pinós, one of the most highly reputed Catalan feudal families. In the XVIIIth century, by which time the evolution both of society and military technology had made such eagles' nests obsolete, Gósol was moved to the more benign valley floor, where it stands today.

GÓSOL CASTLE
42º 14' 05" N, 01º 39' 36" E

Very little remains of the medieval splendour of Gósol Castle, now reduced to the ruins of its fortified precinct, of the keep and of the church. These vestiges are surrounded by another ruin from the past: the dry-stone walls which held back the soil of the precarious agricultural terraces laboriously built on the calcareous slopes of the hill. These terraces most probably came to occupy the site on which the village originally stood. Whatever the case, the villagers must have made truly colossal efforts to combine the needs of agriculture and of defence at a time of permanent hostilities. Today, boxwood trees (Buxus sempervirens) have taken possession of this medieval landscape. tinging it with their characteristic yellowish green.

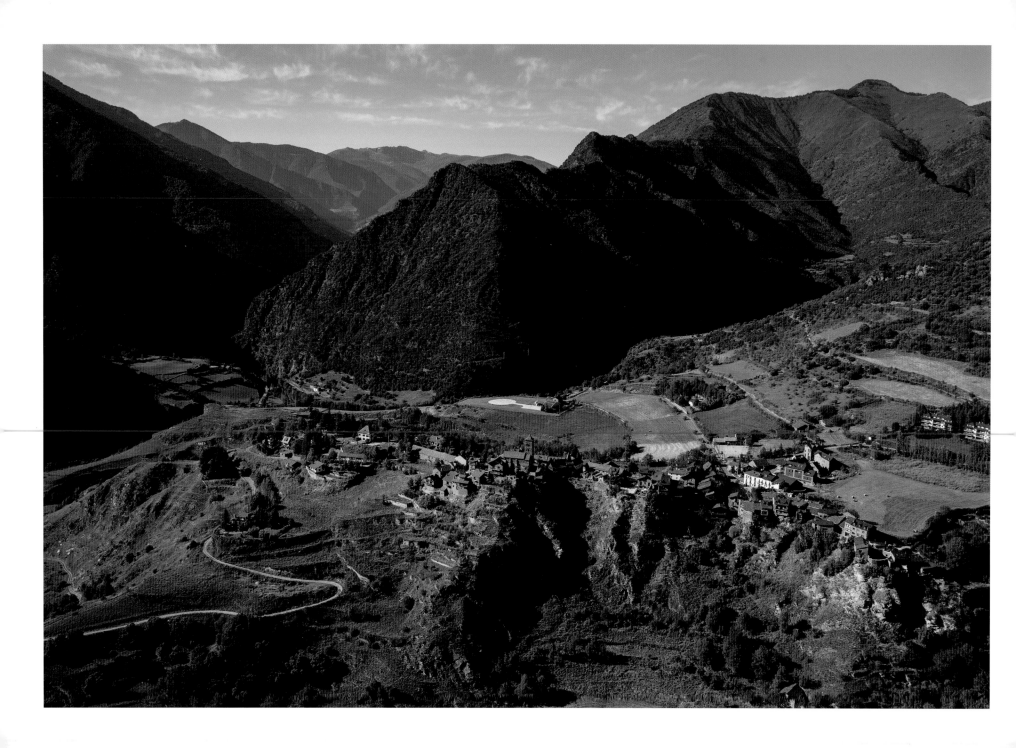

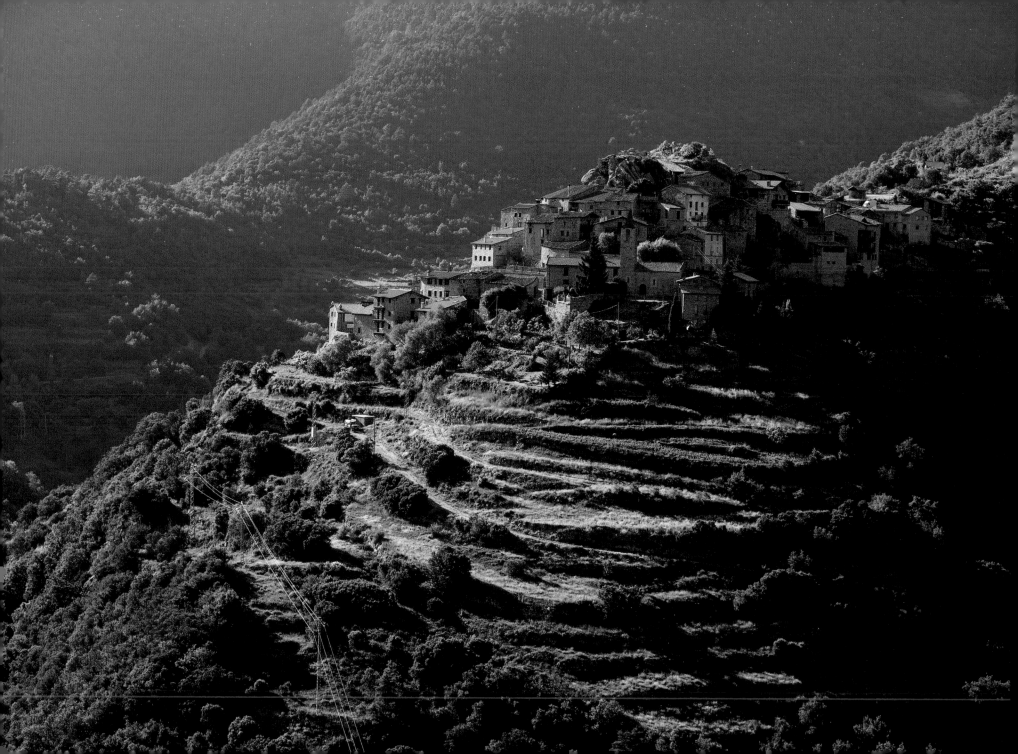

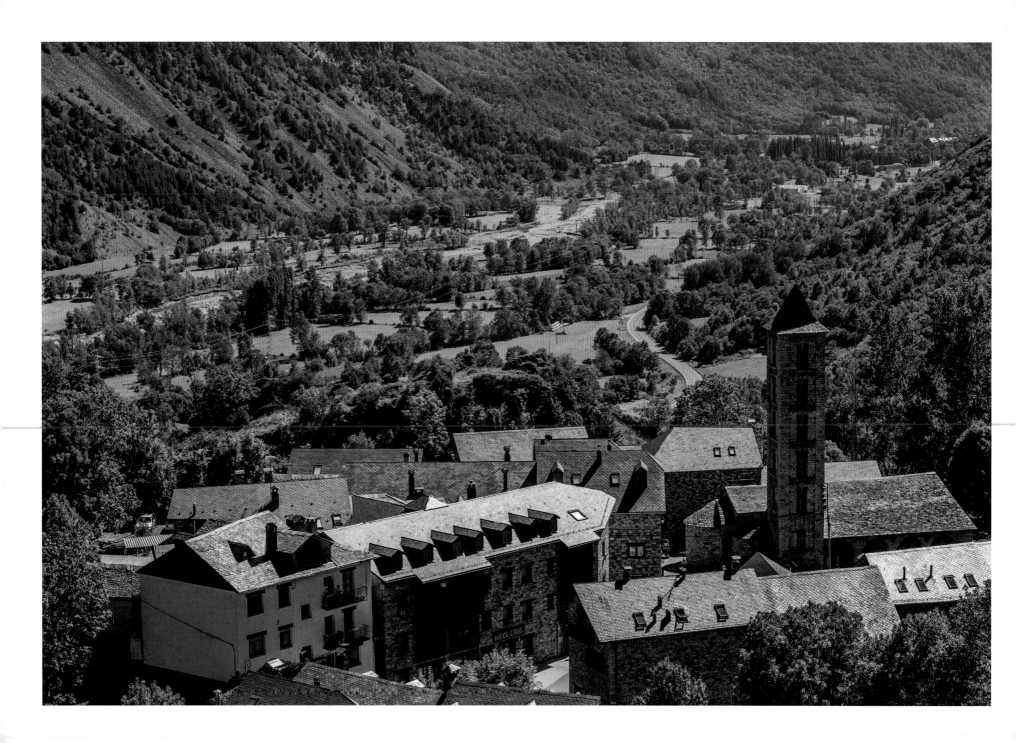

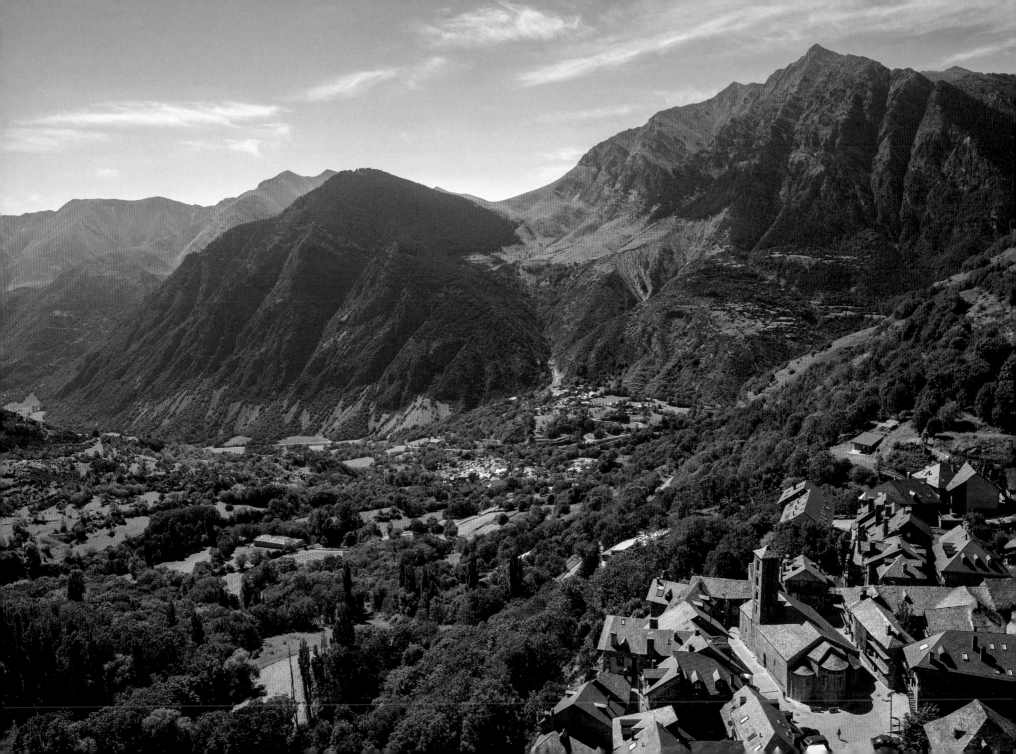

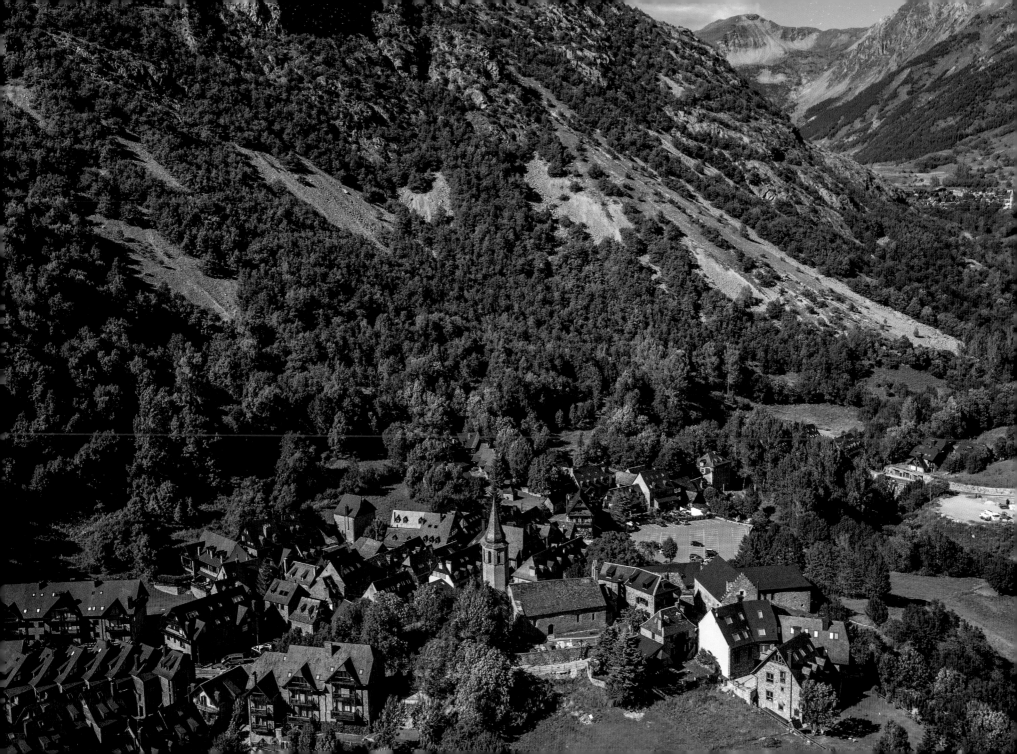

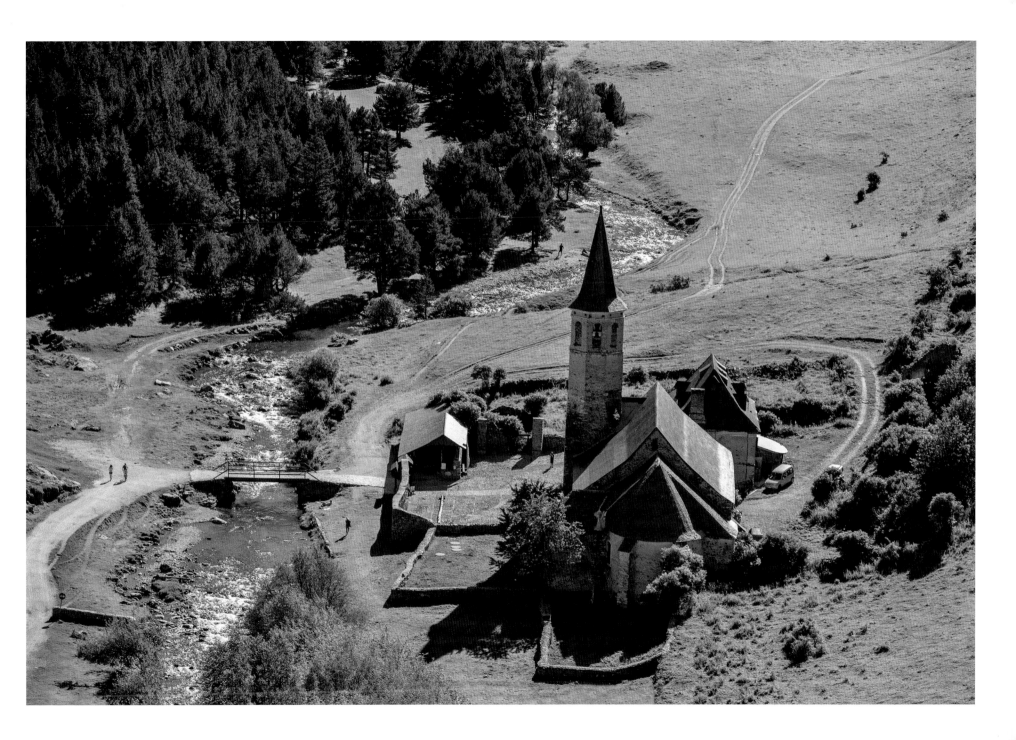

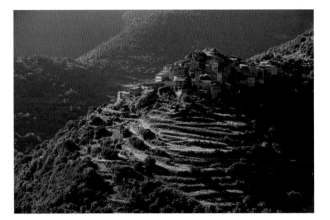

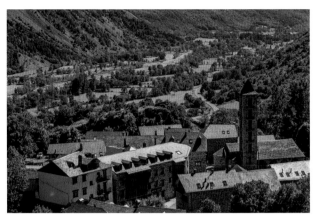

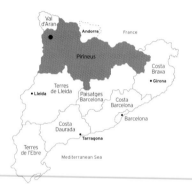

TÍRVIA
42º 30' 54" N, 01º 14' 35" E

Tírvia stands at the confluence of two of the Catalan Pyrenees' most emblematic valleys: to the north, the Vall de Cardós and, to the east, the Vall Ferrera, so called by virtue of its old forges and iron works. We are in the heart of the Pallars Sobirà, which is tantamount to saying the heart of the inhabited Pyrenees. Not very inhabited, because living conditions are harsh and activity is restricted largely to cultivating mountain crops (barley, rye, potatoes and so on) or grazing livestock on pastureland, where the relief permits. Nonetheless, they have been inhabited since ancient times, because the Pallars was one of the Carolingian counties on which Catalonia was founded. Tírvia, specifically, is documented as an alou (allodium: full property) belonging to the counts of Pallars as from the Xth century. The village stands on a rocky shelf at a height of just under 1,000 m above sea level. The lowest of these Pyrenean valleys lie at 800 m, while the highest peaks exceed 3,000

ARISTOT
42º 22' 46" N, 01º 37' 24" E

Hard by the Cadí range, with the River Segre on the valley floor, rise the first slopes of the axial Pyrenees, very close to Andorra. A number of villages are scattered through the area, witnesses to those times when the counts of Urgell and La Cerdanya ruled and paved the way for the future Catalonia. One such village is Aristot, the first written records of which date back to 839. A castle was built here, some of whose vestiges still remain. The village prospered above all in the XIIth and XIIIth centuries, clinging to the slope of a hill at an altitude of 1,250 m. Like so many other mountain villages, however, it now barely manages to survive. It belongs to the municipality of El Pont de Bar, together with Toloriu and Castellnou de Carcolze. All told, fewer than two hundred people grouped together in tiny nuclei such as Aristot. The mountain, which provided so much shelter from the ravages of medieval conflict, is hardly favourable to modern urban development.

ERILL LA VALL
42º 31' 30" N, 00º 49' 32" E

Vegetation and slate characterise the landscape in the Vall de Boí, in the comarca of the Alta Ribagorça. Llicorella is the local name for schist or slate, the metamorphic rock that dominates these valleys, which may be flaked easily to obtain tiles for house roofs. Indeed, the image most closely associated with these mountain villages is that of llicorella roofs. Erill la Vall is an example: blocks of schist (and granite also) for walls, thin slabs of slate for gable and mansard roofs. Presiding over the village is the slender six-storey Gothic belfry of the Church of Santa Eulàlia, a splendid XIIth-century Romanesque construction declared a UNESCO World Heritage Site in 2000. Remaining from the original decoration is a magnificent wooden sculptural group depicting the Descent from the Cross, now preserved at the Museu Nacional d'Art de Catalunya and at the Museu Episcopal de Vic.

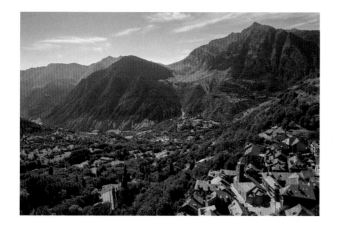

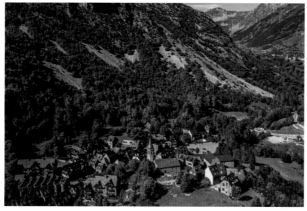

TAÜLL
42° 31' 04" N, 00° 50' 56" E

Right opposite Erill la Vall, on the other side of the Vall de Boí, stands the village of Taüll, which had remained in absolute anonymity for centuries until it became world famous in 1907, when its magnificent XIIth-century Romanesque frescoes were discovered, exceptionally well preserved in the two churches, dedicated to Santa Maria and Sant Climent, both of which were consecrated in 1123. The apse of Santa Maria de Taüll contained a fresco of The Virgin Mary while that of Sant Climent featured what is now the most famous Pantocrator (Christ in Majesty) in Romanesque art. These paintings are now preserved at the Museu Nacional d'Art de Catalunya (Barcelona). Santa Maria (in the centre of the village), Sant Climent (on the outskirts) and Santa Eulàlia in Erill la Vall, surrounded by meadows and deciduous forests and standing between 1,200 and 1,500 m above sea level, have together been a World Heritage Site since 2000 and one of Catalonia's most interesting landscape-cultural destinations.

UNHA, SALARDÚ
42° 42' 34" N, 00° 54' 07" E

The toponym *Vall d'Aran* (Val d'Aran in Aranese) is a tautology, since aran means 'valley' in the ancient language of Basque origin that has remained fixed in a multitude of Pyrenean place names. For this reason, the valley is commonly referred to simply as L'Aran. It is the only Catalan *comarca* in which Gascon Occitan is spoken in a local variant that is now the co-official language. It is also the only Atlantic Catalan *comarca*. Indeed, it marks the source of the Garonne, which flows into the Atlantic near Bordeaux. The climate reflects this circumstance in the form of Atlantic-type vegetation, characteristic of the northern slopes of the Pyrenees. Unha, hard by Salardú, is a typically Aranese village in the midst of meadows and oak forests. Its Church of Santa Eulàlia, with two belfries, the main octagonal one presiding over the village, is a XIIth-century Romanesque building.

MONTGARRI
42° 45' 34" N, 00° 59' 42" E

The inhabitants of Montgarri once contemplated the headwaters of the Garonne, a view that now belongs to the past. The river rises on the nearby Pla de Beret (1.860 m above sea level), the extensive plain on which the village livestock grazed. Today, however, Montgarri is deserted; all that remain are the ruins of houses and huts that were still occupied only a few decades ago. All that has been preserved is the sanctuary of Nostra Senyora de Montgarri and a building that has now been converted into a mountain refuge. The climatic conditions at this altitude (1,640 m above sea level) are too harsh. The few villagers were forced to move to the villages further down. Montgarri, together with Arties, Salardú, Unha, Gessa, Tredòs and Baguergue are now a single municipality: Haut Aran. Mountaineers and tourists, on the other hand, are becoming increasingly numerous in these villages, forgotten when they were inhabited, particularly since they have been accessible by car. Some leave, others arrive...

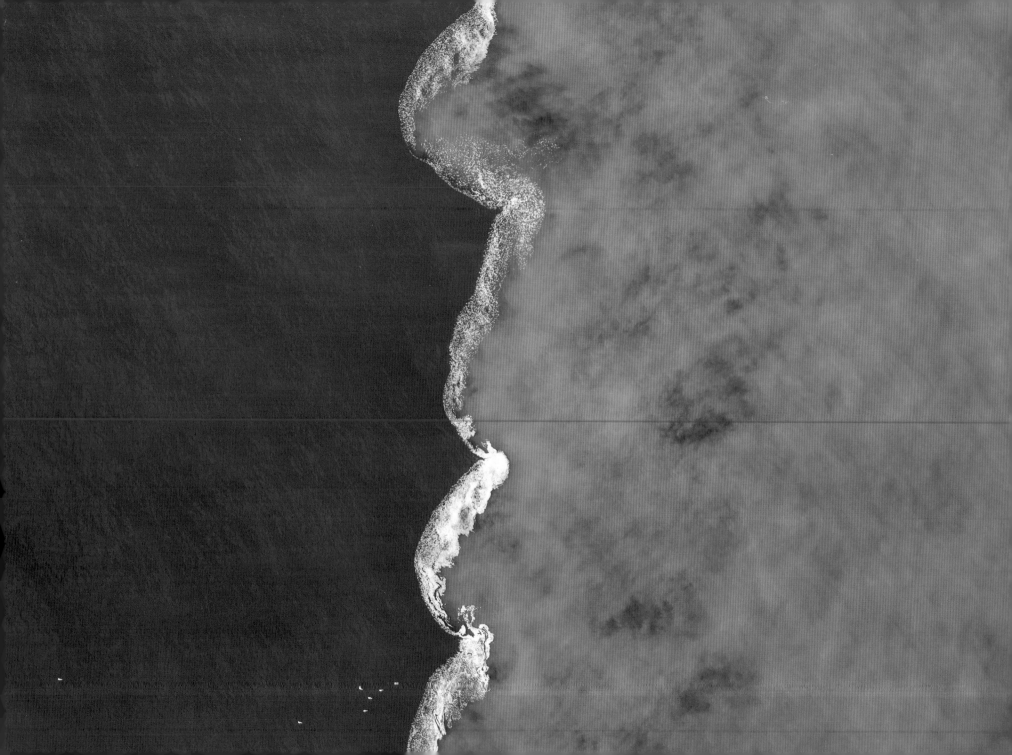

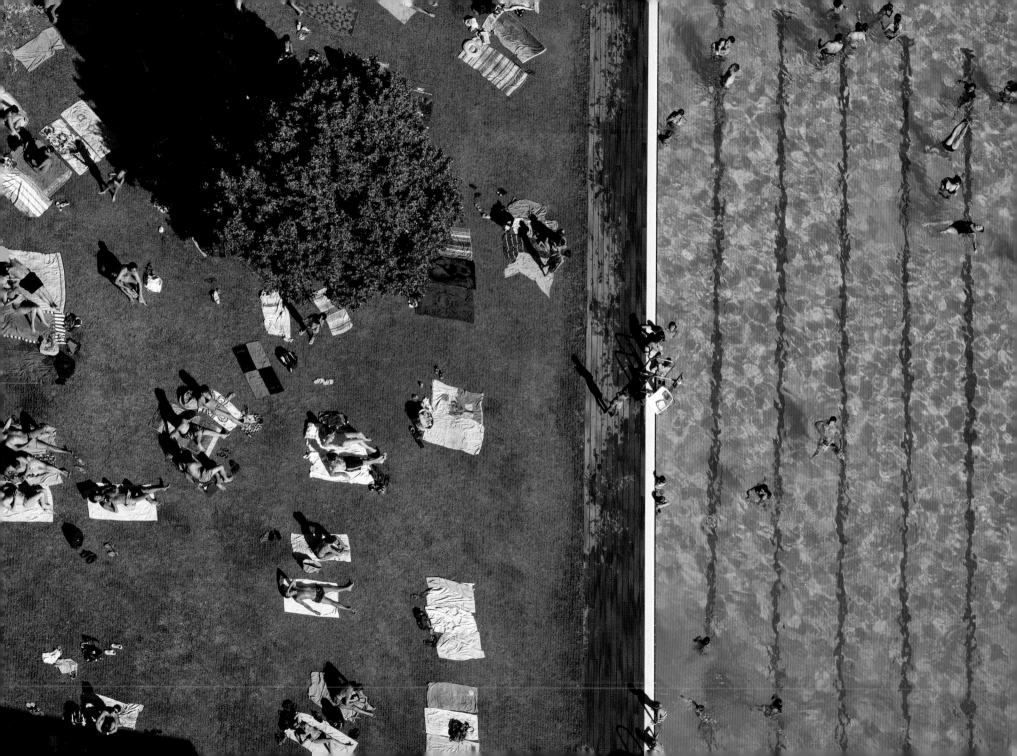

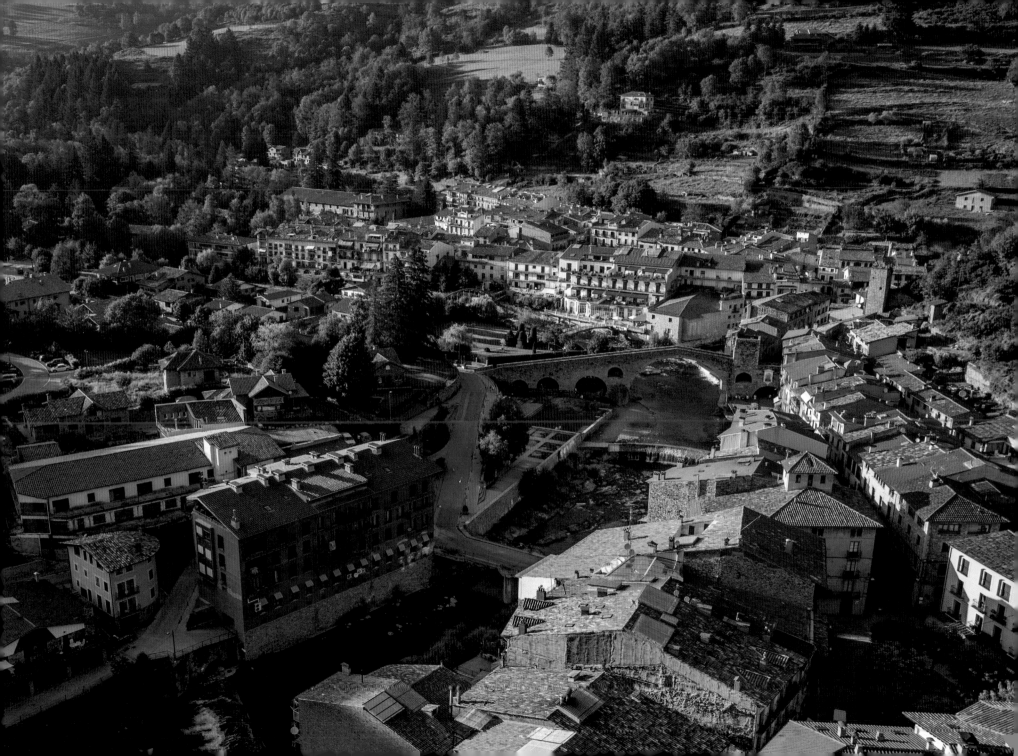

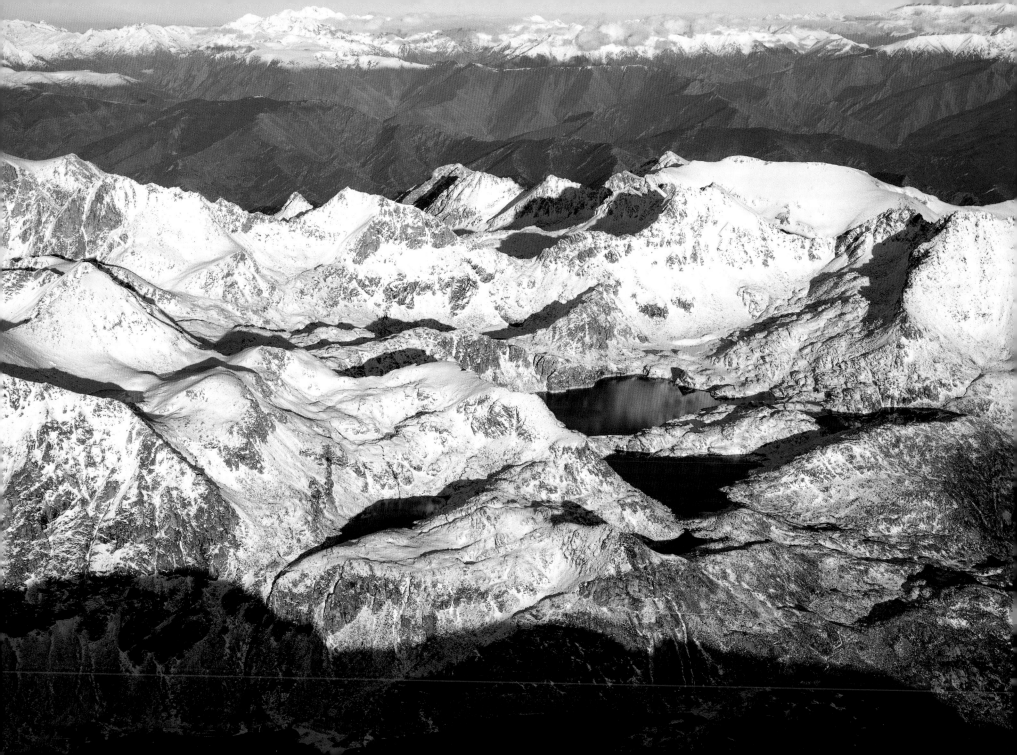

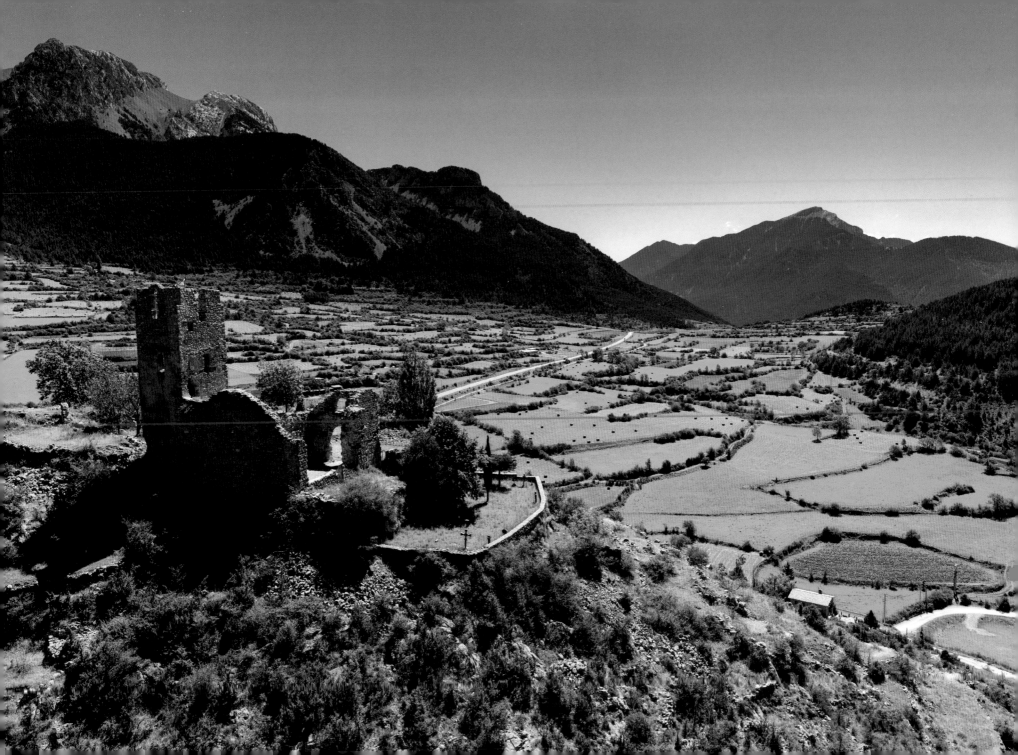

INDEX

ACKNOWLEDGMENTS

The Catalonia from above team

Photographic assistant: Thomas Sorrentino
Iconography: Françoise Jacquot, who has been
involved in the entire project
Coordination: Morgane Sbernardori

The Quadrilaser team for the photogravure,
and particularly to Régis Chevrinais for
the quality of the results

Yann Arthus-Bertrand has worked mainly
with CANON EOS 1Dx digital cameras equipped
with lenses ranging between 24 and 800 mm

Yann Arthus-Bertrand's photographs are
disseminated through the Altitude agency,
Paris, France
www.altitude-photo.com

The Catalonia from above film crew
Many thanks to Florent Gilard, Armand Amar,
Jean-Paul Husson, Bruno Cusa...

The Agència Catalana de Turisme team for their
unflagging enthusiasm and motivation. And in
particular to Josefina Mariné and Emmanuelle
Poiret for their commitment to the project.

Editorial Lunwerg for the publication of the book

And all those who have contributed to the project
from the sidelines:

Thanks to TAF Helicòpter: Marina Blesa
and Xavi Rovira

To the natural parks of the Generalitat
de Catalunya: Parc Natural del Montseny,
Parc Natural del Cap de Creus i Illes Medes,
Parc Natural del Cadí-Moixeró, Parc Nacional
d'Aigüestortes i Sant Maurici, Parc Natural
de l'Alt Pirineu, Parc Natural del Garraf,
Parc Natural del Delta de l'Ebre, Parc Natural
de Montserrat and Parc Natural del Montsant.

Thanks to the city of Barcelona for authorising
the flights

Thanks to Vueling for their collaboration

Thanks to Port Aventura

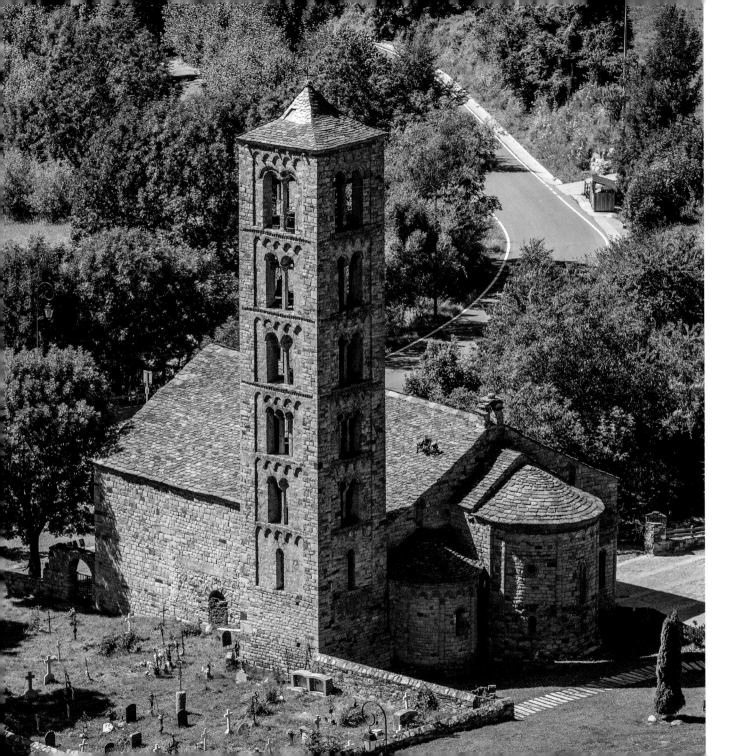

Sant Climent de Taüll.

PREVIOUS PAGES
Where the river meets the sea; Swimming pool in Salardú; Camprodon; Central Pyrenees; Rice fields on the Ebro Delta (see p. 33); Sant Pere de Lavern.

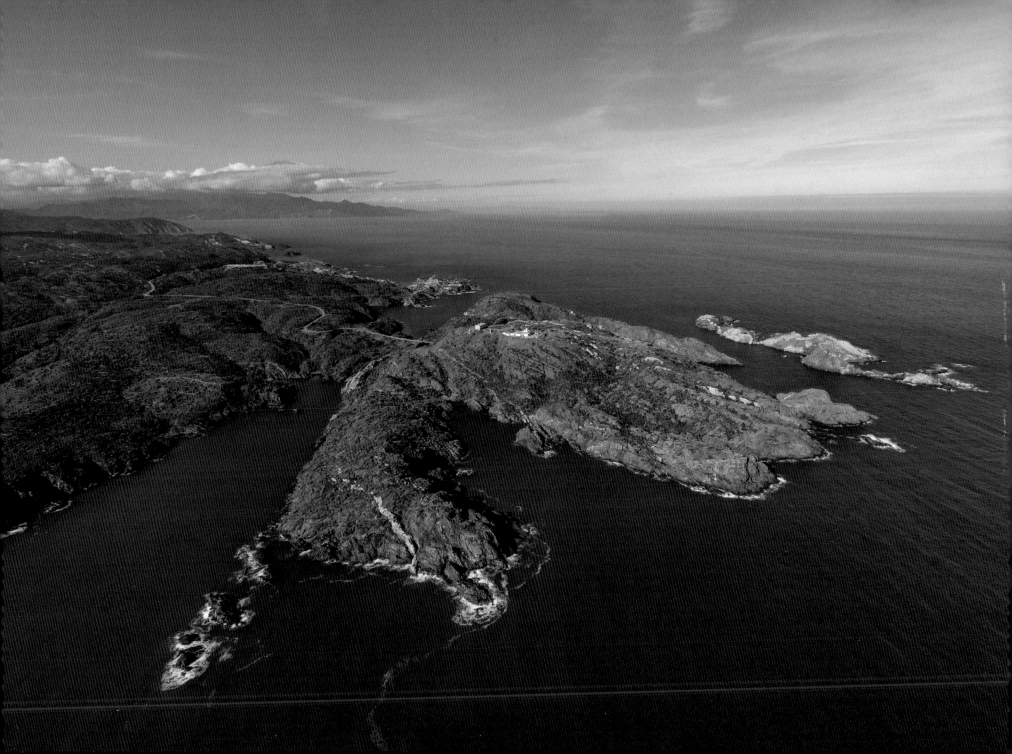

Yann Arthus-Bertrand as always been fascinated by the animal world in particular and nature in general. On his return from Kenya, where he and his wife Anne had studied the behaviour of a family of lions, he published his book *Lions*. He subsequently became a major photographic reporter. On the occasion of the first Rio conference in 1992, he decided to undertake a major Unesco-sponsored photographic project on the state of the world, fruit of which would be publication of *La Terre vue du ciel*. By now thoroughly committed to the environmental cause, he created the GoodPlanet Foundation. In 2009, he made the film *HOME*, on the state of the planet, which was seen by some 600 million people. At the Grand Palais, Paris, he exhibited *6 milliards d'Autres*, 5,000 videos shot all across the world, in which men and women give their opinions on a wide range of subjects. In acknowledgement of his commitment, on April 22 2009 he was appointed, Goodwill Ambassador for the United Nations Environment Programme. On the basis of this experience, and as an extension of his commitment, in 2015 he will direct a new feature film entitled *HUMAN*.

For further information see: www.yannarthusbertrand.org

Ramon Folch (Barcelona, 1946) is a doctor in biology and sociologist. Founder of the ERF strategic environmental consultancy and member of the Spanish Chapter of the Club of Rome, he has taught at Barcelona University and held the UNESCO/FLACAM Chair (La Plata). He has also been a Unesco environmental consultant (Paris) and President of the Consell Social de la Universitat Politècnica de Catalunya.

Folch has contributed to professional projects in Europe, Africa and America. He is the author of numerous works on socio-environmental and energy-related themes. A great communicator, he has disseminated his wide knowledge through lectures, exhibitions, television programmes and so on. He was curator and author of the catalogue for Yann Arthus-Bertrand's exhibition "La Terra vista des del Cel" (Barcelona, 2000).

Graphic design and art work: Élisabeth Welter

Translation from French: Richard-Lewis Rees

Library of Congress number 2018934211

Printed and bound in 2018 in Italy
10 9 8 7 6 5 4 3 2 1

Abrams books are available at special discounts when
purchased in quantity for premiums and promotions
as well as fundraising or educational use. Special
editions can also be created to specification. For details,
contact specialsales @abramsbooks.com
or the address below.

195 Broadway, New York, NY 10007
abramsbooks.com

ISBN: 978-1-4197-3784-8

Photoengraving: Quadrilaser

Printed in Slovenia